sk-interfaces

EXPLODING BORDERS – CREATING MEMBRANES IN ART, TECHNOLOGY AND SOCIETY

EDITED BY JENS HAUSER

FACT & LIVERPOOL UNIVERSITY PRESS

First published 2008 by

Liverpool University Press

4 Cambridge Street

Liverpool L69 7ZU

and

FACT (Foundation for Art and Creative Technology)

88 Wood Street

Liverpool L1 4DQ

British Library Cataloguing-in-Publication data
A British Library CIP record is available

ISBN 978-1-84631-149-9 cased

The publishers are grateful to Editions François Bourin and the University of Michigan Press for permission to reproduce copyright material from Michel Serres, *The Troubadour of Knowledge* (1997/1991)

Cover concept, endpapers and section dividers by Zane Berzina

Designed by Alan Ward @ www.axisgraphicdesign.co.uk
Printed and bound by Andrew Kilburn Print Services

COVER AND 4–5
Zane Berzina, *Topology of Skin III*,
2007, drawing.

Courtesy of the artist

Contents

Welcoming *sk-interfaces* to FACT

Mike Stubbs

sk-interfaces presents a set of artists' works that propose a 'skinless society'. A metaphor for society where boundaries are increasingly merged. Skin as a medium rather than a fixed barrier in a society where our ability to define smaller and smaller units of time and matter enables more subtle distinctions between one thing and another.

With increased overlaps between technologies, materials, academic research and science it is inevitable that artists find themselves experimenting on the edges of new technologies and practice. Similar experiments to those that led to New Media Art itself, a term now not so new at thirty years old. A practice that has shifted from formal experiment with technologies and media through to the social and cultural meanings referenced in all that we do. It is no surprise then that as our new media migrates into the realm of life sciences and how they interface, artists too move into those subjects, curious in what they are and how they can be appropriated to creative ends. With the invention of new materials and processes to join them together artists have made them fair game. And with the permission and freedom granted to artists to work outside the constraints facing more formal situations, they raise important questions as a reflection of society. Scientists, artists and technologists are members and products of a society dealing with accelerated complexities and snowballing progress.

FACT celebrates the artists and writers for their pioneering works which explore important aspects of change and through that open conversations about our bodies, our minds and our futures.

FACT wishes to acknowledge Jens Hauser for the project concept, his remarkable expertise and untiring commitment to *sk-interfaces*; Liverpool University Press, in particular Andrew Kirk, Simon Bell and Robin Bloxsidge, for making this publication possible; Alan Ward at Axis Graphic Design for his flexibility and imagination in the design, together with Zane Berzina for her original contributions towards making this catalogue unique; John Lee for translating texts from French and Staci von Boeckmann and Stephen Starck for translating texts from German; Dr John A. Hunt at the Department of Clinical Engineering, Liverpool University, for his open-minded engagement and advice on numerous aspects of the exhibition. FACT would specially like to thank all the artists and writers who have made this ground-breaking project at the intersection of art, science and society possible, as well as all the FACT staff who helped to realize this project.

Culturing Change

Marta Rupérez

Since its inception at the end of the 1980s, FACT has been at the forefront of new developments in creative technologies offering knowledge, resources and inspiration which have allowed artists and audiences to explore new processes, forms and potential languages. From the presentation of net.art in our galleries with Jodi's *Computing 101B* (2004) to new developments in traditional disciplines such as Vito Acconci's *Self/Sound/City* (2005), FACT has always welcomed new challenges. Our commitment to media art is strongly linked to its innate capacity to shift our surrounding reality. At the centre of FACT's activities is a constant need for reinvention, which has determined an open and flexible character that encourages new voices and meanings to be expressed. The *sk-interfaces* exhibition presents a whole new set of challenges, directing our expertise towards unfamiliar fields of practice, such as wet technologies.

The social role that media arts play today is accomplished by creators who constantly question the established path of reality at a given moment. *sk-interfaces* presents a number of artists who are utilizing a set of uncommon tools to comment on the evolution of our 'human futures'. Making the most of the potential of languages with rules and codes that are not yet defined, the works on view stage the utopian as well as dystopian possibilities of our technological present. The questions and social critique materialized in our galleries are explored in depth in the following essays.

In recent months FACT has met the challenge of compiling and communicating our young history of innovation and change to audiences worldwide with the launch of its archive and the *Re: [Video Positive]* exhibition (2007). In the atmosphere of frantic acceleration that characterizes our information society, documenting and communicating one's story ensures its preservation and historical existence. In this perspective, *sk-interfaces* confronts us with even more challenges regarding the display and preservation of these new and often ephemeral forms of expression. The question of how to preserve artworks with an innate transformative nature is not new. The debate, however, reaches new grounds when the intention of the work is impregnated with the idea of organic presence, as opposed to its mere representation or simulation.

The performative character of many of the pieces echoes the experiential element also crucial in interactive artworks. The exhibition represents another step in FACT's ongoing research into the creative explorations of what could account for 'interfaces', materialized in the presentation of the *Human Computer Interaction* (2006) project as well as, more recently, in David Rokeby's *Silicon Remembers Carbon* (2007). Our investigation into the hybrid space between human and machine perception reaches a new direction with the issues at stake in *sk-interfaces* and the culturally relevant centrality of what Jens Hauser refers to as the liminal state that is 'inbetweenness'.

In 2008, with Liverpool at the centre of the international cultural focus, FACT is honoured to be the platform from which the artists in *sk-interfaces* will communicate to the world the hybrid languages that are shaping our existence.

Who's Afraid of the In-Between?

Jens Hauser

When words are 'added up' in our logocentric cultures, we tend to make quick associations, paying more attention to the 'sum' of meaning generated by a neologism's hybridized elements than to the act of hybridization itself and the subtle, catalysing machinery involved in this process of *becoming*. *sk-interfaces*, as a *trompe l'œil* concept both for the exhibition and the publication, is designed to emphasize the growing importance of this liminal state of 'inbetweenness'. While *skin* and *interface* can be readily identified as solid words in their own right, tempting us to make the immediate, literal association of 'skin as interface', it is the title's hyphen that demands our attention. The intrinsic quality of the hyphen to change its position allows it to take up the position of in-between, exploiting its potential to modify our perception of a given word in the manner of a *Vexierbild* (picture puzzle). As a mediating material signifier supposedly devoid of its own meaning, the hyphen is indeed more than merely a link; it dynamically induces an *ability to become* into the very 'body' of the concept *sk-interfaces*. But it is not the position of the hyphen alone that determines whether the modified word may be understood as a discursive tool or as pure slang, and by whom; it also depends on whether the word is read, thought or spoken aloud. The specific materialities of communication[1] *matter* – they matter in art, and they matter even more in the current state of a still developing post-digital paradigm for which Roy Ascott has coined the intriguing term *moist media*, 'comprising bits, atoms, neurons, and genes in every kind of combination' and in which 'the dry world of virtuality and the wet world of biology' merge to become a substrate of art.[2] Since we cannot expect such techno-holistic views of how matter will then be in-formed to unfold 'naturally', nor cultural notions or concrete physical realities to warmheartedly collapse into each other, it is first and foremost the mediating membranes that warrant our consideration – membranes conceived as active rather than passive, membranes that do not merely separate insides from outsides nor are simply crossed or transgressed, but instead are negotiated.

sk-interfaces attempts to make these membranes tangible in a twofold yet mutually informing approach through art and cultural theory which provides a locus both for phenomenological experience and embodied thought. Put succinctly, art came first and cultural theory followed, unless it was already taken up in the artistic position itself. In contrast to the trend in academic publications to use art primarily as a mere placeholder or litmus paper, illustrating otherwise self-sufficient arguments from pre-existing heuristic frameworks with the most 'meaningful' examples, the artworks and performances in *sk-interfaces*, reflecting a wide variety of forms both with respect to discourse and technique, should first be considered independently. A five-year empirical study of why and how artists have recently developed an interest in the material properties and functionalities inherent in the notion of 'skin as a physiologically mediating instance' revealed common patterns of motivations. What these works share

1 Hans Ulrich Gumbrecht and K. Ludwig Pfeiffer (eds), *Materialities of Communication* (Stanford. CA: Stanford University Press, 1994). Gumbrecht illustrates the expectation of 'high abstraction' in the humanities, to refer to phenomena that one would tend to qualify as 'spiritual' rather than 'material' as a sort of 'everyday Cartesianism', through an anecdote reported from a university lecture: 'I was interrupted by a man in the small audience (apparently a colleague) who showed clear signs of impatience: "Could you please define what you mean by *meta-realities* of communication?" It took us further questions and answers to a recurrent nominal phrase in my talk that I had hoped would be understood as *materialities of communication*.' 'A Farewell to Interpretation', in Gumbrecht and Pfeiffer, *Materialities of Communication*, 389.

2 Roy Ascott, 'Technoetic Territories', in Ric Allsopp and Scott Delahunta (eds), *Performance Research: Digital Resources* 11.4 (2006), 39–40.

is their liminality within which major shape-shifting transformations can occur. In the ambiguity, openness and disorientating indeterminacy of these unstable transition zones, ontological crises and epistemological doubts relating to our ever-expanding identities are given material form: from trans-border, -gender or -species issues and mixed ethnicity to the fascination of growth, self-experimentation, infection and healing, to matters of the living and non-living, such as the status of foetuses, stem cell research and tissue culture.

PERFORMING THE LIMINAL

The performance of the liminal in the arts poses the proverbial chicken and egg question: Is art merely reflecting and anticipating the consequences of far-reaching biomedical developments? Or does it play a more active role, providing the aesthetic framework which paves the way for the very coming-into-being of these *liminal lives*? Susan Merrill Squier, in her book *Liminal Lives – Imagining the Human at the Frontiers of Biomedecine*,[3] argues that (science) fiction, poetry, literature, visual and performance art are cultural spaces located at this threshold where worries about ethically and socially charged scientific procedures are being worked through. Squier examines 'the whole range of interventions including embryo culture, in vitro fertilization, growth hormone administration, inter-species fertilization as part of assisted reproduction, stem cell therapy, xenotransplantation, and fetal cell transplantation',[4] arguing that 'we must link our contemporary strategies for modifying things and people with our strategies of representation'.[5] Artists and other cultural practitioners located at this threshold may function as agenda-setters, and therefore not only share responsibility in our perception of these liminal lives but in their development and design as well.[6]

To illustrate how these liminal lives come into our world, Squier borrows and extends the notion of liminality from Scottish anthropologist Victor Witter Turner and his concept of the rite of passage, an emotionally uncomfortable 'betwixt and between' period of transition[7] during which one is in a 'neither here nor there' situation of enhanced self-reflexivity – for example during an initiation ceremony. But Squier views us as human beings in the era of biotechnological interventions in birth, growth, ageing and death as *liminal ourselves*, 'as we move between the old notion that the form and trajectory of any human life have certain inherent biological limits, and the new notion that both the form and trajectory of our lives can be reshaped at will'.[8] In reference to anthropologist Paul Rabinow, Squier distinguishes *bios*, 'the appropriate form given to a way of life of an individual or a group', and *zoë*, 'the simple fact of being alive and applied to all living beings per se', but 'zoë is increasingly confused with bios, with the result that we are finding it harder and harder to define what life is, much less to decide whether we should attribute a variation we encounter to forces of nature or culture'.[9] As a result,

> Turner's notion of cultural liminality superimposed safely on a solid biological life no longer applies, with destabilizing consequences that reach from our cultural analysis to our medical practices, shifting the very ground of being. The stories we tell about our lives – whether fiction or fact – are crucial maps to this shifting ground.[10]

The overlap of both cultural and biological liminality is central to artistic strategies dealing with biological systems or biotechnological techniques as means of expression and extending into areas such as cell and tissue cultures, neurophysiology, transgenesis or medical self-experimentation. In Julia Reodica's work, the



3 Susan Merrill Squier, *Liminal Lives – Imagining the Human at the Frontiers of Biomedicine* (Durham, NC, and London: Duke University Press, 2004).

4 Ibid., 17.

5 Ibid., 10.

6 In the chapter 'Transplant Medicine and Transformative Narrative', Susan Squier discusses how the cultural perception of the human body and its constituent parts is being shaped through the visual arts and science fiction. Ibid., 168–213.

7 Victor Witter Turner, 'Frame, Flow and Reflection: Ritual and Drama as Public Liminality', in Michel Benamo and Charles Caramello (eds), *Performance in Postmodern Culture* (Madison, WI: Coda Press, 1977), 33–55.

8 Squier, *Liminal Lives*, 9.

9 Ibid., 7.

10 Ibid., 9.

'inbetweenness' conveyed by the hyphen in *sk-interface* materializes as hymen: tissue cultures of smooth rodent muscle tissue, bovine epithelial cells and the artist's own vaginal cells, designed to symbolically re-virginize repeatedly. While in clinics worldwide, hymenoplasty, the reconstituting of the hymen, is carried out as pre-marital *fine tuning* to ensure female bleeding on the wedding night, Reodica negates the notion of assigned gender: *hymNext* cultures can be transplanted to men as well.[11] 'The technical research and manipulation of cells in a novel environment does not include gender at all, but purely the cell as a living, architectural being.'[12]

Architectural beings might also be an appropriate term for Zbigniew Oksiuta's constructions out of biological polymers, which use the processes of self-organization and internal tensions in semi-permeable polymer surfaces as sources of amorphous shape formations. Drawing on the principle of living systems that emerge out of protective liquid membranes, *Breeding Spaces* is a project designed to generate forms 'in which the borderline separating the interior from the outer environment is not a foreign body, made of neutral material (such as Petri dishes or glass containers), but an immanent element of the whole structure. It is simultaneously a boundary *and* a spatial scaffold. It plays an active role in the processes inside the system.'[13] While the building of large-scale fluid but stable forms is impossible in the earth's gravitational field, Oksiuta attempts to create such forms in underwater environments and, potentially, outer space, where suitable conditions for the growth of soft membranes can be found:

> The organisms which live in a gravitational field are themselves in a hermaphroditic condition, divided between solid and fluid material; they consist primarily *of* water and even develop, as well, particularly in the

embryonic stage, *in* water. On earth, these fluid bodies are kept in form by their soft membrane, the skin, and stabilized with a skeleton.[14]

Interestingly, Gilles Deleuze and Félix Guattari delineate similar principles for performing the liminal, analogous to the scale of individual behaviour and the biological mechanisms of life. In *1837: Of the Refrain*[15] they describe the formation of dynamic *milieus* through the creation of functional rhythms to escape chaos and create provisional boundaries, milieus that are reopened once stability is achieved. Like the child who quells its fear in the dark through song and so creates a reassuring space, for 'home does not preexist: it was necessary to draw a circle around that uncertain and fragile center, to organize a limited space'. Thanks to this provisional, protective 'skin', 'the forces of chaos are kept outside as much as possible and the interior space protects the germinal forces of a task to fulfil or a deed to do', before the natural impulse to open recurs and 'one opens the circle a crack, opens it all the way, lets someone in, calls someone, or else goes out oneself, launches forth'. Yet here, too, the membrane is not passive but active: 'One opens the circle not on the side where the old forces of chaos press against it but in another region, one created by the circle itself'. This principle of self-organization through the linking of fluctuating and intermingling milieus in Deleuze and Guattari figures, ultimately, as a general model of the living as such:

> Every milieu is vibratory, in other words, a block of space-time constituted by the periodic repetition of the component. Thus the living thing has an exterior milieu of materials, an interior milieu of composing elements and composed substances, an intermediary milieu of membranes and limits, and an annexed milieu of energy

11 A *hymNext* prototype has been applied to a male volunteer, artist Adam Zaretsky, and the defloration act carried out in his nostril.

12 Julia Reodica, 'Feel Me, Touch Me: The *hymNext* Project', in this volume, 73.

13 Zbigniew Oksiuta, 'Biological Habitat: Developing Living Spaces', in this volume, 137.

14 See below, 139.

15 Gilles Deleuze and Félix Guattari, *A Thousand Plateaus: Capitalism and Schizophrenia*, trans.Brian Massumi (London: The Athlone Press, 1988) (originally published as *Mille Plateaux*, Volume 2 of *Capitalisme et Schizophrénie* [Paris: Les Editions de Minuit, 1980]).

sources and actions-perceptions. Every milieu is coded, a code being defined by periodic repetition; but each code is in a perpetual state of transcoding or transduction. Transcoding or transduction is the manner in which one milieu serves as the basis for another, or conversely is established atop another milieu, dissipates in it or is constituted in it.

This could by all means constitute a theory of interfacing as well, but one in which the human would be a co-constitutive rather than an external, dominant element in an increasingly complex biocybernetic environment.

SKINNING THE INTERFACES

It is fascinating to examine more closely the initially contradictory levels of meaning of such a tension-filled word as *skinning*. Most commonly, 'skinning' refers to the act of removing the skin from a dead animal. By extension, skinning can be understood metaphorically as scaling something down, or removing much of the essence of something. Ironically, what is understood in the physical context of the body as a 'taking away' is now in the language of digital culture an 'adding on', where skinning refers to the design of surfaces, for example, in video games. It may describe the process of creating 2-D textures to be applied to 3-D meshes, or creating 'skins' as themes to change the appearance of a computer program. Software capable of having a 'skin' applied is referred to as being *skinnable*. We might ask how our culture has arrived at this astonishing degree of reflexivity – which seems to be reflected linguistically in the reversibility of levels of meaning – and if, in light of the transitivity of verbs, contradiction even exists here.

In her analyses of skin, and in accordance with Didier Anzieu's concept of the skin-ego,[16] Claudia Benthien emphasizes two extreme phantasms associated in an anthropological sense with the skin: 1) 'the masochistic phantasm of the flayed body' and 2) 'the narcissistic phantasm of the doubled skin'. Both phantasms are related to the early childhood fantasy of sharing the skin of the primary caretaker.[17] Moreover, as the history of anatomy shows, Western thought is shaped by the idea that the penetration of the skin's surface is synonymous with the production of knowledge, for the body's interior holds the core of truth. The notion of the reflexivity of skinning becomes even more significant when we consider that in numerous anatomical representations the skinned 'object' participates as 'subject' in its own, apparently painless and nonchalant, skinning, as if the only concern was to increase the knowledge we abstract from the body.

It is precisely this reflexivity that we see in the interpretation of the Greek myth of Marsyas, the agonistic duel between Marsyas and Apollo whose climax is the punishment of Marsyas by flaying. This is a struggle between world order and chaos, for 'fundamental differences are at stake: the sphere of Dionysus and the sphere of Apollo. This is the divided intellectual world of the Greeks: on the one hand, dark, Silenic pessimism, on the other Apollonian science, the light of rationality.'[18] It is a battle over *sophia, over the form of knowledge*'.[19] Stéphane Dumas sees the Marsyas myth to a certain degree as the mirror image of the subject/object paradigm:

My hypothesis is that Apollo here becomes the prototype of the *I*, an expression of the subject as viewed in Western civilization. This *I* is the subject of an absolutely transitive action: *I flay you!* [...] The *Hanging Marsyas* is the passive object of the transitive verb 'to flay' whose subject is Apollo. However, it seems to me that this transitivity involves a degree of reflexivity. This in fact is why it expresses the action of a true subject. In a

16 Didier Anzieu, *The Skin Ego* (New Haven/London: Yale University Press, 1989) (*Le Moi-Peau* [Paris: Bordas, 1985]).

17 Claudia Benthien, *Skin: On the Cultural Border between Self and World* (New York: Columbia University Press, 2002), 9.

18 Ursula Renner and Manfred Schneider, 'Die Aktualität des Marsyas', in Renner and Schneider (eds), *Häutung. Lesarten des Marsyas-Mythos* (Munich: Wilhelm Fink Verlag, 2006), 8.

19 Ibid., emphasis mine.

way, through the duel and then the flaying, Apollo and Marsyas form an indissociable pair.20

Here arises the subject/object paradigm, the central preoccupation of epistemology, yet it arises as an instance of actual bodily flaying in which the skin becomes a reflexive interface – indeed, in numerous interpretations of the myth, Apollo's skin almost seems to fuse with that of Marsyas. Nevertheless, it is Apollo who wins the battle and gains the upper hand –

> one of the reasons why Apollo wins this duel: he is able to sing to the music of the lyre, something quite beyond his flute-playing rival. To be sure, Apollo's voice is not that of the modern *ego*. But it is a signifying voice, that of the *logos*, in contrast with his rival's purely instrumental music21

– and thus seems to stand for the enduring logo- and phonocentrism of Western culture.

In this context, we can revise our understanding of 'interface' to go beyond the common limited notion of a data-transmitting connection between analogue and digital entities which relate to one another through shared, language-like protocols. Apollo and Marsyas both have *faces* and between (*inter*) them is the corporality of the skin. We can assume that none of this was lost on media artist Maurice Benayoun in designing his emblematic, interactive CAVE-Installation *World Skin*, which still today, ten years after its inception, poses the question about the site and role of bodily presence in a digital culture. Benayoun allows viewers to experience this *skinning* in its etymological ambiguity, inviting them to a perfidious photo safari in a land at war. On the one hand, the real and subsequently digitized images of war, as two-dimensional surfaces, are pulled like clothing onto the matrix of coordinates of an abstract landscape, yet the stereoscopic effect gives them a three-dimensional appearance. The immersive effect is intensified as war tourists, armed with digital cameras, are sucked into the display through the assigning of a task. This is a classic strategy of interactive media art in which 'artists have frequently responded to the so-called dematerializing tendencies of information culture by bringing bodies into direct contact with computational hardware in their work'.22

Yet the virtual encounter with soldiers and victims serves less to create empathy with the numerous faces than to generate a sort of numbing automatism through the medial extension of the viewers' own senses. In *World Skin* the voyeurism, self-generated by the whole technical apparatus, is transformed into action – by *taking* pictures the viewer leaves white spots on the war landscape. Through this skinning of the virtual world, Benayoun skins the interface itself, making it the subject of the installation: 'Photography deletes memory in the very process of creating it'.23 And this applies all the more, since the digitization of documentary sources in *World Skin* already in the process of skinning annihilates the indexical quality of the photographic medium. Moreover, the simulated depth of the immersive sensory experience is ultimately reduced to flatness when safari tourists take laser prints of their photoshoot home. The ludic moment of interface-interaction is supplemented *ex post facto* through contemplation and reflection.

WHICH/WHOSE FACES?

The interaction of the installation *World Skin*, then, is designed above all to provoke communication with one's self, to lead us to examine our own mediated perception. When discussing the materiality of mediating instances, what or whom to interface with is significant. More than the purely technical modality of such interconnecting

20 Stéphane Dumas, 'The Return of Marsyas: Creative Skin', in this volume, 19–20.

21 See below 19.

22 Anna Munster, *Materializing New Media. Embodiment in Information Aesthetics* (Hanover, NH: Dartmouth College Press/ University Press of New England, 2006), 120.

23 Maurice Benayoun, 'World Skin: A photo safari in a land of war', in this volume, 111.

systems, this dynamic liminality becomes interesting as a transformative instance. Nevertheless, the great temptation remains in media art to let digital–analogue interfaces do what they would otherwise do, albeit with a playful twist, as in the case of what might be referred to as 'data translation art'. In 1996 artist Jim Campbell mocked such interface art in his *Formula for Computer Art*,24 which can be seen as a critique of art that maps an arbitrary input (e.g. heartbeat, net activity, stock markets, earthquakes, etc.) onto an arbitrary output (e.g. motorized objects, wind or rain generators, moving images, dynamic graphs, etc.), reducing the transformative potential of interfacing to the act of translation.

On the other hand, there are many interfaces in which *the other* as machine is dominant, sometimes even facialized. The typical example that comes to mind is the dotted, rudimentary smile or the dissatisfaction expressed through the arch of the semi-circular 'mouth' that welcomes users of certain operating systems. Anna Munster argues that the computer takes in facialized attributes because it comes to figure as a 'subject':

> these interfacializations aim to overcome the differentiation always at stake in body–computer interaction, by eradicating the distinction between human and machine. This is achieved by ignoring the material conditions of human–computer engagements and by 'elevating' this interaction to a communicative, cognitive level. Interfacializations also bequeath certain powers and even proto-subjectivities to computers, such as the helpful servant or the suprahuman conquering race of future robots.25

Hence, we must pose the more fundamental question, whether interfaces, to speak in purely ontological terms, need necessarily be *computer* interfaces, and whether there is something genuinely tautological at the root of this monolithic association: Humans, those 'tool-making animals', who define themselves through cognitive superiority to other creatures and in the broadest sense through *techne* and *poiesis*, communicate with machines they themselves have created, using language protocols they have also developed, through a kind of interactive mimesis.

In *Understanding Media*,26 Marshall McLuhan describes media in general as an extension of human sensory capacity. This is characterized by a synaesthetic interplay generated by the multiplication of these extensions, which now, however, in the electronic age, not only expand the entire capacity for perception but allow the senses to numb one another. To clarify the process of *autoamputation* which parallels that of medial extension, McLuhan turns to the myth of Narcissus, putting deliberately into play the similarity of the Greek *narcosis* (numbness) and *Narcissus*:

> The youth Narcissus mistook his own reflection in the water for another person. This extension of himself by mirror numbed his perceptions until he became the servomechanism of his own extended or repeated image. The nymph Echo tried to win his love with fragments of his own speech, but in vain. He was numb. He had adapted to his extension of himself and had become a closed system. Now the point of this myth is the fact that men at once become fascinated by any extension of themselves in any material other than themselves.27

In the context of the question at hand, whether and how interfaces should be understood not only through cognitive-language vectors but beyond that through direct physiological ones, McLuhan opens up greater

24 Jim Campbell, 'Delusions of Dialog: Control and Choice in Interactive Art', lecture at the Museum of Modern Art, New York, *Technology in the 1990s: The Human/Machine Interface* symposia series, May 1996, http://www.adaweb.com/context/ events/moma/technology.html http://www.jimcampbell.tv/ (accessed 12 December 2007).

25 Munster, *Materializing New Media*, 123.

26 Marshall McLuhan, *Understanding Media: The Extensions of Man* (1964) (Cambridge, MA: MIT Press, 1994).

27 Ibid., 41.

possibilities, in particular because his media theory is not limited to telecommunication or information theory but includes such various 'media' as clothing, housing, weapons, aeroplanes and so on. Coupled with his theory of inclusion, that media *per se* always already contain other media (the infamous 'the medium is the message'), McLuhan's theory can be extended to biomedia[28] as well, which in the age of xenotransplantation and transgenics may no longer be considered from a strictly anthropocentric point of view.

With what or whom do we need to interface today and how, beyond the established protocols? Louise Poissant brings the issue to a head when she writes that, in new media art, 'the raw material, one must say, is algorithmic and abstract and at the same time composed of communicational flux made of sensations, emotions, ideas, and exchanges'.[29] She sees in interfaces the potential for the extension of telescopy and microscopy:

> both of them open us up to worlds, allowing us to redefine ourselves. The former relativizing our position, the latter establishing continuity between different kingdoms: animal, vegetable, and mineral. A large number of interfaces developed by artists fulfil similar functions.[30]

Poissant suggests replacing the term *interactivity*, often inappropriately yet automatically associated with interfaces, with the term *alteraction*. 'The notion is even more interesting since it puts the emphasis not only on the action but also on the encounter with the other.'[31] But just what would such a perspective on interfaces look like when contact with *the other* is our goal, with those already telescopically and microscopically grasped instances of plant, animal or mineral otherness?

MOVING AWAY FROM MOTION

A central characteristic of contemporary media art has long been its affinity for interactive displays and the inherently processual nature of the exchange between artist and participant, in order to clearly distinguish themselves from 'dead object and material art', where processes merely culminate in the end product of the completed work. Media art's emphasis on the processual implies progression on the scale of time, and movement, whatever the form, set in motion by cognitively initiated, binary logical processes, hence conceived as *active*. By contrast, material properties are considered *passive* and would fall outside the realm of interfaces. But are there not, then, points of interconnection between two entities when parameters are 'programmed' not electronically but chemically, mechanically or biologically? Emulsions and dispersions can also be understood as interfaces. When water and oil are mixed, they tend to separate and at equilibrium become two distinct strata with an oil–water interface in between – processes such as those employed by Zbigniew Oksiuta in his *Isopycnic Systems*[32] in order to create empirico-material forms of such complexity that no computer simulation could calculate the parameters in their entirety. Even the surface of Narcissus's lake may be regarded as an interface of water and air.

Performance artists such as Yann Marussich encroach upon these spaces in-between. In *Bleu Remix*, Marussich creates a controlled biochemical situation that generates an apparently motionless choreography of methylene blue, using thermal regulation and precisely calculated timing, which then seeps out of body cavities and pores, thus making 'the motionless body a monochrome vibration that hints at the problem of the relationship between outward immobility and inner mobility. What is going on inside the body ahead of the visible movement. The pre-

28 Eugene Thacker, *Biomedia* (Minneapolis, MN: University of Minnesota Press, 2004).

29 Louise Poissant, 'The Passage from Material to Interface', in Oliver Grau (ed.), *MediaArtHistories* (Cambridge, MA/London: MIT Press, 2007), 244.

30 Ibid., 240–41.

31 Ibid., 235.

32 See below, 134.

movement is written down in the body.'33 Marussich, who actually comes from the field of dance, intentionally plays here with the topos of an activity perceived externally as passive, speaking of 'motionless sculpture' and the 'bloodless flaying of the body'. What interests him is less the expression of psychological states or the externalization of cognitive processes than the notion of presence: 'Presence and the bubbling mobility of the inner body which are complementary to the image of the motionless body [...] Art is no longer a *representation* but a continuous inner state *presented* before third parties.'

Here we encounter what Hans Ulrich Gumbrecht has termed an 'oscillation between *presence effects* and *meaning effects*'.34 Gumbrecht maintains that material elements, those that 'touch' the bodies of communicants, 'have been bracketed (if not – progressively – forgotten) by Western theory building [...] ever since the Cartesian *cogito* made the ontology of human existence depend exclusively on the movements of the human mind', and calls for a rediscovery of presence effects and a critique of our abstract hermeneutic culture of interpretation. Gumbrecht brings into play two distinctive cultural paradigms in whose oscillation it is possible to *think* materiality and corporality: *meaning cultures*, which include primarily the culture of Protestantism since the (Early) Modern age, and *presence cultures*, which refer more to medieval, early Catholic and ritualistic culture. Accordingly, the dominant human self-reference in a meaning culture is the mind, while that of a presence culture is the body. In a meaning culture, time is the primordial dimension, as it enables consciousnesss; moreover, it takes time to carry out transformative actions through which meaning cultures define their relationship to the world. Humans conceive of themselves as detached and eccentric in relation to the world to be transformed; and knowledge is legitimate when human subjects produce this knowledge by scratching the material surface of the world. In a presence culture, humans consider their bodies in their surrounding space to be rhythmically part of a cosmology that makes inherent, magical sense, and in which knowledge is revealed. Further, in a meaning culture a sign is understood as a purely spiritual signified, which can only be expressed by a purely material signifier. In presence cultures, however, the sign exists as substance. Meaning cultures attempt to effect future transformations by means of competition between temporal successions of abstract ideas. Presence cultures, however, attempt to enact extant cosmology in spatial terms by means of ritual.35 From a historical perspective, as Gumbrecht writes, this repeated epistemological twist has 'brought up the question of a possible compatibility between world-appropriation by concepts (which [he calls] "experience") and a world-observation through the senses (which [he calls] "perception").'36

INDUCING GROWTH

Eduardo Kac's *Telepresence Garment*37 pursues an analogous interface strategy using both telecommunication to conceptually bridge distance as well as direct, bodily experience. This work, conceived initially in 1995, can be seen as a manifesto for concrete phenomenological experience in an increasingly abstract world model. Kac's creation, here, of a remote and externally determined 'zomborg' deals with the concrete experience of estrangement through abstract and teleported realities, such as

the interconnectedness of the world economies and ecologies. Glaring examples are the financial crashes that resonated across Asia, Russia, and Latin America in the 1990s and the dramatic consequences of the geographic

33 Yann Marussich, 'Immobile, Bleu... Remix!', in this volume, 128.

34 Hans Ulrich Gumbrecht, *Production of Presence: What Meaning Cannot Convey* (Stanford, CA: Stanford University Press, 2004), 2.

35 Ibid., 78–90.

36 Ibid., 39.

37 Eduardo Kac, 'The Telepresence Garment', in this volume, 106–10.

displacement of viruses and insects around the world as a result of increased travel and commercial shipments.38

McLuhan's media are not far off here, and the restrictive form of Kac's communications-technological second skin is a stark reminder of the image of a general 'turning into skin' through sensory extensions in the electronic age, which at the same time hold the potential to 'cut themselves off':

> Ultimately, the question is not how these technologies *mediate* our exploration of the world, local or remote, but how they actually *shape* the very world we inhabit [...] This *prêt-à-porter* foregrounds the other meanings of the verb 'to wear': to damage, diminish, erode, or consume by long or hard use; to fatigue, weary, or exhaust.39

However, not all of Kac's works using telepresence have this dystopic touch. In general, Kac explains, they should have 'the power to contribute to a relativistic view of contemporary experience and at the same time create a new domain of action, perception, and interaction'.40 But above all, they should 'create dialogical and multilogical telepresential experiences. They suggest the need to nurture a network ecology with humans and other mammals, with plants, insects, artificial beings, and avian creatures.'41 Here, Kac makes explicit reference to trans-species communication, which makes up the central focus of many of his bio-telematic works and poses questions of paralinguistic vectors and empathy.42 But it is a different interactive installation that takes the step from the telecommunicative bridging of distances and virtual movement to real biological growth. In *Teleporting an Unknown State*, Internet video-conferencing was used to teleport light particles (and not messages) from several countries with the sole purpose of enabling biological (and not artificial) life and the growth of a plant from a single seed installed in a very dark room. During the show, photosynthesis depended on remote collective action through the Internet as a life-supporting system. Change takes place here less through movement than through growth.

To an extent, Stelarc's *Extra Ear: Ear on Arm* project represents the antithesis to this communications-technologically facilitated plant growth. Here, the potential for wireless telecommunication is to be generated bit by bit through the organic matrix of a superfluous outer ear, implanted initially as scaffolding and then gradually growing inward through the later injection of stem cells. This telecommunicative potential is parasitically nested: an inter-*face* as inter-*ference* that caricatures medicine's standard bodily norm. Thanks to the built-in microphones and wireless transmission technology, the extra (but redundant) 'sensory organ' is meant to become functional. The raising of the arm to mouth or ear, a performative gesture as if ringing someone up, reminds us of those historical engravings illustrating early rhinoplastic transplantation techniques, such as those depicted in Gaspare Tagliacozzi's sixteenth-century flap for nasal reconstruction – whereby the skin fragments transplanted to the nose remain fused initially to the arm. Insofar as *Extra Ear: Ear on Arm* symbolically becomes an interface capable of receiving and emitting, as otherwise only the skin can do, Stelarc redoubles the dialectical reflexivity inherent to the skin as metaphor. It fits the concept of Stelarc's work, however, that certain complications and infections constitute part of the process. Indeed, Stelarc would not be Stelarc if there were not a certain sense of satisfaction in seeing that wetware and hardware may prove not to be fully compatible after all. Stelarc is not one to hide such imperfections. On the contrary, they play a central role in his artistic strategy.

38 See below, 107.

39 See below, 106.

40 See below, 110.

41 See below, 110.

42 *Essay Concerning Human Understanding* (1994), in reference to John Locke, is an inter-species sonic bio-telematic work which promotes dialogue between a bird and plant; *Darker Than Night* (1999) explores the human–robot–animal interface: participants, a telerobotic bat and over 300 Egyptian fruit bats share a cave and become aware of their mutual presence through sonar emissions and frequency conversions.

REVERSE OTHERING

Since the vector of change is shifting from the use of networks to bridge distances to microscopic modelling at the cell level, and from presence as a temporal dimension to presence as a spatial dimension of proximity, it is no surprise that artists have turned to the use of skin cells. For one thing, in comparison to other cells they reproduce and renew themselves faster; and for another, they are suited for use *per se* as biological metaphors for '*trans*', as in trans-racial, trans-species, trans-gender. The duo Art Orienté objet, in *Artists' Skin Cultures*, cultivated the epidermal cells of both artists together, then grafted this layer of epidermis onto pig derma, before finally tattooing it with motifs of endangered species. Their trans-species totems are ultimately and ideally supposed to be grafted onto compliant art collectors themselves, who can then make the art bodies part of their own, and not necessarily merely in a symbolic sense. The work materializes 'the projection of a hybrid world where xeno-transplants would be common currency, and the distinctions between different living species would be blurred until they finally disappeared altogether'.43

In a continuation of her *Carnal Art*, Orlan creates a patchwork-like coat from hybrid skin cultures that mix her own cells, obtained through biopsy, with those of various ethnicities, as well as animal cells. This *Harlequin Coat* takes as its point of departure Michel Serres' text *The Troubadour of Knowledge*,44 a declaration of self-determination and ethnic hybridity. The installation, as a satellite body, completes those modifications achieved by Orlan on the level of virtuality in her *Self-hybridations Africaines* and repositions them, in turn, in the sphere of real physiological design, pointing back to her early plastic surgeries. In Orlan's bioreactor skin cells cohabit which, *in vitro*, do not even 'consider' developing skin

colour by means of melanozytes. Much more, Orlan's live installation caricatures the logic of racist theories that sought to explain skin colour in physiological and 'scientifically water-tight' terms as 'filth' or 'pollutants' which supposedly settled in the bodies of 'blacks'.

The Australian Tissue Culture & Art Project (Oron Catts and Ionat Zurr) has specialized for a decade in cell and tissue culture and exhibits miniature sculptures that the collective itself describes as 'semi-living'. These are characterized by the fact that they are put on display in bioreactors and incubators as artistic growth processes. On the other hand, these fragmentary satellite bodies occupy an ontological grey zone. The collective's doll-size cell sculptures in *Victimless Leather* grow from human, mouse and pig cells cultivated together into the utopic vision of leather produced without victimizing animals,45 whereby the characteristic of leather as a dead surface here, in the age of xeno-transplantation becomes a *trans-species interface*. What in psychoanalysis is referred to as the protective and defining surface which constitutes the human individual, much as Didier Anzieu has described it in the paradigm of skin-ego, is here inverted into its opposite: progressive permeability.

In these examples of *biofacts* which are created for the sake of art, we are dealing with 'models of something that does not yet have a body but could have one'.46 It is the notion of growth that makes up the central thematic of Nicole C. Karafyllis's concept of biofacts – growth, which as a process suggests a self-dynamic, though 'directed growth ensures from the beginning that technical control' requires precisely this materiality to expose the 'trick of living material [growing] as natural material, although it is considered technology and is cultivated for specific purpose'. But the vegetal and the notion of growth represent the quintessence of nature, which, on the one hand, stands

43 Marion Laval-Jeantet, 'The Fusional Haptics of Art Orienté objet', in this volume, 91.

44 See reprint of the introductory text to *The Troubadour of Knowledge* in this book, 83–89.

45 Indeed, because of the use of calf serum in tissue culture, there is indeed a victim, as Adele Senior points out in her essay 'In the Face of the Victim: Confronting the Other in the Tissue Culture and Art Project', in this volume, 76.

46 Nicole C. Karafyllis, 'Endogenous Design of Biofacts: Tissues and Networks in Bio Art and Life Science', in this volume, 50.

in opposition to the technological and instrumental; yet it is precisely this sense of the 'vegetal, which has always accompanied machine discourse'.[47] Here, the example of tissue engineering is interesting insofar as it does not represent a revolutionary new technology but rather an older technology that, in McLuhan's sense, is capable of generating and pointing to new media and of referencing their repercussions. After all, it can be argued in the face of the convergence today of biomedia as information transmitters, nanotechnology, synthetic biology, DNA chips and DNA sequencing that we are dealing with a certain virtualization of biology; yet 'the matching with wetware, that is, with the biological system for monitoring the function, remains necessary'.[48]

Naturally, the form of the cellular sculpture in *Victimless Leather* is recognizable as a 'leather jacket'; the image that people have even of body fragments conceptually holds the body together, to a degree as an *imprint* – however, not as negative but as positive. But the peculiar thing about biomedia, in this case, is that in the contemplation of cellular mixes signifier and signified – image body and body image overlap. The medium as 'body of the image' is itself materially identical to the body of the viewer; it is not merely a reference to it, nor does it 'stand for' something, so that this relationship is less metaphoric than metonymic. Herein lies a common characteristic of the biomedia used in art: they refer synecdochally to a whole and constitute a material part of this whole 'represented' by the fragment, so that we may speak both of *epistemological metaphors* and of *ontological metonyms*. The hybrid as a result may be seen more easily than the becoming of a biofact may be grasped.

WILL IT G(R)O(W) TO PLAN?

'Grids, Guys and Gals: Are you Oppressed by The Cartesian Coordinate System?': this was the title of a panel at the 22nd annual American Computer Machinery Conference on Computer Graphics and Interactive Technologies (SIGGRAPH) in 1995. At this conference, Anna Munster relates the story of a crucial experience that led her to write the book *Materializing New Media. Embodiment in Information Aesthetics*. For not everyone at the conference agreed with the views expressed on this panel lamenting the dominance of binary logic and the lack of corporality in digital culture:

> A group of staunch neo-Cartesians filled the front rows of the audience and – bringing the seventeenth century into an odd alliance with late-twentieth-century computer geekdom – sported logos emblazoned across their mass-printed t-shirts declaring 'I ♥ Descartes' [...] These lovers and champions of information culture and its mechanistic antecedents heckled the panel. For them, the session represented an assault on the epistemological foundations of present-day computing technologies.[49]

In the 1990s, computer simulations of biological processes accordingly proliferated. When Ars Electronica in Linz dedicated the 1993 festival to *Genetic Art – Artificial Life*, the items first and foremost on the agenda were 'autopoietic systems, virtual creatures, AL software, genetic images, synthetic life, evolution and the ecology of digital organisms, interactive evolution and the algorithmic beauty of nature'. Computer culture had promoted 'the shift of paradigms from defining life as substance, material hardware or mechanisms to conceiving life as code, language, immaterial software, dynamical system'.[50] Since then, new media art has re-materialized itself. The former fascination with the 'code of life' is receding and making way for practices involving *wetwork*. There has also been a shift from a dominant focus on genetics to

47 See below, 48.

48 See below, 53.

49 Munster, *Materializing New Media*, 2.

50 Peter Weibel, 'Life — The Unfinished Project', in *Genetic Art – Artificial Life* (Vienna: Ars Electronica, PVS, 1993), 9–10.

culturing cells when it comes to artistic practice.[51] Here art runs parallel to theoreticians of science such as Evelyn Fox Keller. In 'Beyond the Gene, but Beneath the Skin',[52] Fox Keller complains of the still strongly gene-centred focus of much of molecular biological research, which is only slowly subsiding. She argues that not the gene but the entire cell must be put into focus as the scale of evolutionary biology. While the gene may be the *locus* of heredity, it cannot be its *source*. Genes remain stable only as long as the machinery in the cells responsible for that stability persists. Hence, according to Fox Keller, we must always examine the entire interaction within the cell and not the gene; for it is the cell that regulates so much of the traffic between inside and out, whereby the cell membrane is itself an active agent. Yet the focus on genetics reopens 'a far older controversy namely that concerning the relations between *form* and *matter*'.[53] Here, form is generally construed as *active* and matter as *passive*. This old debate now appears conceptually in art in the light of genes as 'active agents' and of the cellular and extra-cellular environment as 'passive material', as a substrate formed by an originally inscribed genetic code. Still, as Fox Keller reminds us, talk of a 'genetic program' is misleading and teleological, as if there were somehow a purpose or perhaps even a theological signpost behind it all.

For *sk-interfaces*, Jun Takita is cultivating a brain covered with transgenic bioluminescent moss. *Light, only light* is a sculpture in the shape of the artist's own brain, made using a magnetic resonance scanner. The transgenic moss is capable of emitting light in the same way that fireflies, glow-worms and certain deep water fish do. Takita materializes the transgenic as an achievement of the human brain to transfer to plants the ability to emit light, something they themselves require for photosynthesis. At the same time, he emphasizes human dependence on the oxygen produced by plants in Earth's ecosystem.

Certainly, Takita's work here does not reference Descartes. Perhaps he would rather have read Descartes' materialist and atheist adversary Julien Offray de La Mettrie, who describes man as 'that arrogant animal, made of clay like the others' not only in *L'Homme-Machine* but in a lesser known manuscript, *L'Homme-Plante*:

> There is no animal, however feeble and mean in appearance, the sight of which does not diminish a philosopher's self-esteem. If chance has placed us at the top of the scale, do not forget that a trifle more or less in the brain, in which is found the soul of all men (except the Leibnizians), can immediately plunge us to the bottom, and let us not despise beings whose origin is the same as ours. They are, in truth, only the second rung, but their position is more solid and stable.[54]

The artistic preoccupation with programmed and technologically induced growth has many ramifications: only at the opening of the exhibition will we be able concretely to test the oscillation between effects of meaning and presence.

> 'Bio Artists' and bioscientists share a core experience: waiting for growth. It takes a relatively long time for cells and tissues to grow sufficiently that they can be used as media and means. The phenomenon of growth, in its slowness, mediates between subject and object because it *makes present* the time both share with one another synchronously.[55]

And it is not yet clear whether visitors will encounter *enlightenment*, and how much, nor whether or not it will be at all visible to them. No plug-and-play here. We'll wait and see if everything will go, grow and glow to plan.

51 Jens Hauser, 'Bio Art – Taxonomy of an Etymological Monster', in Gerfried Stocker and Christine Schöpf (eds), *Hybrid – Living in Paradox* (Ostfildern-Ruit: Ars Electronica/Hantje-Cantz, 2005), 182–93.

52 Evelyn Fox Keller, 'Beyond the Gene, but Beneath the Skin', in Eva M. Neumann-Held and Christoph Rehmann-Sutter (eds), *Genes in Development. Re-reading the Molecular Paradigm* (Durham, NC/London: Duke University Press, 2006), 290–312.

53 Ibid., 292.

54 *La Mettrie: Machine Man and Other Writings*, ed. Ann Thomson (Cambridge: Cambridge University Press, 1996), 86.

55 See below, p. 56.

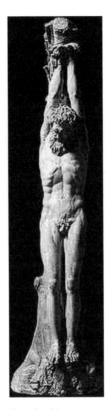

Hanging Marsyas,
Roman copy from
a Hellenistic model
dating from the third
century BC, marble,
H: 2.05m. Musée du
Louvre, Paris.
Photo courtesy
Musée du Louvre.

The Return of Marsyas: Creative Skin

Stéphane Dumas

APOLLO FLAYS MARSYAS

'Creative skin'[1] here means the skin of the creator (a term I use to take in both the artist and the receiver) metaphorically flayed and turned over to be offered as a medium for our representations of the world. The cutaneous envelope of a creative body is not reducible to just a surface to be inscribed upon, bearing a submissive cosmetic or protective image of the marks made on it by a demiurgic creator. As an element, the skin is in itself a medium, halfway between the world and the internal media of the visceral body, the meat body, or the sensory body. Through our skin, it is a matter of our relationship to the outside world and to ourselves. The 'creative skin' is the medium in which a body takes shape and becomes writing. Even more than a projection screen, it is a thickness through which legibility exudes. It is a way of coming to the surface, a bunch of viscera outcropping in broad daylight.

The Greek myth of Marsyas offers a tremendously rich medium for a reflection that is at once anachronistic and of great current relevance in respect of creative visual arts. The musician and satyr challenges the god of music to a musical contest. Marsyas plays the *aulos*, a kind of oboe. Apollo, on the other hand, accompanies his own singing on the cithara. After winning the competition, the divinity decides that as a punishment his defeated opponent is to be flayed. This torture is more than just stripping bare and goes more than skin deep. The victim is totally excoriated, his mortal coil literally shuffled off, a radical revealing that results in death. The flayed man streams until he is drained

of blood.[2] The musical confrontation is turned into radical torture, the annihilation of the vanquished by making an open wound of the inside of his body. Clearly this shows an excess, a disproportion between the stake of the duel and the punishment, even allowing that the harmonious satyr has committed an unpardonable crime in measuring up to a god.

My hypothesis is that Apollo here becomes the prototype of the 'I', an expression of the subject as viewed in Western civilization. This 'I' is the subject of an absolutely transitive action: 'I flay you!' This hypothesis is linked (but it is not really a causal link) to one of the reasons why Apollo wins this duel: he is able to sing to the music of the lyre, something quite beyond his flute-playing rival.[3] To be sure, Apollo's voice is not that of the modern *ego*. But it is a signifying voice, that of the *logos*, in contrast with his rival's purely instrumental music.

HANGING MARSYAS

The satyr, hung by the wrists from a tree, naked, his body fully stretched, his feet dangling, is an often reproduced motif in Hellenistic and later in Roman sculpture. It is the most suitable position for flaying. In the sculptural fragments in the round that have come down to us, Marsyas is alone. But, apparently, he might be associated with a slave sharpening a knife as he prepares to inflict the punishment, and maybe also with Apollo facing the scene, either seated or standing, his cithara lying at his side, clothed, calm, imperious and utterly composed.[4]

1 See Stéphane Dumas, *La peau créatrice* (Paris: Klincksieck – Les Belles Lettres, 'Collection d'Esthétique', forthcoming 2008).

2 Several ancient sources indicate that Marsyas was turned into a river: Palaephatus, *Concerning Incredible Tales* 47; Hyginus, *Fables* CLXV; Pausanias X.30.9; Nonnos of Panopolis, *Dionysiaca* XIX.324

3 Diodorus Siculus III.LIX.3–4; Plutarch, *Moralia* VII.8. In *Parallel Lives* ('Alcibiades', IV) Plutarch reports Alcibiades' account of the scorn certain Athenians had for the *aulos*, which did not allow the player to sing.

4 This is how Raphael and his workshop depict the event, on the ceiling of the Stanza della Segnatura in the Vatican. The Renaissance painter takes his inspiration from the composition on a Roman sarcophagus that is now lost (cf. E. Wind, below). Other ancient low-reliefs depicting the scene have come down to us.

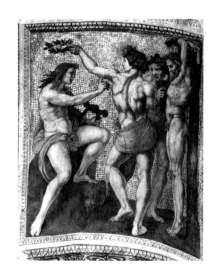

Raphael and his workshop, *Apollo and Marsyas*, medallion on the ceiling of Stanza della Segnatura, between 1508 and 1511, fresco and mosaic. Vatican Museum, Rome. Photo courtesy Vatican Museum

The *Hanging Marsyas* is often humanized, with his animal attributes kept to a minimum. His body is in a vertical position, but not standing. Sometimes depicted head down, from the Renaissance on, his posture is that of a game animal or a drowned man whom one is trying to help to cough up the liquid filling his lungs. Here we can see the paradigm of the victim and the expression of a tragedy; the human being who has taken on a god can measure the extent of his powerlessness along the entire length of his stretched body. But also and most of all, it expresses weight. We might see here the human body depicted as simply a viscera bag waiting to be emptied to relieve itself of its own weight.

The *Hanging Marsyas* is the passive object of the transitive verb 'to flay' whose subject is Apollo. However it seems to me that this transitivity involves a degree of reflexivity. This in fact is why it expresses the action of a true subject. In a way, through the duel and then the flaying, Apollo and Marsyas form an indissociable pair.

Edgar Wind has argued that the Renaissance turned this myth into an allegory of the Apollonian 'know thyself': 'flaying was itself a Dionysian rite, a tragic ordeal of purification by which the ugliness of the outward man was thrown off and the beauty of his inward self revealed'.5 In the allegory of the flaying of Marsyas, the Apollonian *logos* is staged as a signifying word revealing the meaning of things above and beyond their appearance. The bodily envelope is reduced to the role of an opaque screen masking the body's inner workings, an obstacle that the anatomist brushes aside in order to proceed with his scientific exploration. Likewise, the Neoplatonist philosopher, in his search for the 'substantific marrow',6 removes the bark to get to the kernel, the essence of things. The *Hanging Marsyas* then becomes the paradigm of the object of knowledge exposed and offered up to the scalpel of learning.

If the subject can position himself as such to the world, it is because knowledge of the world enables him to know himself. This reflexivity of knowledge has become fundamental to Western thought. So we note, in the cognitive process of the subject towards the object of his knowledge, both a distancing and a backlash from the object at the subject producing a kind of contact with oneself. The function of appropriating the world inherent to the Western cognitive process is broadly based on the haptic sensorimotor model. The subject's very existence depends on this two-way movement, this breathing, which can border on fainting. 'But I touches itself as it spaces itself, loses contact with itself, precisely by touching itself. To touch itself, it cuts off the contact, it refrains from touching. You can touch an I.'7 The sense of touch, the taboos on touching,8 and overstepping it in the haptic9 are the core elements of the relationship between subject and object, and the questioning of it through the notion of tact, which we shall be coming to later.

Apollo, the 'far-shooting Phoebus',10 strikes me as symbolizing the subject's cognitive posture with regard to the world. The divine attributes are the bow and the lyre, instruments enabling him to reach and touch at a distance, whether it be to strike violently or to brush against by penetrating the listener with an artistic emotion. So the ability he has is to touch without coming into contact. Marsyas, on the other hand, whose instrument merges into his mouth and becomes almost an extension of his respiratory system, can only touch through direct contact. The Apollo–Marsyas pair I see as representing the tension between nearness and distancing, between merging and tearing apart.

5 Edgar Wind, *Pagan Mysteries in the Renaissance* (London: Faber & Faber, 1958), ch. 11, 'The Flaying of Marsyas', 143. Raphaël Cuir, going back to this hypothesis, interprets the figure of the skin of St Bartholomew, in Michelangelo's *Last Judgement*, as an injunction placed on the artist to flay himself ('Dissèque-toi toi-même, portrait de l'artiste en silène post-humain', in *Ouvrir Couvrir* [Paris: Verdier, 2004]).

6 Rabelais, *Gargantua*, 'Prologue', in *The Portable Rabelais*, ed. and trans. Samuel Putnam (New York: Penguin Books, 1946), 49. The author refers to *Alcibiades' Silenes*, in the famous passage

in Plato's *Symposium*, where Alcibiades compares Socrates to Marsyas. Both are like the carved boxes in the shape of Silenes, very common in Athens, which, beneath a grotesque exterior, contain a valuable treasure. This passage inspired, among others, Pico della Mirandola ('Letter to E. Barbaro'), Marsile Ficin (*Commentarium in Convivium Platonis, de Amore*) and Erasmus (Adage 2201, 'Alcibiades' Silenes').

7 Jacques Derrida, *Le toucher, Jean-Luc Nancy* (Paris: Galilée, 2000), 47 (*On Touching, Jean-Luc Nancy*, trans. C. Irizarry [Stanford, CA: Stanford University Press, 2000]).

8 In the psychoanalytical theory of the 'Skin Ego' by Didier Anzieu, some of these taboos are described as being necessary for the other senses to develop in the child, weaving a kind of intersensoriality that fosters the development of symbolic language. Didier Anzieu, *Le Moi-peau* (Paris: Dunod, 1995 [1985]) (*The Skin Ego* [New Haven and London: Yale University Press, 1989]).

9 '"Haptic" is a better word than "tactile" since it does not establish an opposition between two sense organs but rather invites the assumption that the eye itself may fulfil this non-optical function'. Gilles Deleuze and Félix Guattari, 'The Smooth and the Striated', in *A*

Thousand Plateaus, Capitalism and Schizophrenia (London/New York: Continuum, 2004), 543. See also, on the relationship between the hand and the eye, Gilles Deleuze, *Francis Bacon: The Logic of Sensation*, trans. D. W. Smith (Minneapolis, MN: University of Minnesota Press, 2005 [1981]).

10 'Hekebolos', Homer, *The Iliad* I.19, trans. G. Chapman (Wordsworth Editions, 2000), 5. It was one of the god's many nicknames, recalling his skill as an archer. See G. Dumézil, 'Les quatre pouvoirs d'Apollon dans le prologue de l'Iliade', in *Apollon sonore et autres essais. Esquisses de mythologie* (Paris: Gallimard, 1982), ch. 6.

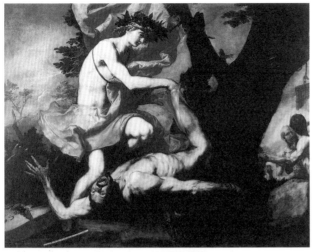

Jusepe de Ribera, *Apollo Flaying Marsyas*, 1637, oil on canvas, 185 x 242 cm. Musées Royaux des Beaux Arts, Brussels. Photo courtesy Musées Royaux des Beaux Arts

Detail from Jusepe de Ribera, *Apollo Flaying Marsyas*.

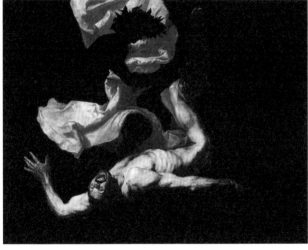

Montage from Jusepe de Ribera, *Apollo Flaying Marsyas*: the skin of Marsyas and Apollo's mantle.

APOLLO DISMEMBERS HIS VICTIM
WITH HIS BARE HANDS

The above hypothesis forms the basis of my proposed reading of the twin figure painted by Ribera in his *Apollo Flaying Marsyas*.[11] The satyr is spreadeagled on the ground. His wrinkled, furrowed skin smells of sweat and earth. He is part of the landscape in which the scene is set. His upturned face and bulging eyes call out to us. He is on the point of having his whole body spill out through the gaping floodgate of his mouth, as though he were about to be caught up in the convulsions of an unstoppable vomiting. In this climax of his life, his face embodies 'a cry of fear that sees', to quote Georges Bataille's striking expression.[12]

Apollo, the radiant subject, has smooth, white skin. He stands out against the heavens, which are his domain. He rips off his victim's skin with his own hands.[13] He is so focused on what he is doing that he almost closes his eyes. But while everything opposes the two enemies, they are nevertheless depicted in a corps à corps that is fusional as well as antagonistic. The dumbstruck onlookers stand back, relegated to the edge of the canvas. The divinity's left hand pulls away the torn skin, while his right hand, holding the knife, plunges into the flesh. It seems to be literally welded to Marsyas's knee, as if the two characters were really only one. The vermilion colour of the inner face of the torn-off integument is close to that of the mantle draped around the god's body. The billowing fabric recalls some fleshy fruit. Its movement starts from the satyr's stomach, onto which the fabric has slipped, and wraps itself round

11 Jusepe de Ribera, *Apollo Flaying Marsyas*, 1637. There are two versions of this composition. The one I analyse more particularly here, basing my argument on certain elements in it, is at the Musées Royaux des Beaux Arts in Brussels. The other, painted with a livelier touch and doubtless more powerful, is at the San Martino Museum in Naples.

12 'Un cri de peur qui voit', Georges Bataille, *Le coupable*, in *Œuvres complètes* (Paris: Gallimard, 1973), V, 296.

13 This representation only appeared after the sixteenth century. Before that, the god is not depicted as inflicting the punishment himself.

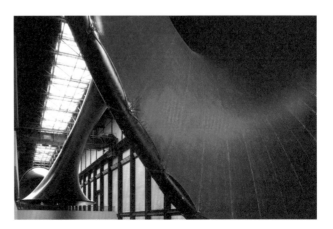

Anish Kapoor, *Marsyas*, 2002, PVC and steel, ca. 30 x 130 x 20 m, partial view. Tate Modern, London. Photo © Tate

Apollo, before flying off, sucked off the picture, as it were, for dramatic effect.

APOLLO TURNS MARSYAS'S SKIN
INSIDE OUT AND WEARS IT

In a reflexive turnaround, the smooth subject dons the skin of his rough direct object. Without this wrenching event, the over-distant reality of the Apollo subject could well become so *smoothed out* as to tend towards the non-event. In exchange for this roughness, the divine gesture introduces 'a discrepancy in the contact, the outside on the inside of the contact',14 a reversal materialized by the turning of the satyr's skin inside out, its transfiguration into an aerial element.

We find an echo of a similarly mutating skin in Michel Tournier's novel *Friday*. After a hand-to-hand struggle with a wild billy-goat which he finally kills, Friday makes a kite out of its tanned hide. Fastened with a string onto his leg, the aerial membrane follows him around, inscribing the choreography of his every movement in the sky. We also observe the figure of the airborne skin, unusually deployed on an architectural scale, in the stretched sculpture entitled *Marsyas* which, for a few months in 2002, Anish Kapoor anchored to the walls of London's Tate Modern.

As it happens, this skin figure has already been mooted by certain ancient sources of the myth. Nonnos of Panopolis writes 'but Phoibos tied him to a tree and stript off his hairy skin, and made it a windbag. There it hung, high on a tree, and the breeze often entered, swelling it out into a shape like him, as if the shepherd could not keep silence but made his tune again.'15 Herodotus locates the satyr's skin in a public square, while Xenophon places it in a cave from which sprang the River Marsyas.16 Aelian adds 'at Celaenae, if someone plays a Phrygian tune in the vicinity of the Phrygian's skin, the skin moves. But if

one plays in honour of Apollo, it is motionless and seems deaf.'17 Thus Marsyas would seem to have survived his flaying, in the form of his bodily envelope.

APOLLO, VOICELESS, IS DRAPED IN MARSYAS'S SKIN

The relationship between Apollo and Marsyas is a surprising one to say the least. Of course, from an anthropological standpoint, the god donning the satyr's skin, like Xipe Totec,18 is something I have completely made up. However, the hypothesis does strike a chord for modern visual arts.

In 1966 Joseph Beuys gave a performance during which he sewed a felt cover over a grand piano, as if to

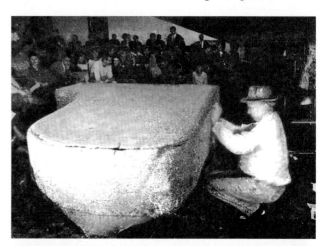

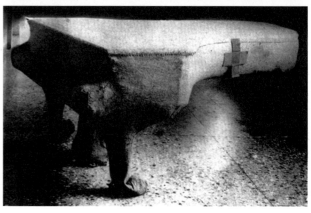

14 Derrida, *Le toucher*, 148.

15 Nonnos of Panopolis, *Dionysiaca* XIX.319–23. Other writers use the term *askos* (skinbag), when referring to the satyr's flayed skin: Herodotus VII.26; Plato, *Euthydemus* 385c; Aristide the Quintilian, *Music* II.XVIII; Agathias IV.23.

16 Herodotus VII.26; Xenophon, *Anabasis* I.2.8.

17 Aelian, *Various History* 13.21.

18 Xipe Totec, 'our lord the flayed one', is an Aztec god who presides notably over the rebirth of the plant cycle. Human victims were sacrificed to him by flaying. He was portrayed dressed in a human skin. See Jacques Soustelle, *L'Univers des Aztèques* (Paris: Hermann, 1979).

ABOVE
Joseph Beuys making *Homogeneous Infiltration*. Performance at the Fine Art Academy, Düsseldorf, on 28 July 1966.
Photo taken from Caroline Tisdall, *Joseph Beuys* (catalogue), New York, The Solomon R. Guggenheim Museum, 1979

Joseph Beuys, *Infiltration Homogen für Konzertflügel – der größte Komponist der Gegenwart ist das Contergan-Kind* [*Homogeneous Infiltration for Grand Piano, the greatest contemporary composer is the thalidomide child*], 1966, grand piano and sewn felt cover. Musée National d'Art Moderne, Centre national d'art et de culture Georges Pompidou, Paris.
Photo taken from Caroline Tisdall, *Joseph Beuys* (catalogue), New York, The Solomon R. Guggenheim Museum, 1979

OPPOSITE
Joseph Beuys, *Die Haut* [*The Skin*], 1985, sewn felt cover, Musée National d'Art Moderne, Centre national d'art et de culture Georges Pompidou, Paris.
Photo courtesy Centre Pompidou

drape it in a coarse garment.[19] The short title given to this sculpture was *Homogeneous Infiltration*. This refined instrument's glossy form completely disappeared under its envelope of fulled animal hairs, where all that was left to be seen was this lumbering body with all the grace of an elephant.

As far as I know, Beuys never spoke of Marsyas. And yet, at that performance, did he not carefully drape the subject Apollo with the skin of his direct object Marsyas? It strikes me as legitimate to associate the Greek god of music with the piano, a major instrument in our European musical culture. We still need to justify the particularly worrying state in which the Apollonian instrument is placed under its felt cover, no longer able to emit any sound.

The German sculptor considered Western civilization to be gravely ill. Apollo's *logos* seems to have lost its voice, by dint of being stifled by narrow-minded rationality. But in the figure of the wrapped piano, the satyr's skin (the felt cover) is not just a huge damper – the piece of felt used to stop the vibrations of a piano string. Beuys gave as the reason why he used felt so often in his work its capacity to store heat (notably human body heat), while allowing the bodies wrapped up in it to breathe. One supposedly autobiographical episode that the artist was fond of recounting highlights the soothing effect of the felt blanket. So maybe, far from stifling it, Marsyas's rough skin is wrapped round Apollo's body to warm it up and bring it slowly back to life.[20]

BY FLAYING HIM, APOLLO FUSES WITH MARSYAS,
FOR THE SPACE OF AN INSTANT

This tension created between the Marsyas myth and certain modern or contemporary visual artworks enables me to envisage an interpretation that is vastly different from the Neoplatonist reading that prevailed during the Renaissance. Let us hypothesize that our relationship to the world is based upon a kind of suspended touch, which Jean-Luc Nancy terms *tact* 'from before any subject', '[…] setting and removal, the rhythm of the body's coming and going in the world. Tact unleashed, split from itself.'[21] Tact is more of a 'weighing' than a mere touch. If our relationship to reality is too distant, too smooth, too suspended, it ends up becoming fossilized. If the virtual no longer bears any relation to the actual, to the actual body, it is in danger of disappearing or becoming a projection tending to appropriate reality in a tyrannical way. As if Apollo, as portrayed by Ribera, were irremediably detaching himself from Marsyas's body and the ground on which he is standing. As if knowledge no longer involved a degree of inherence in its object, but just gave it the 'once-over', keeping it firmly at a distance.

So let us take the view of tact as syncopated contact with the world. The representation we have of the world, and of ourselves as part of it, only exists through a tension with something that is not of the order of representation, something unnameable located either this side or the other side of our spectrum of representation, something that relates to the body – not the idealized body, more likely the meat-body – something that escapes any pre-ordained meaning or carving in stone. Jean-Luc Nancy coins the verb *'ex-crire'* ('to ex-scribe') to express the act of accounting for this thing that is laid out but does not know it. 'Ex-scription' is the basis for a creative topology, and an extremely delicate one, for it has no known categories, it is unrestrained: *'à corps perdu'*.[22] What is this 'spasmed space' between tearing apart and fusion, in which the corps à corps takes place between Apollo and Marsyas as painted by Ribera, if not the *'spacing of bodies*, which […] means precisely the never-ending impossibility of homogenizing the world with itself, and meaning with blood'?[23]

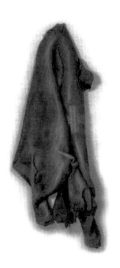

19 Joseph Beuys, *Infiltration Homogen für Konzertflügel – der größe Komponist der Gegenwart ist das Contergan-Kind* [*Homogeneous Infiltration for Grand Piano, greatest contemporary composer is the thalidomide child*]. Performance at the Fine Art Academy, Düsseldorf, on 28 July 1966. Purchased by the MNAM, Centre Pompidou, Paris, in 1976. Thalidomide was a painkilling drug on the market in the 1960s. It was often prescribed to pregnant women, but caused serious malformations in the newborn child.

20 A few years after the Centre Pompidou purchased *Homogeneous Infiltration*, the sculptor came to restore his work; he stripped the piano of its old, damaged cover, and put a new one in its place; then he hung the dead skin on the museum wall, giving it the title *Die Haut* [*The Skin*]. In 1985, towards the end of his life, he gave a whole new dimension to the relationship between the piano and its felt skin, creating the environment entitled *Plight*.

21 Jean-Luc Nancy, *Corpus* (Paris: Métailié, 2000 [1992]), 85 and 102. To be published in English by Fordham in 2008.

22 Literally 'with body lost'; Nancy, *Corpus*, 9.

23 Nancy, *Corpus*, 94.

It is also possible to make a very precise reading of Ribera's painting in terms of Deleuze's thinking on the fold, built up around the philosophy of Leibniz and the baroque world view.**24** From this angle, it seems to me that we might paraphrase and modify Nancy's concept: it is not a matter of 'homogenizing', but of 'folding' the world over itself and meaning over blood. For Apollo and Marsyas do indeed seem to be unfolding on either side of the horizon from one and the same fabric. The world of bodies, the opaque 'immonde',**25** is folded onto the subject itself, like the 'blood' on 'meaning'. Does the flaying make any sense? 'The thought drives you mad [...] the world is its own rejection, the rejection of the world is the world'.**26**

But how can we link the flaying of Marsyas to tact? It is hard to picture Apollo inflicting on the satyr anything that might be in the order of a restrained touch, a caress – even a lethal one! Let's not forget, however, that, no less than the bow, the lyre is an attribute of Apollo and that, if his music caresses the ear, it is a weapon all the same. From a Neoplatonic and Christian standpoint, this flaying, as a sacrifice and a metamorphosis, becomes a ravishment, in both senses of the word.**27** By stripping him of his bodily exterior, Apollo carries out a brutal, radical abduction of Marsyas. But this stripping is also a metaphor for mystical ecstasy, an unquenchable thirst for the divine expressed by Dante at the start of his *Paradiso*:

> Benign Apollo! this last labour aid,
> And make me such a vessel of thy worth [...]
> Enter into my bosom, and there breathe
> So, as when Marsyas by thy hand was dragg'd
> Forth from his limbs unsheath'd.**28**

The poet is addressing Apollo, often identified with Christ, asking him to turn him into a mere 'vessel', to fill him with his divine breath, even if that means first being flayed alive and emptied like Marsyas's skinbag.

Is it at all feasible to reconcile this mystical thirst for transcendence, for devastating purification, for self-dispossession, linked to Christianity in an almost warlike way – to reconcile, then, this thirst for absorption by the divine in martyrdom with a thinking of the body 'from before any subject', a thinking of tact and its two-way journey between bodies and consciousness? Can flaying and the caress be conceived together in a single movement?

This, it seems to me, is one of the things Georges Bataille undertakes to do. He certainly has a singular way of going about it, no doubt at once masculine and singularly unmasculine, to reach the other, the feminine, or the other of the feminine, without really attaining it; to miss it, then, but without aiming at it – which is perhaps the only way of 'attaining':

> We don't have the means of reaching at our disposal: to tell the truth, we do reach; we suddenly reach the necessary point [...]; but how often we miss it, for the precise reason that seeking it leads us away from it. Joining together is doubtless a means ... of missing the moment of return forever. – Suddenly, in my darkness, in my solitude, anguish gives way to conviction; it's uncanny, no longer even wrenching (through constant wrenching, it no longer wrenches), *suddenly B.'s heart is in my heart*.**29**

As Jean-Luc Nancy writes opposite this passage from Bataille: 'Everything happens perhaps exactly between loss and appropriation: neither one nor the other [...]'.**30** 'Loss' and 'appropriation' are assuredly two keywords to describe Apollo's encounter with Marsyas. 'Everything

24 Gilles Deleuze, *The Fold* (London/New York, Continuum, repr. 2006).

25 Translator's note: 'immund', 'unclean', a pun on *mundus*, 'world'.

26 Nancy, *Corpus*, 95.

27 See Marianne Massin, 'Figures de silène et troublants supplices', in *Les figures du ravissement* (Paris: Grasset, 2001).

28 *Entra nel petto mio, e spira tue si come quando Marsìa traesti de la vagina de le membra sue.* Dante, 'Paradiso', I.13–20. *The Divine Comedy: Paradiso*, trans. H. F. Cary (Edison, NJ: Book Sales Inc., 1982).

29 Georges Bataille, *The Impossible. A Story of Rats. Followed by Dianus and by The Oresteia*, trans. R. Hurley (New York: City Lights Books, 1991), 25–26.

30 Jean-Luc Nancy, *Être singulier pluriel*, quoted by Derrida, *Le toucher*, 136.

31 Georges Didi-Huberman, *La ressemblance informe, ou le gai savoir visuel selon Georges Bataille* (Paris: Macula, 1995), 10–11. Quotations from Georges Bataille are taken from *L'Expérience intérieure* (1943) (*Inner Experience*, trans. L. A. Boldt [New York: Suny Press, 1988]) and 'Le coupable' (1944).

happens', then, on a threshold, on the border. This topography of the border, where extension is reduced to a fringe, a line of friction, or even a point of contact – the targeted point, the focus, but also the apex of the cone of vision, the eye – this topography brings us back to the skin, to its sensitivity, capable of distinguishing a tiny dot, and its power to produce an image. 'And this is what Bataille himself must have meant, in *Inner Experience*, when he talks about "reaching the point", this point of tearing, that "moment of torture" of the image in the crucible of which "to see" had to be equivalent to "a cry of fear that sees".'31

MARSYAS'S FLAYED SKIN SHIVERS
ON HIS NEW BODY

So, unsurprisingly, the 'moment of the return' in the myth is when the satyr's flayed skin quivers as music is played nearby on the *aulos*, as we read in Aelian. In 1972 Giuseppe Penone produced a sculpture entitled *Ganto* [*Glove*], of which it appears only a photographic trace survives, showing the artist's two hands with open palms. One glance at this photograph shows nothing of note. And yet the right hand, on the left side of the picture, leaves us with the strange impression of having a newer skin than its neighbour. On closer inspection, we notice that instead of being hollow, the furrows on the skin are in relief, forming a barely perceptible dermographic.

What the sculptor has actually done is to make a plaster cast of his left hand and take a relief imprint of it in a very fine latex membrane. Once turned inside out like a glove, this second skin is donned by the right hand, and is a good fit. So this hand has donned the negative of the skin loaned by the left hand. Here we have a depiction of the fusion, or at least exchange, of integuments, in a presentation of the imprinting process the very existence of which depends on the suspension of fusional contact.

This simultaneity of the touching and the touched comes about through a representation of the touched: the new skin donned by the right hand is nothing but the tiny chink existing between the two hands when the one touches the other. A representation at the boundary, this membrane may be seen as a materialization of the sensation of being touched, experienced by the left hand, as if both hands were having this conversation: '– Touché! You are touched! – Touché! I am touched... You are sheathed in my sensation of being touched by you!' *Ganto* is a visual chiasmus, a chiasmus of skin.

'– Touché!', says Apollo as he flays Marsyas.

'– Why are you flaying me? cries the satyr. In return, I wrap you up!'

Ganto is a figure of tact, a paradoxical figure because a felt sensation has no extension (tact is in the order of a syncope), unlike the material trace left by a gesture, the pictorial touch for instance. The important thing here is the touch, in which something felt in the order of the invisible ends up taking on the extension of a body. *Ganto* shows something invisible and very private, as through a skin graft, which would be almost too literal were it not, precisely, almost invisible.

THE ARTIST (MARSYAS–APOLLO) FLAYS HIMSELF
AND TURNS HIS SKIN INSIDE OUT, TO OFFER UP AND
SHARE THE INNER INNERVATED THICKNESS AS A
MEDIUM FOR AN INSCRIPTION OF THE WORLD

With this reflection on the Marsyas myth, we can now make a start on a topology of the creative sharing of our sensory experience of the world, a sharing based on tact. This topology is partly based on the skin. This need for extent, in a relationship to the world grounded in an awareness which in itself has no extent, is assuaged by weaving a second skin. This second skin corresponds to

Giuseppe Penone, *Ganto* [*Glove*], 1972, latex glove. Private collection. Photo taken from the *Giuseppe Penone* catalogue, Paris, Centre national d'art et de culture Georges Pompidou, 2004

Enlarged details of Giuseppe Penone, *Ganto* [*Glove*].

the symbolic turning inside out of the artist's skin during the creative act.

Psychoanalysis provides a host of aids to interpreting artistic creation in terms of a second skin, a substitute body, the materialization of a projection onto a cutaneous screen and a paradigm of the ground as an inscription surface. The theory of literary creation developed by Jean Guillaumin based on the myth of the centaur Nessus is especially interesting in this connection.32

Heracles punishes the centaur for trying to seduce his wife, Deianeira. The hero fires an arrow at him soaked in the blood of the Hydra of Lerna. Before he dies, in an act of vengeance, Nessus reveals to Deianeira a charm that will ensure that her husband will be faithful: he advises her to give Heracles a tunic soaked in his own semen and blood. When Heracles puts it on, the magic garment sticks to his skin and he suffers the excruciating pain of all-over burns, to the point that the hero has no alternative but to commit suicide in a blaze.

According to Guillaumin, the Nessus myth expresses the workings of the creative process, and the tunic covered with excreta is a metaphor for the vehicle of artistic creation. This second skin, which merges with Heracles' own to consume him, is a diversion, a reversal of the mother's protective envelope which serves to bolster the construction of the ego (Guillaumin's idea is similar to Didier Anzieu's *skin ego*). According to the psychoanalyst, the 'projective reversal' of the skin inside out corresponds to a creative posture. We build up for ourselves a psychic protection filter system with which to channel aggressions coming from the outside without having to suffer them, but also from within the psyche. Through the artwork, this filter is turned into a medium, into a body in which the writer's fantasies are embodied.

This inside-out skin effect may be present in any creative phenomenon; the skin, holding traces of life, becomes the cave wall, the white ground of the paper, the touch screen. Taking this further, one might claim that, being irrigated by the wall of the uterus, the placenta becomes the innervated web of the Internet.

My hypothesis accepts that it is actually these inscriptive surfaces of traces that, halting and retaining the negative of the active movement of projection, constitute both the analogon and (for the purpose of providing a wrapping for the child work) the concrete representative of the skin on the artist's body, at the same time as that on his mother's body; more precisely still, of the inner wall of his own body and of his mother's body. Skin on the inside, then turned inside out into an outer casing, which becomes the almost hallucinatory medium for the author's imagination in the work he gives birth to.33

Guillaumin's theory is very similar to the one that my pondering the Marsyas myth has led me to. However, one of my reservations (which also holds for Anzieu's theory) is to do with the deliberately filmy appearance taken on here by the skin. Even though the skin is sometimes used as a synecdoche for the entire body, it is generally the equivalent of a tissue that is perhaps too readily identified with the image or text.

We should remember that the skin is only a film by analogy with the bodily wrapping as image or simulacrum. On the contrary, as the organ of touch, but also of perspiration, the thickness of the skin is perhaps as important as its superficiality; it forms practically an integral part of the nervous and respiratory systems (and possibly the digestive, but to a considerably lesser degree).34 These functions link the body's outer casing and its thickness.

32 Jean Guillaumin, 'La peau du centaure. Le retournement projectif de l'intérieur du corps dans la création littéraire', in *Corps création. Entre Lettres et Psychanalyse* (Lyon: Presses Universitaires de Lyon, 1980). I do not go into Didier Anzieu's 'Skin Ego' theory here, but it underlies several passages of this text. This theory, whereby the psyche is bolstered by the skin model, is very specifically and openly linked to Anzieu's reading of the Marsyas myth. Cf. Anzieu, *The Skin Ego*.

33 Guillaumin, 'La peau du centaure', 257.

34 On this point, see François Dagognet, *La peau découverte* (Paris: Les empêcheurs de penser en rond, 1993).

For this reason, my approach to a topology of plastic creation based on a reading of the Marsyas myth, however close it comes to Guillaumin's theory regarding writing, moves away from it with this notion of thickness. Artistic creation, then, is not perhaps a second filmy skin, but a thickness of innervated flesh, laid bare when the artist's skin is turned inside out. And this reversing process is not a transposition, a metaphorical laying out flat of an inner personal archaeology through complex fictional mechanisms. This turning inside-out is rather the sharing of an inscription medium that is unscheduled and up to a point asocial, an 'ex-scription' medium to quote the term coined by Jean-Luc Nancy, an in-depth medium in which the aesthetic inscription of the world does not freeze but is delivered in its becoming.

MARSYAS, RUNNING OUT OF SKIN

I shall now raise the question of the relationship between the virtual and the actual, as it operates on our relationship to the skin as image, as simulacrum (*eïdolon* is the word used by some Greek philosophers) in a number of works by visual artists of today.

In 1997 Maurice Benayoun created the interactive installation entitled *World Skin: un safari photos au pays de la guerre* [*World Skin: a photo-safari in the land of war*].35 In it we have a screen showing a virtual montage made with photographic material drawn from the media coverage of wars (the Second World War and the conflict in Bosnia from 1992 to 1995). The audience are given cameras and access the area where this dramatic scene is being projected in three dimensions. Each time a 'war tourist' takes a picture, a white patch appears in the landscape, corresponding to the framing of the photograph, depending on the exact angle of the shot.

While the audience moves forward virtually into the landscape, this white rectangle is distorted according to the perspective. For instance, one character will stand out from his surroundings, silhouetted in his white reserve, then, further on, another element in the landscape will appear separately, also erased after being pictured. 'These are fragments of frozen images dotted around the space. It leaves us with the weird impression of walking through a ghost war, a cemetery of images that has nevertheless profound current relevance.'36

As the photographic machine-gunning intensifies, the three-dimensional landscape gradually shrinks to make room for the white reserve, the skin of the projection screen overrunning the image. However, the panorama is refreshed as the viewer moves about, bringing up elements 'still untouched by other people's gazes'.37 The sound material, meanwhile, introduces a shift away from visual mimicry; a clicking camera becomes gunfire for instance. On leaving the room, the 'tourists' are allowed to take home paper prints of the photographs they have taken, which thus become metaphors for war captures.

'We take photos. Through our gesture – aggression then pleasure in sharing – we tear the skin off the world. This hide becomes a trophy and our glory is enhanced when the world disappears.'38 The haptic dimension of photography, a mode of appropriating the world via the substitute image, is fully operational here. The camera unwittingly becomes a weapon, 'an eraser weapon' with which to strike from a distance. Once again Apollo flays Marsyas through the hand of his slave!

'The issue here is the place of the image as we take over the world.' The image that slips in between the world and us, especially when this is multiplied many times over by the media, is primarily a record, sometimes even an uncovering: 'With the media, war becomes a public

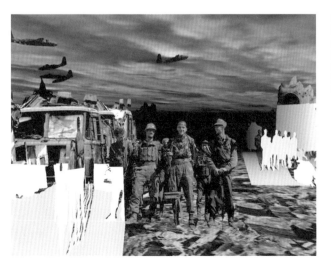

Maurice Benayoun, *World Skin: un safari photo au pays de la guerre* [*World Skin: a photo safari in the country of war*], 1997, interactive video installation.
Photo courtesy of the artist

35 Work created at the Ars Electronica Center, Linz, under optimal technical conditions: immersion room, screen-walls, stereoscopic vision, surround sound, etc.

36 Maurice Benayoun, *World Skin: un safari photo au pays de la guerre*, on the artist's website, www.moben.net

37 Benayoun, *World Skin*.

38 Benayoun, *World Skin*.

stage – the way we call a streetwalker *"une fille publique"* – obscene, where suffering is turned into a spectacle.'39

But as a weapon, the photographic image both appropriates and neutralizes: '[war] is involved in the reification of the other. Taking pictures dispossesses one of the privacy of pain in the very process of witnessing to it.'40 Our posture as spectators of contemporary war, through the media, thus inspires the artist to have us play again the flaying of Marsyas by Apollo: 'we tear the skin off the world'.

Using a medium usually reserved for the smoothing by the mass media of our relationship to the world, such sophisticated stage-managing faces us squarely with the problem of our reality as being more virtual than actual. The artist takes up a stance in relation to the phenomenon whereby reality boils down to a screen connected to a communications network:

> The other problem in connection with how we currently relate to global spacetime is the total fluidity and absence of any roughness in the communication space. For me if there is no roughness, no surface for friction, there is a danger of over-reacting […] The artist's role is to reinject roughness, the spanner in the works.41

The artist's aim in taking over the new media is to adopt these smooth techniques and breathe into them a relationship to the actual body: a little of the 'roughness' of the satyr's skin. We may wonder whether interactive electronic processes are truly capable, at least at this time, of restoring a bodily dimension to art. They do at any rate enable the artist to compose an effective allegory of how we relate to the world, in a dramatic parody of the attitude of the tourist holding his camera like a shield between the world and himself.

Olivier Goulet's *Trophées de Chasse Humains* [*Human Hunting Trophies*] also speak to us of appropriation through the skin, only in a more embodied medium and within a more personalized relationship. For several years now, this artist has been offering to make your bust in plaster using a casting process. The French term used to describe the resulting effigy is '*prise*', which plays on the different meanings of the word. Referring to plaster, it means hardening, and also the possibility of taking and conserving imprints; it also means 'taking' a photograph, or again the idea of grasping (a 'hold' in judo, climbing, etc.), and lastly appropriation (the 'prize' in war or hunting).

The plaster cast is painted or covered with a coloured latex skin, often leaving parts of the rigid support showing through. The commissioner can hang this effigy on the wall like a 'hunting trophy'. The flaccid skin can also be displayed as a matching piece to go with the plaster cast, as if the original bust were duplicated in a soft likeness.

What is at issue here is our identity and our relationship to others and to ourselves through the image. These sculptures lend body to the notion of the *simulacrum* by turning it into a hide, itself diverted into a 'trophy'. This flayed skin, dressed up as a decorative item, is at once a vanity, in the sense used in seventeenth-century painting, and a metaphor for the often mixed feelings that underlie our social relations and our self-image. Just like Marsyas's skin hung up in its tree, at once a relic, death mask, trophy and desolate windbag.

As a plastic artist myself, I too work on the skin and the human image. I have produced an installation entitled *La salle des peaux perdues* [*The Lost Skins Room*] made up of rectangular latex and silicon veils of body height, bearing fragmentary imprints of human organs. These 'skins' hanging in the space, with transparent lighting, envelop the area entered by the public. Actually, the prints are not

39 Benayoun, *World Skin*.

40 Benayoun, *World Skin*.

41 Interview between Maurice Benayoun and Julien Knebusch, March 2003, at the www.olats. org website, project Fondements Culturels de la Mondialisation (FCM).

Olivier Goulet, *Trophées de Chasse Humains* [*Human Hunting Trophies*], 1998–2005, plaster and latex.
Photo courtesy of the artist

enables me to give these effigies an identity that is both very personal (illness-related) and completely anonymous (the people these ex-votos refer to are not identified). Hence the expression 'lost skins' which finds its way into the title.

The casting technique requires the imprint to be torn away from its matrix: the skin appears when it is peeled off, dissociated from its mould, for hanging. However, far from tearing someone's skin off, even virtually, my production process rather involves casting the image (the material is liquid to begin with), making a kind of integument to take in all the disparate ex-voto fragments in a single entity.

Plastic creation lies somewhere between loss and appropriation, as I was saying earlier, 'neither the one nor the other', or rather both the one and the other at the same time, at once a flaying and a cicatrization.

A number of visual artists are currently seeking to harness various biotechnologies to embody their ideas. Several of them seem to be fascinated by the possibilities of *in vitro* human skin cell culture. The artistic twosome Art Orienté objet has produced human skin cultures that were later tattooed with various designs.42 These pieces of skin, used as media for signs, are displayed in Petri dishes or in jars as laboratory-produced artworks.

Julia Reodica's approach is similar to this. She markets in transparent boxes 'hymens' made of cell tissue grown from her own vaginal cells with perforations that form signs.43 Her aim is to offer a hymen graft to the buyer, who, provided that the technical and legal problems are overcome, can choose which of their bodily orifices to have this new virginity implanted in ahead of the performance during which they will be deflowered. This Philippine-born artist is accomplishing a critical work and a parody of the sacred value that certain civilizations attach to proof of virginity.

cast from bodies. This would be a very delicate task as, in these hybrid effigies, images of internal organs (intestine, stomach, etc.) go side by side with external body parts (hand, face, breast, etc.). In reality, the imprints are made from ex-votos, objects cast in wax, representing parts of the human body and hung in churches in certain Latin countries as a sign of gratitude for a cure. The fact of working from these existing objects charged with a secret

ABOVE
Stéphane Dumas, *La salle des peaux perdues* [*The Lost Skins Room*], 1999–2003, latex and silicon, partial view.
Photo courtesy of the artist

Art Orienté objet (AOo), *Skin Culture*, 1996, tattoo on skin cell tissue culture in a Petri dish.
Photo courtesy of the artists' website, www.artorienteobjet.com

RIGHT
Julia Reodica, *Unisex_Hymen @2weeks*, 2004, culture of rat aortic muscular tissue and the artist's vaginal cells in a transparent box.
Photo courtesy of the artist

42 Art Orienté objet (AOo), *Skin Culture*, 1996.

43 Julia Reodica, *hymNext™ – Designer Hymen Project*, produced by vivoLabs, 2004.

Orlan began making a *Harlequin Coat* from skin cells grown from different origins in the laboratory. This garment represents a further stage in her work on hybridization. The skins created by all these artists offer up their physical medium to our cultural projections, primarily related to social, political and gender identity.

I shall now look in more detail at the approach of Kira O'Reilly. This artist addresses *the* body as a theme, through *her* body which becomes the site, medium and substance of the work. The question her work raises is: 'How to be a body, now?' In her performances, O'Reilly takes her skin from the status of a private territory to that of an area for experiment shared with the audience. 'The relationships between bodily interior/exterior spaces are explored as a continuum. The permeable boundaries of the skin membrane defy it as an impenetrable container of a coherent or fixed "self".[44]

The artist explores various ways and means of removing this barrier between the inside of the body and the public space. Thus, her *Blood Drawings* are just that: drawn with her blood. She also finds inspiration in medical, specifically surgical, practices. Sometimes she offers the audience her skin as something to write on or even cut into, her body tissue 'invoking notions of *trauma* (a wound) and *stigma* (a mark) towards a "spoiling" and opening of the body suggesting an alterity or otherness'. Her casing of skin, exposed to the gaze, becomes a veil, whose 'narrative threads of the personal, sexual, social and political knot and unknot in shifting permutations'.[45]

The notion of the performance is crucial to what Kira O'Reilly is about. Her own skin, turned into a 'palimpsest of fading cuts, disrupted skin architecture of scars', suggests a topography where the surface area becomes the flow of time; each gesture, having left its trace, has taken place 'in the right place at the right time to engage with the moment,

Kira O'Reilly, *Post Succour (legs)*, skin bearing incision marks. Photo taken at the end of the *Succour* performance, 2001.
Photo © Manuel Vason, courtesy of the artist.

the action, the event'. It is 'an unexpected topography of proximities and distances where other connections are made and events pulled backwards and forward in the same time at the same place'. This singular mapping of the human body involves a way towards 're-conceptions of the body and embodiment'.[46]

In her project entitled *Marsyas – running out of skin*,[47] the artist has attempted to produce a cell culture of her own skin, like a lacework pattern.

Making lace involves a generation of tensions into patterned networks, gaps and loops. Its associations suggest the domestic, the intimate, the private, the

44 The Kira O'Reilly quotations that follow are taken from the artist's presentation at the *Bio Difference* conference, BEAP (Biennial of Electronic Arts Perth), Perth, 9 November 2004, available at www.beap.org.

45 O'Reilly, presentation at the *Bio Difference* conference.

46 O'Reilly, presentation at the *Bio Difference* conference.

47 Kira O'Reilly, *Marsyas – running out of skin*, project the artist worked on in 2003–04 during her residency at the SymbioticA laboratory, University of Western Australia, Perth.

48 O'Reilly, presentation at the *Bio Difference* conference.

49 O'Reilly, presentation at the *Bio Difference* conference. The artist later revived these experiences in a performance involving a dead pig.

50 Diodorus Siculus, *Library of History* III.59.5.

51 Plato, *Symposium* 221. In Plato's *Symposium*, Alcibiades, as I have already stated, compares Socrates to Marsyas: under a rough exterior, Socratic discourse contains treasures, like the satyr's music. This topology of the core (the soul) concealed under the bark no longer corresponds to the question we are concerned with at this point in our reflection. It is the satyr's coarse skin that is an indication here: '[…] the skin of a wanton satyr […]'.

52 On this subject, see the article by Jens Hauser, 'Derrière l'Animal l'Homme? Altérité et parenté dans l'art biotech', in Bernard Lafargue, 'Animaux d'artistes', *Figures de l'Art* 8 (2005), 397–431. Thomas Zaunschirn has recently published two major articles entitled 'Im Zoo der Kunst' ('At the art zoo') in *Kunstforum* 174 and 175 (2005), 39–103 and 38–125, on artists who have worked with live animals or biological material since the 1960s.

53 SymbioticA is an Art and Science Collaborative Research Laboratory at the University of Western Australia, Perth.

personal, undergarments, the feminine, the excessive, precious and precarious.48

The technique of this work is complex and to date it has not been possible to achieve the desired outcome. The cell tissue has to grow along a lacework structure sewn with degradable surgical thread. Kira O'Reilly has to mix pig cells with her own skin cells. She biopsies pig tissue samples herself. With a scalpel in her hand, she is prey to some strange identity-based considerations as to her relationship with this pig: 'using the pig as dummy, stand in, double, twin, other self, doll, imaginary self; making fiercely tender and ferocious identifications with the pig, imaginings of mergence with the pig, co-cultured selves'.49

When Apollo carried out an altogether more radical biopsy on Marsyas, did he entertain any such feelings? The appearance of a cold distance that most depictions of the scene give to the god allow us to suppose no such qualms. And yet Diodorus mentions Apollo as being depressed following exaction of the punishment: 'but he afterwards repented of this and, tearing the strings from the lyre, for a time had nothing to do with its music'.50 With the flaying of the satyr, what troubled identity change takes place deep down within the god?

'THE SKIN OF A WANTON SATYR'51

By using biotechnology, the artists discussed above are addressing questions which deal not only with personal identity but which embrace the human species as a whole. The theoretical reflection on the post-human is already being amply fuelled, notably by calling into question the boundaries between the human, the animal and indeed the other kingdoms of living things. By embodying their project in a live medium, certain artists do more than cross the borderline between the virtual and the actual. Their motivations are often rooted in a questioning of man's dominant position over animals.52 Is not the use of laboratory guinea pigs cruelty on a scale comparable to Apollo's flaying of the man-animal Marsyas?

Artists working on the materialization of their ideas by means of cell cultures or other bodily processes relying on scientific techniques have in the last few years added a critical dimension and corporeity to the growth of this type of scientific research and its everyday applications. The following comment by Kira O'Reilly on her work at SymbioticA53 has nothing to do with the scientific method:

> There is a strong desire with the work to confuse the integrity of embodiment with all its connotations of the welcomed and abhorred, all the accompanying proliferation of ambivalences and ambiguities. In this vein it is continuous of narratives of the 'other' and the 'monstrous' and the profound anxieties embedded within cultural readings of contemporary innovation of the biomedical and biotechnical.54

Art crosses boundaries, notably the boundary drawn between the human and the animal, and likewise between the subject and its object. Rilke quoted in a letter the remark of his friend, the painter Mathilde Vollmoeller, that Cézanne, when painting from life, was 'like a dog': 'he sat there in front of [the object to be painted] and simply looked, without any nervousness or irrelevant speculations'.55 The inside-out skin of the 'wanton satyr' brings us not so much the projection of an inner world onto the outer one as the return, with no irrelevant speculations, to the dimension of fact, to its roughness.56

54 O'Reilly, presentation at the *Bio Difference* conference.

55 Rainer Maria Rilke, *Lettres sur Cézanne*, trans. Ph. Jacottet (Paris: Seuil, 1991), 47 (*Letters on Cézanne*, ed. Clara Rilke, trans. J. Agee [Fromm International, 1985], 46).

56 Francis Bacon even talks of the 'brutality of fact', an expression David Sylvester uses as the title of his interviews with the artist: David Sylvester, *The Brutality of Fact. Interviews with Francis Bacon* (London: Thames and Hudson, 1975). In his fine article 'Marsia scoiato', Claude Jamain, for his part, views Marsyas, a figure of the 'incongruous', as an embodiment of the bodily dimension in art: the cry and 'raucous' side to singing. Claude Jamain, 'Marsia scoiato', in *L'Incongru dans la littérature et l'art*, ed. Pierre Jourde (Paris: Kimé, 2004), 99–109.

An earlier version of this article was published in German with the title 'Der Mythos des Marsyas. Ein Bild-Paradigma' ['The Marsyas myth. A plastic paradigm'], in *Häutung. Lesarten des Marsyas-Mythos* [*Flayings. Readings of the Marsyas Myth*], chief editors Ursula Renner and Manfred Schneider (Munich: Wilhelm Fink, 2006), 263–89.

clothing, an | extension of the skin...

When the evolutionary process shifts from biology to software technology the body becomes the old hardware environment. The human body is now a probe, a laboratory for experiments.

In the electric age we wear all mankind as our skin.[1]

Marshall McLuhan

McLuhan and the Body as Medium

Richard Cavell

1.

One of the singular paradoxes of Marshall McLuhan's career as a media theorist is that the theory he inaugurated has rarely been revisited by those who today claim the status of media theorists. As W. J. T. Mitchell has recently put it, 'thirty years after the death of Marshall McLuhan, the great pioneer of media studies, the field still does not have its own identity. Symptomatic of this is the need to constantly overturn McLuhan, to recite all his mistakes and bemoan his naive predictions.'[2] The point is more complex, however, because McLuhan's theories were not put forward in the highly delimited sphere in which he has subsequently been contested. He is by no means a media theorist in the vein of those cited by Mitchell – Kittler, Virilio, Lunenfeld and Manovich. What distinguishes him from these theorists and others was the much broader notion of media that informed his theories. Indeed, so broad were the claims he made that he would be much more accurately addressed as a cultural theorist.[3] *Understanding Media*, the foundational text of 1964, contains chapters on roads, numbers, clothing, housing, money, clocks, comics, nationalism, bicycles, photographs, the press, automobiles, advertising, games, the telegraph, the typewriter, the telephone, the phonograph, movies, radio, television, weapons and automation.[4] Even this listing, however, does not fully address the radical nature of McLuhan's theory of mediation; as he might have said, the list focuses on the figure but ignores the ground, which, in this case, is that of biology. As McLuhan puts it in a key passage of *Understanding Media*:

Physiologically, man in the normal use of technology (or his variously extended body) is perpetually modified by it and in turn finds ever new ways of modifying his technology. Man becomes, as it were, the sex organs of the machine world, as the bee of the plant world, enabling it to fecundate and to evolve ever new forms. (46)

In order to understand how McLuhan came to this radical vision of biomediation, it is necessary to examine his early training as a scholar of Renaissance literature. In his dissertation, 'The Place of Thomas Nashe in the Learning of his Time',[5] McLuhan examines the rhetorical tropes of Renaissance literature that resonated in the work of a minor *littérateur*, Thomas Nashe, and it is rhetoric that provides the key to McLuhan's subsequent intellectual development. It is rhetoric as a shaper of speech, of expression, which seeks to achieve an embodied (affective[6]) as much as a rational response in the listener to whom it is directed that informs McLuhan's notion that media are extensions of our bodies. Coupled with the notion of the 'environment' to which he was introduced by his most influential Cambridge professor, F. R. Leavis,[7] this rhetorical notion of mediation became the basis for McLuhan's subsequent media theories. Media, in short, seek to shape utterance in such a way as to produce a total environment of signification, such that the medium is the message; as all utterances are *outerances*, these environments are embodiments of their speakers. Thus the medium is also the 'massage' in its manipulation of the skin of culture.[8]

1 Marshall McLuhan, *The Book of Probes* (Corte Madera: Gingko Press, 2003), 111, 316–17.

2 W. J. T. Mitchell, *What Do Pictures Want? The Lives and Loves of Images* (Chicago: University of Chicago Press, 2005), 206.

3 See Richard Cavell, *McLuhan in Space: A Cultural Geography* (Toronto: University of Toronto Press, 2002), and, with Jamie Hilder, www.spectersofmcluhan.net

4 Marshall McLuhan, *Understanding Media: The Extensions of Man* (New York: McGraw-Hill, 1964).

5 This dissertation has recently been published under the title *The Classical Trivium*, ed. W. Terrence Gordon (Corte Madera: Gingko Press, 2005 [1943]).

6 I allude here to the considerable body of work that has grown up around affect. See, for example, Teresa Brennan, *The Transmission of Affect* (Ithaca, NY: Cornell University Press, 2004).

7 F. R. Leavis and Denys Thompson, *Culture and Environment: The Training of Critical Awareness* (London: Chatto and Windus, 1933).

8 Marshall McLuhan, with Quentin Fiore and Jerome Agel, *The Medium is the Massage: An Inventory of Effects* (New York: Random House, 1967); images from this book accompany my text with the kind permission of Gingko Press.

When McLuhan arrived in Madison, Wisconsin, to begin his teaching career, and found that his students were ill-prepared to follow a course from him in the area of his training, he was immediately able to put together a new course on advertising,[9] which he understood as the contemporary avatar of the rhetorical practices he had studied in his dissertation. The aspect of embodiment, however, was much more highly articulated in advertising, given that the ads were directly aimed at the libidinal economy that had established itself in the post-war effort to contain the immense gender dysphoria that was one of the major effects of the war. In writing the *Report on Project in Understanding New Media* (1960) – which he revised as *Understanding Media* – McLuhan reflected this aspect of embodiment in his argument that media require a greater or lesser extent of 'completion', a notion he revised in the subsequent book as 'hot' and 'cool' mediation. 'Hot' media, like the radio, required little or no completion by those to whom they were directed; 'cool' media, like television, were deeply involving. This involvement, in the case of television, was profound, not because the content of television was significant, but because the medium was invasive, penetrating the body with its radioactive waves and requiring an interaction with the primitive core of the brain in the production of images that were not perceptible to the eye alone. As he put it in one of his most powerful articulations, 'The TV screen just pours that energy into you which paralyzes the eye; you are not looking at it, it is looking at you'.[10]

In a parallel development, the rhetoric of the speech act (an utterance which has a material effect, such as 'The accused will stand') has become the basis for the most influential contemporary theory of gender, that of Judith Butler.[11] Elaborating her theories from the speech act theory of J. L. Austin, Butler has argued that the body of gender is a rhetorical performance that is no less embodied for being performative. Anne Balsamo connects the notions of gendered embodiment with technological embodiment in *Technologies of the Gendered Body*, where she writes that:

> It is not simply that technologies create the *concept* of the body, but rather that communication technologies reproduce the body itself. To this end, McLuhan critically examines a variety of images and texts from popular culture to demonstrate how communication technologies function as the new body sensorium. We know our bodies through technological sense organs (self-surveillance devices), and the bodies we know have been irrevocably transformed by technological practices.[12]

In *Embodying Technesis*,[13] Mark Hansen argues for the importance of the experiential in assessing the impact of technology on being. As Hansen notes, our perceptual experiences are themselves subtended by technologies, a notion that McLuhan had developed in his early writings

9 See Philip Marchand, *Marshall McLuhan: The Medium and the Messenger* (Toronto: Random House, 1989), 43.

10 McLuhan, *Probes*, 532.

11 See, for example, *Bodies that Matter: On the Discursive Limits of 'Sex'* (New York: Routledge, 1993).

12 Anne Balsamo, *Technologies of the Gendered Body: Reading Cyborg Women* (Durham, NC: Duke University Press, 1995), 173–74 n. 20.

13 Mark Hansen, *Embodying Technesis: Technology Beyond Writing* (Ann Arbor, MI: Michigan University Press, 2000).

about how our sense of the visual had been constructed by printing technologies. As Hansen puts it, the 'implicit desideratum motivating contemporary techno-criticism' is 'the foregrounding of the body as the site for technology's molecular material impact' (18). This would seem to belie the notion of technology as absolute (i.e. as 'absolute resistance to representational capture' [18]) and would seem to validate McLuhan's notion of technology as an immense prosthesis which we have come to occupy as if it were 'natural' – hence his use of the term 'environment'.14

In effect, Hansen is theorizing that technology cannot be theorized; or, at least, that its materiality cannot be thought. McLuhan, however, was arguing that technology can *only* be thought, that we cannot think beyond technology, that technology is the pre-condition of thought insofar as it is the pre-condition of being, at which point technology and 'being human' collapse into each other. McLuhan thus dislocates ontology from the individual to the mass and from being to *techne*. In a manoeuvre similar to that effected by Derrida in his critique of Rousseau, McLuhan argues that consciousness of being is impossible without prior awareness of *techne*. Whereas Hansen contends that, '[a]s actual forces immanent to the real, technologies furnish an immediate material source of movement (active force) that does not rely on the activity of thinking for its ontogenesis' (19), McLuhan's notion of technology is biological and pre-rational; the television image, for example, was assembled in the core stem of the brain – a position that Antonio Damasio appears to have arrived at independently.15

Hansen and McLuhan have one starting point in common: Samuel Butler's 1872 novel *Erewhon*, in which, as Hansen puts it, Butler's 'vision of the quasi-evolutionary symbiosis of man and machine imposes an enabling holist framework on analysis, one that forbids the analytical

isolation of technology so common in recent theorization' (25; McLuhan refers to *Erewhon* in *Understanding Media* and in *Take Today: The Executive as Dropout*16). It is in Samuel Butler's valorization of the 'experiential domain' (25) especially, as opposed to the 'narrow realm of cognition', that Hansen finds him to be particularly prescient. Hansen seeks to articulate the '*extrascientific*' (26) context in which technology operates, namely the cultural context. To the extent that technologies alter the '"economy" of experience' (26, drawing on Benjamin), they are mediatory. In these terms, embodiment precedes inscription; 'the lived body *is* the site of ... experiential excess' (27). Hansen thus seeks to study technologies 'through the frame of phenomenological embodiment' (28). McLuhan differs here in his insistence on the materiality of *invisibilia*; for him it was not a difference between 'constructivism' and the 'hard materiality of technology'; rather, it was the radio waves that were for him at once constructs and material, modes of communication that also communicated. Thus for him there was no 'unmediated material flux' (36), as there is for Hansen; all was mediated. Hansen makes the qualification that technology is in fact Janus-headed: one aspect of technology enters into networks with the human and is thus 'open to culturalist analysis' (36), while another 'contribute[s] directly *though not without human mediation* [emphasis added] to the autonomous process by which matter "self-complexifies"' (37), a notion that is resonant with McLuhan's notion that we are the sex organs of technology. Hansen's argument is thus not strictly constructivist, since in his formulation we live in an embodied technology – we *are* that technology. Hansen comes closest to this position when he writes that '[e]mbodiment ... constitutes our practical means of interaction with the material flux and with the material reality of technology beyond the theater of representation'

14 Hansen invokes McLuhan directly, rejecting his theory of mediation based on the assumption that McLuhan is a technophile, 'gleefully' proposing that electronic media will provide us with 'a global embrace'. Rather, suggests Hansen, 'we face a situation in which the prostheses we adopt to cognize and intervene in the technologically driven material complexification of the universe only seem to expand our experiential alienation' (71). Yet it was McLuhan who *introduced* the notion of alienation, of amputation, of prosthesis, of ablation into media theory.

15 In her foreword to Hansen, Katherine Hayles writes that 'there is ample contemporary evidence from such researchers as Antonio Damasio that cognition extends throughout the body and includes emotions, kinesthesia, proprioception, and other sensations located in the lower brain, limbic system, and central nervous system. Although such sensations can be given verbal expression, they originate as nonverbal perceptions and need not be brought into language at all' (vii). McLuhan was writing decades ago about how the TV image was assembled pre-cortically rather than recorded as a pre-existing image. Hence

his controversial notion that television was *more* involving than print media. Interestingly, Damasio arrives at his position via his reading of a book that profoundly influenced McLuhan, Julian Jaynes' *The Origins of Consciousness in the Breakdown of the Bicameral Mind* (Boston: Houghton Mifflin, 1977). See Anna Gibbs, 'In Thrall: Affect Contagion and the Bio-Energetics of Media', at journal.media-culture.org.au/0512/10-gibbs.php, accessed 7 September 2007.

16 McLuhan, with Barrington Nevitt, *Take Today: The Executive as Dropout* (Toronto: Longman, 1972).

(41). Rather than being representational of something given and known, technology *transforms*, and thus it exceeds the representational (64). This notion of technology as transformational, as opposed to representational, is similar to McLuhan's notion of communication: that it is a transformation rather than transportation system. Where Hansen and McLuhan disagree is in Hansen's notion that technology is inhuman; for McLuhan, it was profoundly human, with the major proviso that technology is the pre-condition of the human. Technology, in other words, is not ontological for McLuhan; it is rather that ontology is technological. The human, thus, is a product of the technological. Hansen argues cognately that the goal is 'to situate technology in a more encompassing and properly posthuman context without at the same time being compelled to affirm its radical *in*humanity' (70).

2.

The notion that media are *embodied* had profound implications for McLuhan's notions of mediation, and particularly for the ontological implications of these notions.[17] If media extend parts of our bodies – and amputate them as well – then media undermine ontological certainties about subjectivity and selfhood. This notion radically alters the popular view of McLuhan as a technophile, a theorist of electronic utopianism, whose concept of the 'global village' – the notion that vaulted him to fame in the 1960s – was meant to imply a universal communion through electronic mediation. On the contrary, as Christopher Horrocks has noted, McLuhan's theories 'profoundly [affect] the ontological security of the individual'.[18] This ontological insecurity, however, arises not only from disembodiment (amputation) but from *embodiment*. McLuhan's argument is that electronic mediation has vastly distended our bodies to the point that

we live in a totally embodied cosmos, but that by virtue of this extension our bodies are now *outside* us. To this extruded body McLuhan gave the name 'environment', and it is there that we now live – in a 'nature' of our own making.

McLuhan's theories are theories of displacement: the bride in *The Mechanical Bride* has been displaced into mechanical culture; the man of *The Gutenberg Galaxy* has been displaced into typography; the human has been displaced into technology; the local has been displaced globally; temporality has been displaced spatially; the sensorium has been displaced into the electronic ether; media have been displaced into intermedia; nature has been displaced into culture; the subject has been displaced into the mass; the message has been displaced into the medium. But these displacements are not obliterations; they do not operate as binary oppositions, one term collapsing into the other. McLuhan theorized interfaces, gaps, resonances. McLuhan's insistence on the process of displacement emphasizes his status as a dynamic thinker, a thinker of relations in tension. 'It is hard for the … uncritical mind to grasp the fact that "*the meaning of meaning*" is a relationship: a figure–ground *process of perpetual change*'.[19] His *Laws of Media*[20] are laws only to the extent that they can be broken; the modalities of enhancement, obsolescence and retrieval are dynamized by the principle of reversal, and the universe to which these laws apply is a chaos of permeable borderlines constantly shifting ground in new tectonic alliances. In understanding media this way he was declaring himself a citizen of the global village, his most dynamic concept, at once local and global, at once here and there.

McLuhan was thus a theorist of what Peter Sloterdijk has called the 'media-ontological situation',[21] but his ontologies were counter-intuitive in not theorizing a stable

17 In this section I draw on my paper 'Specters of McLuhan: Eleven Notes for a Re-Reading', given at Castle Thurnau, University of Bayreuth, in February 2007.

18 Christopher Horrocks, *Marshall McLuhan and Virtuality* (Cambridge: Icon Books, 2000), 66.

19 McLuhan, *Take Today*, 86.

20 McLuhan, with Eric McLuhan, *Laws of Media* (Toronto: University of Toronto Press, 1988).

21 Peter Sloterdijk, *Critique of Cynical Reason* (Minneapolis: University of Minnesota Press, 1987), 512.

subject position. In his first book, the 'bride' of consumerist culture is 'mechanical' and thus infinitely reproducible; in his second book, the 'man' of his 'Gutenberg Galaxy' is typographical; and his 'understanding media' completely lacks a subject. As the progressive form of the verb, 'understanding' anticipates Friedrich Kittler's comment that media can never be understood;[22] re-reading it as an adjective, it suggests that it is the *media*, here, that are doing the understanding, or even *being* understanding. Ultimately, as McLuhan argued, electronic mediation produces what he called 'discarnation'.[23] Yet technology, for McLuhan, was not inhuman; it was profoundly human. 'In the sense that these media are extensions of ourselves ...then my interest in them is utterly humanistic,' McLuhan states in the dialogue with Gerald E. Stearn.[24] And similarly: 'all technologies are completely humanist in the sense of belonging entirely to the human organism'.[25]

As McLuhan had learned through his study of Renaissance literature, rhetoric profoundly unmoors the speaking self from 'presence'; if all *utterance* is at the same time *outerance*, then utterances are at once private and public, at once personal and rhetorical. Hence mass communication in McLuhan's understanding of it tends to be ritualized and tribal, rather than 'original' and 'individual' (attributes which were the effects of written communication). This was humanism, as he stated, but it was humanism in reverse, the perfection of the individual exchanged for the perfection of the mass, a Bauhaus programme for a totally designed world. The inversion of private and public, inner and outer, in McLuhan, is itself part of the much larger one in which McLuhan theorized an interfusion of the biological and the technological; 'technology is part of our bodies' he writes in *Understanding Media* (68). To ignore this was a fatal critical flaw, in his view, because it encouraged a critique of technology as

22 Kittler comments that 'Understanding media – despite McLuhan's title – remains an impossibility precisely because the dominant information technologies of the day control all understanding and its illusions'; see *Gramophone, Film, Typewriter*, trans. Geoffrey Winthrop-Young and Michael Wutz (Stanford, CA: Stanford University Press, 1999), xl. McLuhan is quite aware of this impossibility, hence the ambiguities of his title. It is a pleasure, here, to acknowledge my colleague Geoffrey Winthrop-Young and our ongoing dialogue about media.

23 McLuhan, 'A Last Look at the Tube', in *Marshall McLuhan: The Man and His Message*, ed. George Sanderson and Frank Macdonald, intro. John Cage (Golden, CO: Fulcrum Press, 1989), 196–200; this quote 197.

24 McLuhan, 'Dialogue with Gerald E. Stearn', in *McLuhan: Hot and Cool* (New York: Dial Press, 1967), 265–302; this quote 294.

25 McLuhan, 'Interview with Eli Bornstein', *The Structurist* 6 (1966), 61–68; this quote 67.

something separate from the social dimension of cultural production. Indeed, he suggested that technology had supervened our bodies, such that we had turned ourselves inside out – extended and amputated ourselves (the other part of the Faustian bargain with the prosthetic gods) – and extruded ourselves into an environment which is at once ourselves and utterly 'other', a prosthetic environment which appears foreign to us – even though it is us – because it is now outside us. We have, in this sense, been *incorporated*.

McLuhan contended that the launching of Sputnik in 1957 turned nature into culture, earth becoming an artifact of technology, contained by technology rather than being its container. 'Technological art takes the whole earth and its population as its *material*, not as its *form*,' he wrote in his 1954 pamphlet *Counterblast*26 (emphases added). This new environment proposes an 'ecology' of 'echo recognition', whereby we confront a 'nature' which is constituted by the biotechnologies of our extended selves: 'Today's ecological awareness is echo recognition' because '[i]n today's electric world, man becomes aware that [the] artificial "Nature" of the Greeks is an extension of himself'.27 McLuhan's *Take Today: The Executive as Dropout* (1972) is a self-help guide for the biotechnologically over-extended. Putatively written for business executives, the book is in fact a manual for navigating the '*corpore*-ate' self, namely that entity formerly known as nature which has now become the vastly distended body of mass culture: 'Consciousness,' writes McLuhan, 'is corporate action.' This is why culture is our business. We are (re)making ourselves in the anti-Cartesian ecstasies of a *homo faber* who has now replaced *homo sapiens*. These paradoxical notions are brilliantly captured in the *Alien* movies (and particularly *Alien 4*), movies that represent in the most visceral way

possible this sense of the *prosthetic*, of the way in which living within a totally technologized environment (the spaceship) has as its concomitant aspect the inescapable prostheticization of our selves. At the end of *Alien 4*, the human protagonist, Ripley, has been cloned and is thus completely 'outside' herself; as she approaches earth and prepares for re-entry we see, through the window 'screen', the earth hovering in space, which appears as a purely aesthetic object – 'It's beautiful,' remarks one of the characters. A shipmate, also a clone, asks Ripley what it's like on earth, to which she replies with the harrowing line 'I don't know; I'm a stranger there myself.' Here the very materiality of the earth – *terra firma* – has itself become an exercise in virtuality, while the 'human' has collapsed into the 'other'.28

In McLuhan we encounter the political and the economic as modes of information technology. With the end of the Second World War, McLuhan argued, the era of Mars had given way to that of Venus, thus inaugurating a libidinal economy of endless consumerism, in which consumption was at once the product and the goal in a vast feedback loop. 'Technology eats itself alive,' he wrote in 1972, 'loops the loop.'29 His study of this libidinal economy, *The Mechanical Bride* (1951), posits the automobile as the bride of a culture whose libido had been displaced by the War's disruption of sexual identity. McLuhan was among those who realized that, in the post-war period, commodification would be generalized within culture. The vehicle for this generalization would be advertising, at once the new poetry of the culture-as-commodity era and a profound expression of the libidinal economy governing it. Thus, the frequent criticism made of McLuhan – that he ignored the political and the economic – needs to take into account the way in which his theories blurred these

26 McLuhan, *Counterblast* (Toronto: np, 1954); this pamphlet is not to be confused with the 1968 book of the same title, although some material from the earlier publication is repeated in the later one.

27 McLuhan, *Take Today*, 3, 6.

28 The second *Alien* movie (1986) was made by expatriate Canadian director James Cameron; it was anticipated by David Cronenberg's *Videodrome* (1982), which is an extended mediation on violence and media. As Cronenberg has stated, the film gestures towards McLuhan in the character of Brian O'Blivion. *Alien Resurrection* (1997) was directed by Jean-Pierre Jeunet.

29 McLuhan, *Take Today*, 111.

distinctions. For McLuhan, economics and politics had collapsed into the cultural, a feedback loop in which we are at once subject and object of our desires, where desire, as Alexandre Kojève once put it, is the negativity of being.30 Yet it was the apparent 'immateriality' of media technologies that tended to make McLuhan's work seem irrelevant during the period when 'critical' most often meant 'Marxist' – why wasn't he dealing with economic practices? Didn't this lead to his deterministic reading of the media? And where was politics in all of this? With the notion of 'performativity', however, the 'immaterial' has become invested with a 'materiality' it had not enjoyed before, as in the concept of the body as 'construct', of the 'death' of the subject, and above all of the 'effect' as meaningful in its own right.

3.

In the 1960s Tom Wolfe famously compared McLuhan to Darwin, Einstein and Freud, and while McLuhan's connections to Einstein and Freud have been explored over the years, the reference to Darwin deserves further pursuit as critical theory increasingly encounters the *bios*. The environment as biotechnological extension presents for McLuhan the notion of an embodied mediation. If this biotechnological extension, this environment, is understood as cultural, rather than natural, then its effect is to promote the notion of culture as a continuation of nature, rather than its overcoming. As counter-intuitive as it might appear, this position has gained increasing validity within biological theory. Freeman Dyson writes, in 'Our Biotech Future' (2007)31 that 'the domestication of high technology ... [will] soon be extended from physical technology to biotechnology', predicting that 'the domestication of biotechnology will dominate our lives during the next fifty years at least as much as the domestication of computers

has dominated our lives during the previous fifty years'. In the future that Dyson predicts, 'Designing genomes will be a personal thing, a new art form as creative as painting or sculpture', analogous to the way in which breeders, today, produce new varieties of roses and pets. In support of these predictions, Dyson (himself a physicist, though one who argues that, while the twentieth century belonged to physics, the twenty-first will belong to biology) draws on the work of microbial taxonomist Carl Woese, and in particular two essays: 'A New Biology for a New Century', in *Microbiology and Molecular Biology Reviews* (June 2004), and, with Nigel Goldenfield, 'Biology's Next Revolution', in *Nature* (25 January 2007). Perhaps the most revolutionary claim that Woese makes is that Darwinian evolution is not a constant of biological life; rather, he argues, it was preceded by 'horizontal transfer',32 that is, by 'the sharing of genes' in a non-hierarchical fashion (which is crucial to the need in evolution for one species to fail in order for evolution to continue). Woese thus postulates 'a golden age of pre-Darwinian life, when horizontal gene transfer was universal and separate species did not exist'.33 The fundamental genetic principle was that of sharing; the whole community advanced, rather than a single species. Then, as Dyson summarizes, 'a cell resembling a primitive bacterium happened to find itself one step ahead of its neighbors in efficiency. That cell, anticipating Bill Gates by three billion years, separated itself from the community and refused to share' (4). This was the beginning of the 'Darwinian interlude'. Ironically, notes Dyson, the Darwinian interlude slowed down evolution, since it did not permit lateral transfers of information. This interlude ended

when a single species, *Homo sapiens*, began to dominate and reorganize the biosphere. Since that time, cultural

30 Alexandre Kojève, 'Introduction to the Reading of Hegel', in Mark C. Taylor (ed.), *Deconstruction in Context: Literature and Philosophy* (Chicago: University of Chicago Press, 1986), 98–120. McLuhan would have encountered the work of Kojève in the work of Merleau-Ponty.

31 Freeman Dyson, 'Our Biotech Future', *New York Review* (19 July 2007), 4–8.

32 Dyson, 'Our Biotech Future', 4.

33 Dyson, 'Our Biotech Future', 4.

evolution has replaced biological evolution as the main driving force of change. Cultural evolution is not Darwinian. Cultures spread by horizontal transfer of ideas more than by genetic inheritance. Cultural evolution is running a thousand times faster than Darwinian evolution, taking us into a new era of cultural interdependence which we call globalization. And now, as *Homo sapiens* domesticates the new biotechnology, we are reviving the ancient pre-Darwinian practice of horizontal gene transfer, moving genes easily from microbes to plants and animals, blurring the boundaries between species. We are moving rapidly into the post-Darwinian era, when species other than our own will no longer exist, and the rules of Open Source sharing will be extended from the exchange of software to the exchange of genes. (6).

Dyson's easy – horizontal – transition from computer-speak to biological theory is telling, as is the notion that *Homo sapiens* must now turn back on itself – having evolved to the top of the ladder, it must now move from the vertical plane to the horizontal, parallel to Ulrich Beck's notion that the only way modernity may go forward is by curving back on itself,34 such that 'environmentalism' can be understood as the undoing of modernity *within* the modernist project. Indeed, Dyson argues that the single most important application of Woese's theories will be within 'green technology'. Summarizing his position as stated in *The Sun, the Genome, and the Internet* (1999), Dyson writes that the three components of his vision are equally necessary: 'the sun to provide energy where it is needed, the genome to provide plants that can convert sunlight into chemical fuels cheaply and efficiently, the Internet to end the intellectual and economic isolation of rural populations' (8).

Because McLuhan rejected Shannon and Weaver's 'transportation' model of information theory as his foundation for media theory, replacing it with a 'transformation' model, his theories of mediation have much more in common with current concepts of biomediation than do other theories of mediation contemporary with McLuhan's work. His theories, in other words, do not seek to understand our encounter with a post-human status, as does that of Katherine Hayles, for example, in *How We Became Posthuman*. As profoundly displaced as they are, McLuhan's subjects are not cyborgs. Rather, it is through our technologies, argues McLuhan, that we encounter our *humanity*. Mediation is not 'out there' but 'in here'; not disembodied but embodied; not immaterial but material.

Rather than understanding how we became post-human, then, McLuhan sought to understand how we became *human*, and his answer was that we became human through our technologies. 'The body,' as Eugene Thacker has put it, 'is a medium.'35 Alluding to McLuhan, Thacker continues: 'It is not just that the medium is the message, but that biology is the new medium: the medium is a message, and that message is a molecule. This is the crux of the concept of "biomedia"' (48). As Thacker goes on to state:

> Biomedia are novel configurations of biologies and technologies that take us beyond the familiar tropes of technology-as-tool, the cyborg, or the human-computer interface. 'Biomedia' describes an ambivalence that is not reducible either to technophilia (the rhetoric of enabling technology) or technophobia (the ideologies of technological determinism). Biomedia are particular mediations of the body, optimizations of the biological in which 'technology' appears to disappear altogether. With

34 Ulrich Beck, *Risk Society: Towards a New Modernity*, trans. Mark Ritter (London: Sage, 1992).

35 Eugene Thacker, 'What is Biomedia?', *Configurations* 11 (2003), 47–79; this quote 48.

biomedia, the biological body is not hybridized with the machine, as it is in the use of mechanical prosthetics or artificial organs. Nor is it supplanted by the machine ... Biomedia is only an interest in digitization inasmuch as the digital transforms what is understood as biological. In short, the body you get back is not the body with which you began, but you can still touch it. The 'goal' of biomedia is not simply the use of computer technology in the service of biology, but rather an emphasis on the ways in which an intersection between genetic and computer 'codes' can facilitate a qualitatively different notion of the biological body – one that is technically articulated, and yet still fully 'biological'. ... The biological and the digital domains are no longer rendered ontologically distinct, but instead are seen to inhere in each other; the biological 'informs' the digital, just as the digital 'corporealizes' the biological. (52–54)

In any communication, as McLuhan stated, it is the sender who is sent.36 Media interact with the biological as extensions of the body, and thus have a profound effect on the sensorium – the collectivity of our senses. Media 'transcode' the senses in a process parallel to that of 'remediation', writes Thacker, whereby one medium 'transform[s] certain visual, haptic, auditory, and corporeal habits specified by earlier media such as film' (54).

As McLuhan put it, the content of a new medium is the old medium. Bolter and Grusin developed this notion in their book *Remediation*, which argues that the body is, in effect, a medium that transcodes sensory stimuli parallel to the shift in the sensorium caused by media themselves. In the cultural domain, as Thacker writes, 'phenomena such as fashion, modern primitivism (piercing, tattooing), body play, cosmetic surgery, transgenderism, body building, cyborg performance ... [are] examples of the

body both as medium (a means of communication) and as mediated (the object of communication)' (56). Indeed, for McLuhan, the body could claim priority in this regard; his reading of Julian Jaynes' *The Origin of Consciousness in the Breakdown of the Bicameral Mind* suggested to him (following perhaps from the dictum of Aquinas that *nihil in intellectu quod non pria in sensu*) that the process of thought gave priority to the body, not the mind. If we ultimately inhabit the body of mediation, then the only way we can become aware of it is by radically juxtaposing it to previous embodied environments, a process which Thacker calls 'hypermediacy' – 'the overcoding, heterogeneity, and saturation of the subject by different media, the empowerment of multiplying media tools in the hands of the subject' (55). It is the role of the artist and the critic alike, McLuhan argued, to make us aware of these environments.

36 McLuhan, 'Violence of the Media', in Sanderson and Macdonald (eds), *The Man and His Message*, 91–98; this quote 92.

Skin does not necessarily form a distinct border between the inside and the outside of an entity, even of something that is already known and concrete. *sk-interfaces* – to use the neologism coined by Jens Hauser for the exhibition at FACT – lack concreteness, as skin is a medium that is continuously growing. When artists deal with tissue culture and various kinds of skin, they use the potentials of the medium in a very material way, similar to the way in which a landscape architect makes use of the growing potential of plants within specific limits. Tissue can shift the borders of organisms and species and, when used as a material in art, it can question the limits of what was once thought to be known. This essay will, therefore, emphasize the tension between the physicality of 'skin' as a medium and the disformation of *what* actually grows.

Endogenous Design of Biofacts:
Tissues and Networks in Bio Art and Life Science

Nicole C. Karafyllis

ENDOGENOUS DESIGN AND THE
MEDIALITY OF SKIN

Here, skin is not considered a mere surface nor a physical container but instead as a hybrid of constantly rearranging natural and social orders. As this hybridity can be triggered by the endogenous design of living things normally employed in the biosciences, its products are called *biofacts*.[1] Fused from the Greek 'bios' for life and the Latin 'artifact', this neologism is itself a hybrid. The word *biofact* still carries the connotation of technical interference with life to arrive at ends envisaged by a human designer, even if the act of interference leaves behind no traces. Biofacts can grow inside the lab or outside, challenging the very border of the laboratory. These living sculptures seem to overcome the design stage during growth. However, they still hint at what they once were and at what they are supposed to become in the future. The modality of biofacts is a general 'inbetweenness'. They materialize in the space 'in between' what is necessary for life and what is possible. Working with tissues requires laboratory skills to cultivate, inhibit and stimulate living media. For that reason artists cannot use cells or tissues as they would use 'dead' materials because they need the medium's specific, endogenous capacities for design. Biofacts exist as the intermediaries of functions which were initially modelled by others but which in the end they have to create themselves.

At present, we are experiencing a general tendency towards rematerialization in new media art, which is taking place in light of an ongoing biologization of the soul, the innermost part of living beings which is assigned no specific location. The internal was always the concealed which had to be exposed before it could be studied. In contrast, the external was the visible casing upon which internal happenings left their mark. Skin as the physical border was and is, therefore, always also a medium of representation of the external past and the internally changeable. It presents the subjectively experienced, scarred and acute and yet, as a tissue capable of regeneration, belongs to the interior of the subjective body (German: *Leib*; French: *le corps propre*). As signifier and signified it provides physiognomical images on the medial border between the interior and the exterior of individual humans as well as other creatures. Even when it is operatively tightened ('lifted'), browned by the sun or tattooed, it says something about the individual and the person's subjective depth of character: the desire to re-fashion and rejuvenate the self. In the face of the other the skin still cannot be objectified.

Tissue can cross the boundary between art and science, as well as between public and private. The term 'tissue culture' even suggests this crossing of nature and culture, the existence of tissue in biology laboratories and the possibility of shaping it in the life world (*Lebenswelt*). Tissues are cultivated and modelled and in the process continue to grow on their own. The following example is almost paradigmatic for endogenous design in so-called 'Bio Art': in her *hymNext Designer Hymen Project*, artist Julia Reodica takes the experimental activities of the laboratory into the private sphere of the home, growing

1 Nicole C. Karafyllis (ed.), *Biofakte. Versuch über den Menschen zwischen Artefakt und Lebewesen* (Paderborn: Mentis, 2003) and 'Biofakte – Grundlagen, Probleme, Perspektiven', *Deliberation Knowledge Ethics/ Erwägen Wissen Ethik* 17.4 (2006), 547–58.

artificial hymens *in vitro* which people can potentially then transplant onto themselves. When we explore the 'othering' of the laboratory in this, at least three viewpoints emerge: free space (into which the growing objects will be 'released'), the life world (in which subjects deal concretely with these new types of 'growths') and society, which of course consists of more than just laboratory assistants and scientific experts dealing with breeding and biotechnical cultivation. When artists use laboratory techniques and imagery, they problematize not only the borders between *in vivo* and *in vitro* but above all the third conceptual method of biological sciences as well: *in situ*. 'In situ' refers to the location where something 'naturally' happens.

The provocative questions posed by the *hymNext Designer Hymen Project* are manifold: Why does the hymen have to grow inside the body? Why does the act of defloration have to take place in the female body, and why only once? And why does the costly restoration of the hymen before marriage, which takes place dozens of times each day as a result of societal pressures, have to take place within the exclusionary domains of experts, that is, in laboratories and clinics? The recovery of the awareness of one's own virginity, of the new ground, the *tabula rasa*, is an element in overcoming elitist laboratory borders. These metaphors suggest that a person can repeatedly begin again and grow in their own life and have a personal history of beginning which is not stipulated by a third party. That means that there are no alternative experts for one's own 'life' and the 'lives' of others any more than there is an alternative owner. One of the discursive symbols that refer to foreign possession, the hymen is a membrane that belongs neither to the internal nor to the external regions of the female body and its biological function remains unclear. It is a skin *under* the body skin, yet nevertheless a delicate skin growing *on* the surface-tissue of the vaginal

channel. Even after being stretched or torn, small pieces of the membrane remain on the vaginal surface. However, in the body of an adult woman the hymen no longer grows. Rather, its material limits represent a functional shift in 'being a woman' against the background of ownership. Reodica describes her project as follows:

> *The hymNext Designer Hymen Project* is an installation that comments on modern sexuality, confronts the traditional roles of the female body, and presents a collection of synthesized hymens. The unisex hymens are sculpted with living materials and the artist's own body tissue into a variety of designs for application on the human body.[2]

The *hymNext Designer Hymen Project*[3] initially appears to consist merely of the *in vitro* breeding of hymens, which are grown from a mixture of fibroblasts from a man's foreskin (no more definite origin is given), smooth muscle cells from a rat aorta and the artist's own vaginal tissue cells. At first, the unisex hymen hybrids develop as a result of the use of biochemical stimulants. They grow on Petri dishes in artificial metal forms (reminiscent of the biscuit cutters used for baking Christmas biscuits) and on artificial matrices of bovine collagens. With the aid of a ceremony box, in which the 'finished' hymens are stored, the deflowering ceremony can be repeatedly performed as a ritual event. This means that a person can be deflowered and can deflower others – irrespective of gender – many times over. Alongside the gender aspect of this installation, which points to internal growth as the pure and virginal in women which someone (a man) could culturally appropriate, Reodica's designer hymens reflect a certain personalization through the use of one's own body tissue. They belong to the individual because a person can 'make'

2 Cf. http://www.vivolabs.org (accessed 7 December 2007).

3 Reodica's installation-happening was first shown on 8 April 2005 at *Living Sculptures*, Contemporary Arts Center, New York.

Julia Reodica, *The hymNext Designer Hymen Project*, 8 April 2005. Metal forms for the cultivation of artificial hymens and cell seeding on Day 1. Artist's body tissue, rat aortic smooth muscle cells, bovine cellular matrix, cell media. Courtesy of the artist

the hymen, and in using it can establish a boundary which one breaks through or allows to be broken through – or perhaps does not. People can mix their own tissue with that of other people or even with that of animals. Rat cells and human cells and bovine growing matrixes generate a flimsy, transparent membrane on a Petri dish which can be symbolically transplanted wherever one wishes. Men, too, here have the opportunity to ritually perform their deflowering. The living laboratory ('vivolab') is conceived of as the site of individual education, in which people continually externalize and internalize themselves, and not as a hidden stronghold of expert culture behind institutional walls.

Purification is a theme of this installation in a variety of ways. First, ritual innocence is stressed critically as a biographical purity that will be lost. Secondly, Reodica plays with the concept of sterile culture and of contamination in the laboratory, which must be prevented in order to ensure the growth of the hymen.4 Thirdly, a sociological interpretation of Reodica's project of replacement hymens can be made in the context of Bruno Latour's notion of purification. Because the modern era especially defines itself, according to Latour, by so-called purification processes, in which the notion of hybridity is *not* condoned but which instead promote segregation, hybrids are driven underground and are a burden to institutions.5 Purification is a process of denaturalization, which in turn promotes the homogenization of human, animal and vegetable entities (and the all-inclusive organism metaphor is an element in this homogenization). This suggests that people should be purified, healed and freed from that which leads to social inequality on the basis of a natural occurrence, for example, when people of particular ethnicities, whose noses or ears have grown 'differently', want to be surgically adapted to conform to a certain notion of 'human'. On the other hand, this process is at the same time a renaturalization of the body insofar as it is desirable that the technology that played a role in designing the body, and the fact that the homogenized nose is not a natural development, should remain imperceptible. 'Sameness' should appear 'natural'.6 Endogenous design, which transforms skin into a medium for artistic creation, leads to the fusion of denaturalization and renaturalization because that which has been artificially normalized still grows as the body matures.

BIOFACTS INSIDE AND OUTSIDE
THE LABORATORY

In the life sciences, trans-species production of biofacts and their implantation in other contexts is quite common. For example, 'purified' viruses are used as vectors in order to smuggle genetic information from an organism into a host and integrate it into the host's genome. Such a course of action is called a 'controlled infection'. The exogenous DNA thereby becomes endogenous, and the host's own cells grow in accordance with the once-foreign information, assuming that the infection has been placed properly, that is, integrated in a specific locus on the host's DNA. A recurring problem is that the gene-expression of the foreign DNA is only sustained in the short term rather than the long term by its 'own' DNA; nature often re-corrects the designer's corrections. Controlled infection takes place not only through the instrumental use of widely varying species components (viruses, bacteria, yeasts, plants, animals and humans), all of which must be bred and cultivated in the laboratory, but it also functions – more or less – across classes. Naturally occurring infections are consequently exploited for technical purposes. Thus, for example, tobacco mosaic viruses are used for the controlled infection of cultivated plants and influenza

4 Email communication from Julia Reodica with the author on 19 April 2006.

5 Cf. Bruno Latour, *We Have Never Been Modern* (Cambridge, MA/London: Harvard University Press, 1993).

6 See Peter Wehling, 'Social Inequalities beyond the Modern Nature–Society Divide? The Cases of Cosmetic Surgery and Predictive Genetic Testing', *Science, Technology & Innovation Studies* 1.1 (2005), 3–15.

viruses for the controlled infection of people, for example within the framework of an experimental gene therapy for lung diseases.

A growth type that is technologically modified in the laboratory and then released into society as if naturally occurring (e.g. transgenic plants) was first defined in 2001 as a *biofact*, initially within the framework of scientific theory and natural philosophy,[7] and without any reference to 'Bio Art'. This coining of a new term came about because of unremitting public resistance to agro-genetic engineering, which since the 1980s had been producing optimized plants in laboratories which, once released into the public sphere, no longer bear the marks of gene-technological manipulation. It is not merely the question of risk but precisely the invisibility and untraceability of genetically modified plants that stimulated political debate. Clearly, the differentiation between nature and technology is significant for praxis in the life world. Because the argument about the terms 'nature' and 'technology' was (and still is) carried out to some degree on ideological grounds, a newer term became necessary to account for the condition of 'inbetweenness'. At the same time, at the turn of the twenty-first century many were attempting to efface the terminological clarity of terms for mixtures such as chimera, bastard, hybrid and cyborg – which in the scientific community still exclusively referred either to animals (chimeras), plants (bastard, hybrid) or humans (cyborg) – for epistemological reasons. With biofacts, the borders between plants, animals and humans are terminologically removed because they have also been methodologically removed in the laboratory. Accordingly, the life sciences laboratory does not consist merely of the experiment room, with the character of a workshop, in which nature is analysed and reproduced, but rather of a variety of cultivation and reproduction rooms, from incubators to hothouses and media rooms in which growing things are stabilized and new growths are produced. Working with substances capable of growth is always provisional and remains dependent on the body and moist media (blood, plasma, gelatine, buffer solutions). Growth and its corresponding media belong to the typical 'malleability'[8] of living things scrutinized in the life sciences.

The term 'biofact' is supposed to occupy the terminological no-man's-land between concepts of nature and technology. The term refers to products that are necessarily at once finished *and* unfinished. This also includes the possibility of manipulated self-reproduction, currently in experimental stages within the laboratory, for example with the aid of purified endogenous retroviruses such as HIV, to which germ line cells may fall prey (or with which they may be artificially infected). Biofacts are natural-artificial hybrids which enter the world as the result of a deliberate procedure but which can, nevertheless, grow. However, while biofacts may grow, they no longer grow independently. Growth is taken here to be the epitome of the alliance between nature and life, which is why such living products always appear to be natural. In contrast to bionics, the interest in biofacts, with respect to the technical possibilities of design, is not in the final form *after* it has grown but rather in the possibility of this growth *before* it has taken place. Therefore the border layer, the skin, in biofacts is from the very beginning not only a medium but also a biotechnical means for a targeted growth. In biofacts, the prosthesis, which is always considered external, from the very beginning grows internally as well. In the words of Jean Baudrillard,

> if the prosthesis is commonly an artifact that supplements a failing organ, or the instrumental extension of a body,

7 Cf. Nicole C. Karafyllis, *Biologisch, Natürlich, Nachhaltig. Philosophische Aspekte des Naturzugangs im 21. Jahrhundert* (Tübingen/Basel: A. Francke, 2001), 189ff.

8 Karin Knorr-Cetina, *Epistemic Cultures* (Cambridge, MA/ London: Harvard University Press, 1999), 26.

then the DNA molecule, which contains all information relative to a body, is the prosthesis par excellence, the one that will allow for the indefinite extension of this body by the body itself – this body itself being nothing but an indefinite series of prostheses.[9]

Baudrillard's statement, however, does not encompass the subjective perception of the independent body situated within the wealth and limitations of personal experiences which are shared with others. Purified DNA is not information and it is not a body; rather it can, when situated correctly, become *informatio* in the true, that is phenomenal, sense of the word.

The various techniques of *endogenous design* are included in these conflict-laden perspectives. This collective term suggests such diverse approaches as regenerative medicine, nanotechnology, gene therapy and biostimulation. In this essay, I am going to concentrate on the models relevant for biomedicine. Biomedical models are based on the dialectic of oppositional concepts – on the one hand, inner and outer and, on the other, growth and movement. They cannot manage without a notion of complete, healthy and functional ideotypic *bodies*, in the broadest sense; however, they attempt to regulate their growth process to the point of functionality within society from the inside out and thereby to mask the fact that growth is an element of their structure. Both denaturalizations and renaturalizations are part of this process. Observed from outside, the bodies appear to develop naturally and thus to *be* 'natural'. Growth as a process suggests an inherent dynamic, although directed growth ensures from the beginning that technical control and the feedback loops of society and the body of the future are taken into consideration *a priori*. This trick, applied across the fields of science, of allowing living material to grow as

natural material, although it is considered technology and is cultivated for specific purposes, can be summarized with the keyword *biofacticity*. Biofacticity is found at various levels of 'life' and connects genetic engineering with social engineering, that is, the biological modelling of bodies with the technical modelling of society. Its most important characteristic is the levelling out of the difference between model and reality. The most important meta-subject in this area at present is the 'human' brain, although in neuroscience this always means a particular model human: rational, functional, young and male.[10] But since this perfect brain must also first be created and grow, the pre- and post-reproductive work and thus also partner choice and pregnancy (elements conceived as female) have recently received a great deal of attention in the neurosciences. 'Neurological' requires 'biological' (including blood and hormones) in order to come into existence, despite computer modelling of the brain as a network.

TRANSPLANTS: THE INTERNAL
IS TEMPORARILY EXTERNAL

Techniques for opening the body and the soul, which turn the natural inside-out, have been communicated via images since the Early Modern era, like those physiognomical patterns for interpreting surface structures. Since then, people have wanted to peer beneath the skin and thus into the internal workings of natural things, though originally they could not examine their own. In the twentieth century, the physiological sketches, woodcuts and copperplate engravings were supplemented by x-rays and ultrasound scans, among other technologies, which allowed people to see their own hearts, tumours and embryos. Nature beneath the skin is visible today via technology and thus made accessible in the external sphere. The objectification

9 Jean Baudrillard, *Simulacra and Simulation* [1981] (Ann Arbor, MI: University of Michigan Press, 1995), 98.

10 Nicole C. Karafyllis and Gotlind Ulshöfer (eds), *Sexualized Brains. Scientific Modeling of Emotional Intelligence from a Cultural Perspective* (Cambridge, MA: MIT Press, 2008 in press).

of the body's interior has meanwhile reached the personal sphere, but it always operates with normalizations of organs and dispositions that bear the epistemic trace of objective history and thus the history of others and the external. Interiors that can be seen and be recognized as one's own must have once been the other, exterior. The body is the most important mediating concept between inner and outer, and where it no longer exists or does not yet exist, natural and cultural reflection on its relation to the world is difficult. It is remarkable that literature in the philosophy, history and sociology of science – critical of the idea of scientific progress – has focused primarily on supposedly natural bodies or corpuscles (cells) and their technical analogies with machines. Within the framework of cybernetics and with regard to the control and regulation of living beings, organic and machine metaphors have become obligatory.[11] However, the use of machine metaphors to describe the body dates back earlier than the Early Modern era, and can be found in Aristotle and his theory of the *organon*, which can be translated as 'tool'. A perspective that is often forgotten in all this, however, is that of the *vegetal*, which has always accompanied the machine discourse.[12] This refers to both the pre- and post-bodily defining characteristics of humans. These include the substantial capacity of instinct and of assimilation, which show themselves in the creation and passing away of 'life' and which have their indefinable interior in the modern psyche. The Freudian *Trieb* (literally 'shoot' but often translated as 'drive') grows 'there' independently, without knowing its particular place, its beginning or its purpose.

In *De anima (On the soul)* Aristotle describes the soul of plants (*anima vegetativa*) as the lowest and essential stage of an ontology of life which can strive beyond the animal stage – the physical stage and the stage of perception – to the stage that is actually human: reason. With the introduction of the modern term 'mind', the soul is finally cleansed of vegetable drive metaphors and denaturalized. Simultaneously, however, it is also biologized, since through 'life', plants, animals and humans are connected as a special nature. Across cultures, life begins with plants, and as a result of this metaphysical view of life every living thing is at the start vegetal. For Aristotle, due to their lack of perception, plants were not considered *living beings* (Greek *zoa*) but rather *living things* (Greek *zonta*) (*De anima* II 2.413b) which conceptually united *nature* (Greek *physis*) with the growth and passing of life in particular *forms* (Greek *morphe*). Since then the autonomous and transgressive vegetal has been the epitome of nature, opposed to technology and instrumental agency. Aristotle's conception of nature and technology is still central for the modern Western world, and the idea of a vegetal beginning is even older than Aristotle's philosophy. In Homer's *Odyssey*, Odysseus digs for the hidden roots of an all-powerful plant, for its *physis*, in order to protect himself against being transformed into a pig by Circe.

At first glance, Aristotle's theory that whatever grows 'from itself' is natural and that whatever is set in motion 'from outside' is technological appears to be suitable for the everyday world without qualification. His technomorphic model of the body as a house and its regulated functions as the household (Greek *oikos*) is similarly convincing. A body is run according to material and formal aspects, similar to the activity of a technician, who for Aristotle is simultaneously both an architect and a craftsman, that is, he plans and builds an object for a particular purpose. In his *Physica (Physics)*, however, Aristotle replaces the concept of growing-from-itself with that of self-motion, which had a momentous impact on the West. Precisely because the *Physica* has historically been one of the most

11 Cf. most recently Barbara Orland (ed.), *Artifizielle Körper – lebendige Technik. Technische Modellierungen des Körpers in historischer Perspektive* (Zurich: Chronos, 2005).

12 This is thoroughly explained in Nicole C. Karafyllis, *Die Phänomenologie des Wachstums. Zur Philosophie des produktiven Lebens zwischen Natur und Technik* (Bielefeld: transcript, 2008 forthcoming).

widely received and critically examined books in the Aristotelian canon, this conception of a self-organization of the natural qua controlled movement has persisted over the centuries. However, in Aristotle's biological writings (especially *De anima, De generatione animalium* and *Historia animalium*), and there primarily with regard to the consideration of embryology, the technician is not an architect of the living but rather a gardener and cook: through planting and incubation, with the help of a mixed substance containing the soul, he develops the form of something which must first become a body.[13] 'Inner' and 'outer', with strict boundaries, do not yet exist, but there are indeed inherently dynamic media such as blood, flesh and soul which one has to know how to mix in the right way at a particular natural location. This mixture yields a milieu from which something emerges. In the hierarchy of nature in the ancient world, this mixture creates the plant soul, which in animal and human bodies is still located in the stomach. There the plant soul is responsible for nutrition, growth and reproduction. In medical history, the tissue of the liver, the uterus and the skin fall under its influence, since these tissues could renew themselves for the entire life of the being.

It is precisely this vegetal capacity that is now required in the laboratory for the production of bodies, and that brings together epistemic approaches to a functional design of the living. Techniques for seeding and transplantation as well as procreation are included here, techniques which always relate to a preconceived notion of completed growth. The typology of biofactual phenomena therefore also includes areas beyond biology, such as imitation, automation, simulation and fusion, which initially determine particular forms in nature and make them imaginable. The design of biofacts is not really endogenous since the origin, when technologically modelled, is no longer hidden in an imaginary interior.

Art that appropriates tissue engineering as a means for its creative purposes explicitly plays with this dialectical potential. Thus, Oron Catts and Ionat Zurr from the Tissue Culture & Art Project, in *Disembodied Cuisine*,[14] speak explicitly of 'seeding' their cells in (or on) their biodegradable polymer-framed sculptures:

> This is an exciting moment – that's the seeding. It's like being a farmer seeding his field. Farming is also a human construct – it is only a difference in complexity, we are creating something that could not exist in nature. These parts of animals were living happily as part of a muscle of a frog. We are now providing a new body for those cells to grow into.[15]

What is categorically new here, then, is the notion that the internal is not merely the opposite of the external, but rather a preliminary stage of an interiority that must still be achieved, that is to be made visible and that can be influenced. 'Nature', then, is no longer the other of 'technology' but its earlier *and* later stage, when reading 'technology' from a historical-biographical perspective, as Gilbert Simondon, for example, suggested.[16] The achievement of an 'artificial naturalness' is, on the other hand, the result of an abstract, prototypical modelling of natural design potentials (of a 'natural artificiality'), for example genes or totipotent cells. Thus, the interior of the individual's own body is less the focus of the concept of biofact than the individual(ity) of the interior. For while the interior of an individual is accorded concrete form through graphic representation, a biofact, as a kind of dialectical negation of visualization, provides no real image for recognizing the living but rather malleable material with its own inherent dynamic and open form.

13 One of the places in which the technician of the living acts as a cook is *De generatione animalium* II 6.743a 26ff.

14 *Disembodied Cuisine* was produced in conjunction with the *L'Art Biotech* exhibition in Nantes as a performative installation whose theme was 'meat production without victimization'. The Tissue Culture & Art Project cultivated tissue to create a pseudo-positivistic junk-food alternative to massive factory farming. Edible 'semi-living sculptures' were cultivated from isolated muscle cells from frogs on biodegradable polymer scaffolds in bio-reactors. See Oron Catts, Ionat Zurr and Guy Ben-Ary, 'Que/qui sont les êtres semi-vivants créés par TC&A?', in Jens Hauser (ed.), *L'Art Biotech* (Nantes/Trézélan: Le Lieu Unique/Editions Filigranes, 2003), 20–32.

15 Quoted from *Pictures at an Exhibition: Disembodied Cuisine by the Tissue Culture & Art Project*, a video by Jens Hauser (Paris, 2004).

16 Gilbert Simondon, *Du mode d'existence des objets techniques* (Paris: Aubier, 1958).

The amorphous nature of becoming shifts into technical focus as homogenate or matrix, like a brown layer of humus, without itself being able to provide an image of growth still under way. Mediating models and their images, like that of the network, are thus necessary for the design process. In the language of endogenous design, 'technology' starts conceptually with 'interior' and allows something to grow, through which the term nature appears to become obsolete owing to a quasi-natural design. As a result of developments in tissue engineering and stem cell research, 'semi-living' models of something that does not yet have a body but could have one and, if the occasion arises, should have one, are increasingly at issue. This is also a central idea in art concerned with biotechnologies, such as the diform organic doll-size garments of *Victimless Leather*[17] by the Tissue Culture & Art Project, or Orlan's *Harlequin Coat*,[18] a prototype of a biotechnological coat containing skin cells of various origins bred *in vitro*.

Skin, membranes and tissue become substances with which something can be designed. Skin is no longer the medium and border of bodies and individuals but rather an imagistic vehicle for designers that should grow either internally or externally – although it is unclear how such spatially assigned borders become plausible. Tissue can be implanted, replanted or bedded out, respectively, depending on the purpose it is intended to fulfil. It should, therefore, be open and yet not transgressive and still locate its border of interiority. How this process of appropriation, which is not a classic integration process, can take place and by whom it will be carried out remains questionable in view of the biotechnical and IT possibilities. Precisely because with biofacts the trace of technical production is lost through growth, doubt is sewn outside the laboratory about just what it is that has grown. In any case this process must be recognized by a self in order to belong to it bodily

– and that also means biographically – and it is precisely here that problems arise through the objectifications of third parties. Plants and tissues, in the literal sense of 'network', constitute cross-disciplinary metaphors for such processes, which upset the classic subject–object dichotomy.

Why is the phenomenon of growth of such central importance? In scientific theory growth is almost exclusively modelled as movement ('interaction', 'self-organization') and quantity, while the general public is still familiar with growth as potential regeneration and quality. Between these two conceptual poles so-called blind spots emerge in relation to technologies of the natural, and their mediality. These blind spots will become clear in the example of the concept of a *network*, which terminologically belongs to the metaphorical field of tissue. The metaphor of the textile network as unfinished tissue has always gone hand-in-hand conceptually with the anatomy of adult bodies and functional organs.[19]

TISSUE AND NETWORKS

Only following the modelling of neural networks by brain researchers, who on the one hand speak of the brain's plasticity (i.e. of its principle of openness to the world) and on the other hand of its endogenous design (i.e. of the principle that it can be technologized), have the humanities in the twenty-first century come to understand that even the spirit requires fluid media and – in the words of William James – is not purified 'mind stuff'[20] but rather a part of the subjectively experienced body. These media have their own historicity of having been grown and are physically existent. In contrast to construction, design can only become effective technical activity when the starting material, as well as the end product, are understood as merely temporary. In anticipation of a technological term

17 http://www.tca.uwa.edu.au/vl/vl.html (accessed 3 November 2007).

18 In BEAP, *Stillness* (Biennale of Electronic Arts Perth, 2007), 44.

19 Thus, for example, the textile metaphor 'needlework' used by Nehemiah Grew, a plant anatomist, at the end of the seventeenth century, and the naturalist Charles Bonnet in the early eighteenth century, who imagined body tissue as weaved by looms. Cf. Nehemiah Grew, *The Anatomy of Plants* (London: The Royal Society, 1682); Charles Bonnet, *Philosophische Prinzipien* [1754], ed. and trans. Tobias Cheung, *Charles Bonnets Systemtheorie und Philosophie organisierter Körper* (Frankfurt am Main: Harri Deutsch, 2005).

20 William James, 'What is an Emotion?', *Mind* 9 (1884), 188–205.

oriented upon design and modelling, the neo-Kantian Ernst Cassirer spoke as early as 1930 of the 'plasticity' of formed nature as its 'inner flexibility', the reforming of which is the task of culture.21 The project to apparently overcome bloody and muddy nature marches straight through the life sciences, which are, primarily, technological sciences including mathematics and computer science. In the Early Modern era the boundary of growth, which was understood as the border layer *upon* which growth was perceived, was reconceived as an abstract, moveable point in a Cartesian coordinate system. Growing entities became – by means of the mathematical ability to represent something using points – 'pointilistic things' with apparently fixed bodily boundaries at particular points in time. Foucault's *The Order of Things* and Latour's *Parliament of Things* could, in an approach to growth in the modern era critical of ideology, be expanded to include a *pointilism of things*.22

This becomes particularly clear in the network modelling of growth, which is fundamental, for example, for protein modelling in proteomics. The proteome, as an accumulation of molecules containing protein which derive from a specific genome, provides the three-dimensional type case for the body in biomedicine that, nevertheless, like the genome, remains interactive and continually reorganizes itself. Network modelling achieves the epistemological step from DNA as a text structure for the genome23 to the proteome as a three-dimensional body structure of a synthetic conception of 'life'. With the aid of this model, it becomes possible to visualize what can become of genetic structure. Here we come across a second blind spot in biofacticity, because 'becoming' is understood in this modelling as exclusively functional: only a protein that makes it possible to conceive of a function for the entire organism can be calculated in the model. The term 'ability' also remains an open question in the modelling of something

that 'can become' something. Do abilities grow, so to speak, naturally and are they thus, on the basis of their capacity, endogenous or can abilities be supplied from outside, technologically? To answer this question, a more detailed examination of current network modelling is necessary. In bioscientific attempts to discover the endogenous potential of living beings, genetics provides a heuristic for establishing structures that are capable in the broadest sense, and that can become specific capacities with the aid of technology. For this, they must be controllable in the laboratory. Since the recent successful total sequencing of the genome of the thale cress (Arabidopsis *thaliana*), yeast (Saccharomyces *spec.*), the roundworm (Caenorhabditis *elegans*), the fruit fly (Drosophila *melanogaster*) and, as of 2001, human beings (Homo *sapiens*), proteomics has focused on the systematic examination of a gene's products (proteins). Practitioners view proteomics as functional genome research in which primarily bioinformaticians collect so-called expression data and create interactive networks (protein–protein interaction networks) on the basis of *random scale-free network* modelling.24 'Interaction' is one of the important keywords in the creation of a network, because the proteome functions in the discovered structures of the genome are what is sought. The model term that mediates between the genome and the proteome is the *interactome*, and it models growth, along bioinformatic lines, as the movement of data. With such methods it becomes clear that speaking of *converging technologies* from biotechnology, information technology and nanotechnology is to some extent justified. For this reason biofacts can also not be assigned strictly to the field of biotechnology; rather, they first pass through certain typologies of technical formation which lie beyond biology. In the process, the types of biofactual effects discovered (imitation, automation, simulation and fusion) are put to use in the production of a functional interaction

21 Ernst Cassirer, 'Form und Technik' [1930], in Ernst Cassirer (ed.), *Symbol, Technik, Sprache* (Hamburg: Meiner, 2nd edn 1995), 39–91, here p. 60.

22 Michel Foucault, *The Order of Things. An Archaeology of the Human Sciences* [1966] (New York: Pantheon Books, 1970); Bruno Latour, *Das Parlament der Dinge* (Frankfurt am Main: Suhrkamp, 2001) (German translation of Bruno Latour, *Politiques de la nature. Comment faire entrer les sciences en démocratie* [Paris: La Découverte, 1999]).

23 Lily E. Kay, *Who Wrote The Book Of Life?* (Stanford, CA: Stanford University Press, 2000).

24 Cf. Evelyn Fox Keller, 'Revisiting "Scale-free" Networks', *BioEssays* 27 (2005), 1060–68.

network, as can be seen in the statement below from proteome researchers Ulrich Stelzl and Erich Wanker:

> The goal of functional genome research is to enter all possible interactions which could take place in a cell – called an 'interactome' – on a map and with this masterplan of the cell to explain the function of uncharacteristic human proteins. With the yeast-two-hybrid procedure protein networks for the roundworm and the fruit fly were initially constructed. Since that time, with robot-supported yeast-two-hybrid projects, we have also managed to construct the first comprehensive protein network for the human organism [...] The network maps are a valuable source of information for further studies. They are the reason that a so-called wiring diagram for our body can now be constructed.[25]

The corresponding network map of an interactome is shown below.

Stelzl and Wanker refer to the pioneer of random scale-free networks, Albert-László Barabási, who along with his colleagues first published the idea that there are scale-free and thus 'teleologically' open networks which follow a power law distribution.[26] He developed his conceptual model based on the distribution of hyperlinks (understood as connections of so-called 'hubs') in the world wide web. What was initially a loose comparison between body and network has since become a basis for the rapidly increasing popularity of the model. The random scale-free network model emerged at the same time as the publication of volumes of data about the human genome without knowledge of the genome's function in or regulation of the whole. Shortly after the publication of the work of Barabási

The network of a human interactome. It represents 3186 protein–protein interactions based on 1705 proteins. Proteins are shown as coloured circles (orange: illness proteins; yellow: unknown proteins; grey: known proteins), and interactions between proteins are shown as lines. Red lines depict interactions with a high level of confidence, which means that there is a good deal of experimental and theoretical evidence to suggest that the interactions fulfil a biological function. Blue or green lines represent interactions with middle or low levels of confidence.
Courtesy of Professor Ulrich Stelzl of the Max Delbrück Centrum in Berlin.

25 Ulrich Stelzl and Erich Wanker, ' Proteinwechselwirkungsnetzwerke: Aufklärung der Funktion von Proteinen', *Biologie in unserer Zeit* 36.1 (2006), 12–13.

26 Reka Albert, Hawoong Jeong and Albert-László Barabási, 'Diameter of the World Wide Web', *Nature* 401 (1999), 130–31.

and his colleagues, cancer researchers Bert Vogelstein, David Lane and Arnold J. Levine described the modelling of tumour supressor gene p53 as follows:

> One way to understand the p53 network is to compare it to the Internet. The cell, like the Internet, appears to be a 'scale-free network': a small subset of proteins are highly connected (linked) and control the activity of a large number of other proteins, whereas most proteins interact with only a few others. The proteins in this network serve as the 'nodes', and the most highly connected nodes are 'hubs'.27

The cells were thus visually determined as scale-free networks and yet mathematically interpretable as open. The network does not have, for example, a given architecture, but is understood by means of the power law distribution as generative, that is, as self-generating. Thus, 'life' can be modelled as an interaction network of cells. In order to problematize the obvious assumption that in this modelling we are dealing with nature and its own apparent growth potential, which is now allegedly known, the following points should be borne in mind:

• Scale-free networks work with stochastic models, that is, with *probabilities* from which *potentials* are derived. With reference to the important differentiation between possibility and potential, in networks it is a question of a *representation of possibility* which is nevertheless weighed. In the process of weighing, a confidence value and thus also a potential for an endogenous ability become initially understandable and move into the sphere of biomedical control. The internal is shifted to the external because it can only be represented as an external. Hence, the idea of interiority of self-starting is lost.

• The question of how a hub 'approaches' another, that is, how an interaction is initiated, remains open. The growth problematic remains hidden behind this ability to create relations: simultaneously to be oneself while also being able to become another.

• Body and network topologies use different referential presuppositions: the comprehensive border (as skin or membrane) with body topologies, the structuring nodes ('hubs') with networks. The constitution of the border itself cannot be modelled and thus the step from network to body remains a blind spot which still symbolically assures the vegetal ability to take root and assimilate as a distinct residue of nature.

• The matching with *wet ware*, that is, with the biological system for monitoring the function, remains necessary. The so-called yeast-two-hybrid experiments perform this function.

Yeast serves as the simplest model organism for eukaryotic cells and thus for human cells as well. With respect to the yeast-two-hybrid technology as the final link in the chain of modelling, the following points, mentioned by Stelzl and Wanker in an aside, are important here: with the help of this technology, it 'is then possible, by means of *growth tests on specific nutrient media*, to prove the interactions of proteins and make them real'.28 Only growth generates the evidence that there is life. Indeed it is through this growth that what 'comes out' of a gene is exactly the functionality that was expected of it in the network model.

The blind spot of this modelling is the apparently technical appropriation of the self-beginning potential. Biotechnologies make available, through the concepts of *genes* and the *totipotence* of cells (typical of all plant cells and a few animal and human cells, such as stem cells), materialized beginnings, including productive potentials

27 Bert Vogelstein, David Lane and Arnold J. Levine, 'Surfing the p53 Network', *Nature* 408 (2000), 307–10, cited in Keller, 'Revisiting "Scale-free" Networks', 1060.

28 Cf. Stelzl and Wanker, 'Protein-wechselwirkungsnetzwerke', 12, my emphasis.

which, however, must be excorporated to be appropriated. In endogenous design the models of molecular biology and genetics and the cultivation techniques of tissues are paradigmatic in the formulation of hypotheses. The appropriation of cells and tissues takes place between donors and recipients of transplants through the mediation of third parties, the scientists who have a good command of the methods of excorporation and incorporation, as well as interim storage, breeding and controlled growth. The most important method is *planting as explantation*, transplantation and implantation, which in previous medical terminology was called 'implant healing'. A potential growth introduced into a body can lead to endogenous processes there – where the endogeneity then refers to the receiving space. Endogenous design, today, does not merely serve the purposes of classical healing but the precautionary improvement and future enhancement of patients as well. The acquisition of functions and their maintenance are the normative suppositions of endogenous design, and they are already inscribed in the network model of the functioning of the as-yet bodiless. The modelling of living beings is not possible without growth and nutrient media, if their construed realities are to become real. And in order for something living to become patently evident, experience in the life world with living beings is necessary so that it can be 'recognized' as such.

HYBRIDITY REVISITED

It is important to point out the scientific, theoretical and anthropological content of these border layers which in design no longer serve as a border and thus defy familiar classifications. With regard to the concept of humans as hybrid beings, humans since antiquity have been defined as an anthropological mixture of nature and *techne*. They are part of the natural order of things, its forms and materialities; however, as a result of human cultural achievements, they represent the other of this order as well. Bruno Latour has pointed out that attempts at purification through separating nature and culture in the modern world are destined to fail. This is not least because the phenomenon of growth is no longer the exclusive preserve of nature since, with the aid of biotechnology, we can make things grow as we want them to. Nonetheless, there remains a last, invisible potential in nature, in which lies the justification that we *can* do that. Human beings are necessarily then not the 'absolute other' of nature, as references to interface technologies for purely informative purposes suggest. So, *sk-interfaces* retain their own productive force and mediality which first of all must be *there* before they can be used for modelling. It is not produced or built; it is first of all perceived.

Hybridity describes a twin structure with an inherent ambivalence which is typical for human life. It is formed of the dichotomies of nature and technology, growth and action, subject and object, inner and outer as well as knowledge and experience. Interpretive conflicts arise chiefly when these anthropological hybrid constellations have to be brought into agreement with biotechnological models of 'life'. In order to achieve a complete harmonization, the phenomenon of growth must be disregarded. Through this suppression and the idea of a living product which is already finished from the very beginning, the bioscientific model becomes an apparent reality. Such efforts towards an anthropological mixture of at least two ways of being nevertheless require, among other things, empirically established, socially negotiable points of orientation for that which can be reasonably understood today by 'nature' and 'technology'. We can strengthen the phenomenon of growth, despite biofactual modelling, as movement, quantity and 'creation probability' with the

appropriated as a means; but mediality as that which takes on and transforms cannot be synthesized. This *ability to become* remains in the province of nature. This will become forcefully clear with a particular cultural technology that provides for cultures themselves: transplantation. Derived from the Latin *colere*, 'doing agriculture', sowing, precultivation and transplantation were always dependent upon an inherently dynamic moment of taking root. Only where plants could take root and be cultivated could people also settle.

We have already become familiar with the numerous indications of the genuine vegetal capacities of tissues, for example, the terms sowing, transplantation as well as deflowering. Art that deals concretely with biological systems can call attention to the eradication of borders between bodies and tissues and the appropriation of 'internal' media as 'external', designable means. In so doing the phenomenon of growth becomes a performative medium in order to dramatize the crossings of borders between the living spaces of subjects and objects. Through this, the gap between elitist, biomedical-technological scientific experience and the supposed egalitarian everyday experience of 'life' itself can be problematized. Not everyone can gain access to spaces of knowledge in order make meaning for one's own life out of media. Our living rooms are not – yet – laboratories. Through the transgressive characteristics of the vegetal in private 'interiors', Julia Reodica plays repeatedly with the phenomenon of growth as a supposed guarantor of external nature. In the installation project *Chlorophilia*29 she and Denise King exhibit the *Lawn Chair* in a living room installation.

Reodica calls attention to human hybridity, especially visible in humans' 'love' of plants: our adoration as well as our design of their lives. The art project stresses

help of coordinate systems and networks as a qualitative differential marker between nature and technology. For nature is that which can grow in a self-determined location, and it is absolutely necessary for transplantation not only as material but also the medium for taking root in a place. The mediality of tissue growth can indeed be

Julia Reodica and Denise King, *Lawn Chair*, 10 April 2002 (sitting: Katherina Audley). Wheat grass, fabric, metal, wood. Courtesy of the artists

29 At Exploratorium, Art & Science Museum, 10 April 2002, San Francisco (CA), curated by Philip Ross.

the consciousness of humans being dependent upon reproductive and assimilable means of life in the broadest sense. In this *Lawn Chair* covered with growing grass on a medium suffused with nutritional fluid, external living space is brought inside and is depicted as growing. The covering of the lamp with a vegetal material that shrouds the light also emphasizes the reversal of interiority and exteriority, of natural and social orders. It is not the plants that need light here to grow but human beings who need it to read, that is, for their cultural technology. One sits in a 'growing chair' and in a 'living room' embedded in a natural surface that continually expands its own borders. Reodica and King emphasize the historical settledness of people through the act of planting as well as the potential danger of manipulation, as expressed in the term 'unsettling' in the installation description which is antithetical to settling and early agriculture. The history of constituting objects thus becomes natural and cultural history and vice versa: natural and cultural history appear in the history of objects. As a result, the tension between subject and object, between observer and 'nature', will be dissolved in a practical, day-to-day perspective. Viewers, even when in terms of their own lives they more strongly position themselves as either a natural being or technology user, cannot escape the historicity of their own, diachronous *experience with nature*. This includes a thoroughly normative moment which refers to nature's own time and its reliance on processes which cannot be entirely appropriated through technology.

'Bio Artists' and bioscientists share a core experience: waiting for growth. It takes a relatively long time for cells and tissues to grow sufficiently that they can be used as media and means. The phenomenon of growth, in its slowness, mediates between subject and object because it *makes present* the time both share with one another

synchronously. In biotechnical laboratories, scientists employ methods analogous to agrarian practice, though under sterile conditions: seeds are sown, they are injected in nutrient-rich soils to ensure strong growth, scientists produce mixed forms like bastards and chimeras, that is, they fuse and transplant that which possesses the inherent ability to self-start. Particularly in the medical field, in the field of organ and tissue transplantation, it is clear how often root-taking does not occur and that the location experts select for rooting functions only temporarily. Rejections take place only after a certain period of time and demonstrate that a superficial root-taking does not necessarily lead to integration into a space (e.g. a body or a landscape), that is, to rootedness.

The hybridity and the biofacticity of an organism do not therefore mean the same thing. Hybridity is an ontological and anthropological term, while biofacticity is an epistemological term. The terms hybrid and biofact each describe the perspective of a relationship to oneself and to others, both of which remain reflexively related to each other. The biofact provides evidence of a technical intervention in the laboratory as well as of the growth of a body outside the laboratory. However, the intervention belongs to the others, while growth belongs to oneself. Biofacts arise of necessity through foreign designs. In contrast, hybridity suggests self-design without the laboratory perspective, that is, that which a person who exists 'freely' can be. This includes rather than excludes human rootedness.[30] By means of the root as the imaginary beginning of everything, the growing object could remain the same and nevertheless become something else. In the modern concept of the subject, this semantic of rootedness has been retained primarily in psychology with its plant metaphors such as 'drive' (*Trieb*) and 'internal growth', despite all the machine metaphors. Humans can move

30 Simone Weil, *L'Enracinement*
(Paris: Gallimard, 1949).

about to different locations and walk through areas, but they remain biographically connected to their own beginning. Age (childhood, youth, adulthood, old age), biography and homeland are corresponding concepts of a historico-genetic self-referentiality which function to foster the subject's identity, especially in the age of mobility. Its vanishing point is a person's own birth as an uncaused beginning of becoming oneself – a long-neglected counterpoint which Hannah Arendt, with the term 'natality', put in opposition to the dominance of mortality in Western philosophy.[31]

However, embryo growth before implantation in a natural (or, perhaps in the future, an artificial) uterus is – because of the preimplantation diagnostic – no longer free from control and regulation with reference to a desirable 'growth' that is supposed to come into the world. What does this biologicalization of the psyche mean for the developing subject? How will our openness to the world change if in the future we view ourselves as explicitly constructed by other people? By 'explicit' I mean that there are specific characteristics, scanned and designed in advance, which ultimately account for a person's birth. The question to be posed – with Jürgen Habermas[32] – to modern philosophy and sociology, therefore, is whether or not autonomy as the freedom to think and act is based upon one's own beginning as an existing growth, which has thus far always been considered secure and has therefore been neglected by philosophy. For is it possibly a part of our genus identity as humans that we cannot 'construct' ourselves through biotechnology? On the other hand, when people breed other people through biotechnology, what then remains characteristic of human-beingness – 'the life' of the 'body' in human form? However, not everything in the laboratory grows according to expectation. The refusal of growth always to take place according to expectation demonstrates

that growth is one of the conditions of possibility for organisms and binds the term nature to the term life in the laboratory. Endogenous design is, therefore, a dialectical concept of growth and action within closed spaces which have to open themselves in order to be experienced.

Art has dealt with this problematic,[33] while scientific and technological research has largely ignored it.[34] The latter has focused in the field of biotechnology for the most part on ethical implications which are then examined under the keyword 'bioethics'. That which can be considered 'bio' is, thereby, by means of an epistemology oriented on classical physics and mechanics, itself theoretically in the grip of dissolution. There is a concentration on particles and their self-organization. Moreover the idea of life is only meaningful in the day-to-day world. The self-design of human-beingness, that which humans as 'humans' can be (their hybridity), collides with the foreign design of living nature-as-such (with biofacticity), understood as that which can be 'made' with nature. In hybrid thinking, nature and technology remain necessary as concepts. This necessity exists also for the conception of biofacts. Biofacts are second-order hybrids because the technical setting cannot necessarily provide contact with 'another' growing self. The established border may in fact be *real* but not *actual* because, in order for it to be actual, it must be possible to experience a border beyond the laboratory.

With biofacts, exclusive *knowledge* of the technical intervention provides access to the visibility of the phenomenon. For all those not in-the-know, this trace is lost. The technologizing of nature began a long time ago; hence, the oft-deployed argument that technicians working on molecules and cells are only carrying on the tradition of agriculture and of grafting varieties of fruit appears at first plausible. What is new, however, is that the trace of construction is lost because it takes place in particular

31 Hannah Arendt, *The Human Condition* (Chicago: University of Chicago Press, 1958).

32 Jürgen Habermas, *Die Zukunft der menschlichen Natur* (Frankfurt am Main: Suhrkamp, 2001).

33 Cf. Jens Hauser (ed.), *L'Art Biotech* (Nantes/Trézélan: Le Lieu Unique/Editions Filigranes, 2003); Eduardo Kac (ed.), *Signs of Life. Bio Art and Beyond* (Cambridge, MA: MIT Press, 2007); Ingeborg Reichle, *Kunst aus dem Labor* (Berlin/Vienna/New York: Springer, 2005).

34 Cf. on endogenous design and nanotechnology, Olaf Arndt, 'BBM. Endogenes Design. Anmerkungen zu einigen Bezügen des Projektes "Nanobots" von BBM', in Elke Bippus and Andrea Sick (eds), *Industrialisierung<> Technologisierung von Kunst und Wissenschaft* (Bielefeld: transcript, 2005), 112–23.

rooms which are not shared with the day-to-day world. While biological growth cannot be replaced, it can be so strongly provoked that only the abstract starting point of root-taking as an automatic element of nature remains. Taking root guarantees the ability to begin. Growth is always *present at hand* in the conception of nature and constitutes *the* medium of life. It becomes a means when it is available, *ready at hand*. Since the formation of agrarian societies, growth has been available as a means within determinate boundaries. Through biotechnical influence, growth becomes chronologically ever earlier a means and spatially ever more central. We are speaking here, too, of a higher level of invasiveness in the body. However, a space is assumed here which still has to be created. For the subject, who undergoes growth as a 'unity of becoming', it remains to ask whether it experiences that growth as a medium of its own life, that is, with its own bodily experience and possibilities to develop itself. Only then will it become an individual. Or perhaps the subject from the very beginning conceives of itself as endogenously designed, as a growing construct that externalizes the goals of third parties. It would then appear as one clone among many, even if it is not cloned in the biotechnological sense. If doubt is created about life-world phenomena through an overdose of scientific information and an enlightened attitude of expectant modern subjects is nourished, what remains instead of a fascination for the endogenous design of growing 'external' objects is the dialectical opposite: the retreat of the subject into the interior as regression and depression.

A different version of this article is to be published in German in Elke Gaugele and Petra Eisele (eds), *TechnoNaturen* (Vienna: Schlebruegge Editor, forthcoming). I would like to thank Jens Hauser for valuable comments on an earlier version of this essay, and Staci von Boeckmann and Stephen L. Starck who took care of the translation.

Fitter, Better, Stronger, Faster

John A. Hunt

Providing materials that will function as an alternative or adjunct to human skin is one of many significant medical and scientific issues coming to the fore as we progress as a species that lives faster, fuller and longer lives. Average life expectancy increases with each generation and although the numerous potential impacts of this point are much debated, the economic disarray and panic concerning pensions and financial projections seems to point to a future with a significantly increased aged if not retired population. If it only came down to economics this detail could be accepted and accounted for financially; however, as we successfully tackle the major fatal diseases, sustain life after major injury and provide more successful treatments for cancers and genetic disorders, we create a new pressing set of issues. Inherent in the animal in all of us is the drive to live for as long possible in the 'best' possible way. The multifaceted complications of life and living come to the fore in many guises; faced with the dilemma of switching off the life support machine for someone, a family is brutally confronted with the issue of life and what's best. Parents wish to provide the best opportunities for their offspring and as individuals we constantly strive to do our best. Death is not an option and is a very unsatisfactory end point for a species that can achieve anything and everything. A slow painful deterioration towards the inevitable would, if we were presented with choices from a healthy perspective, perhaps nudge most towards a brave-hearted exit, to live life to the full to the last day and then pass quickly. It is conceivable (and it can be modelled) that the medical landscape and life expectancy scenarios may force our species to the point where there will have to be a defined end of the road, wherein the date of death will be on the line below the date of birth, and our maximum shelf life or organic lifetime will be clearly defined. With the current critical breakthroughs in science being centred around biological sciences and medical technology these are exciting times, and our knowledge base grows exponentially, providing direct and indirect benefits to the continuation and creation of life – albeit we should consider the potential end point scenarios and plan for our success. Future successes will raise difficult societal issues that will require resolution, but on a daily basis and within the current generations facing these issues, we strive to provide each individual with the opportunity to live a fulfilled and independent life. The coming together of science, engineering and medicine is history, the potential for future successes is tremendous, and the way in which this potential is realized will need to be addressed by society sooner rather than later.

Medicine is increasingly required to maintain form and function after sustaining life itself during and following disease or trauma. Life can be successfully maintained with increasing efficiency, and individually within our own social scenes, and globally as a species, we should rightly be delighted about this. This does, however, create another set of issues pertaining to a patient's fundamental heartfelt desires to return to the way life was before. Often bandied around with impunity and budgeted for in medical health as *quality of life units*, the scientific potential to improve the quality of life rather than merely to sustain life becomes increasingly an economic issue and clashes with the human being in most. In between the times of sickness or injury, life is taken for granted and the living get on with it. In evolutionary terms, as just one of many life forms we should rightly take life for granted; it would be inefficient not to, and surely we should spend our time and energies on the fundamentals for all species: survival and reproduction. At what point will we transcend our origins? Have we already? Is the species already established on different evolutionary pathways that direct us away from solely furthering the species to the next generation? What cost the price of health when you don't have it? The answer is placed firmly in the hands of the healthy. The stark evidence weighs in favour of us having transcended our organic animal origins. In the future life will be mapped genomically and proteomically,

modelled mathematically and predicated financially, ultimately timed to end and the potential for its taking its own course seriously challenged. Hang onto the last point, because organic life won't accommodate this level of control. It fundamentally contradicts evolution and the stage is set for many an unseen turn of events.

Skin, much like the rest of the rich tapestry of life, is a complex subject. The skin we are in is unique to everyone; fundamentally it is required for life, it is remodelled every day and we could say is finally richly sculptured by life by the end of our days. Much can be interpreted about a person from their skin – occupation, origins, age and recent vacation destinations, not to mention lifestyle can be deduced from a brief handshake. Skin provides the body with an interface for interaction with the outside world. The outside world interrogates its every aspect, within the species and across into other species. It provides a significant component of visual and tactile interaction and communication. Unseen by us it provides a significant point of interest for the much smaller world of micro-organisms, the invisible ever-present enemies of our species. We are ideally suited for other species to live in and on; our precious skin provides the barrier to keep these enemies out. Perfectly intact it provides an excellent barrier function and facilitates our every mammalian desire, and allows us to extend our range beyond normal physiological limits. Using its high turnover rate and healing potential we push our boundaries by sending our skin out there to interface with everything. It adapts by toughening up, softening up, roughing up, tanning or falling to pieces and sloughing off. Skin is the ultimate membrane, made to measure as a physically robust but elastic, antimicrobial, semi-permeable sheet.

A quick body check of hands, elbows, arms and legs clearly provides for a canvas to be imagined for a skin that could not be simplified and considered as something that, if laid out flat, would be similar to a single sheet of plain uniform A4 laser printing paper. Catch the light on the back of a hand and look at the miniaturized version of something like the Mer de Glace; open and close the hand and realize the events that have taken place in terms of the mechanical properties: skin must have to provide this function. The depth of its wonders quickly builds into a significant set of problems and objectives for research and

medicine to tackle. For example: consider addressing the needs of our increasingly long-lived population, who want to look like teenagers and behave in much the same way given half a chance – there are many levels of specification for the performance characteristics of fabricated skin that will need to be met. A complex weave of organic molecules laid down by cells provides naturally for its many functions. The scale of the complexity comes home following injury to the skin. The physiologically perfect map, template or design is lost forever, and a rough-and-ready rapidly functional barrier alternative replaces it. Driven by the fight or flight evolutionary origins, the body repair systems race into place to seal the breach. Wound healing is not about ordered structure – it's about rapid closure, stabilizing and making safe. This scar in skin layers, a wound now healed, is the reminder of the magnificent innate defence response; it presents problems when scarring restricts mobility and confines normal function. It is a critical issue to restore function to a body on which large areas of skin may have healed, presenting patches of fibrous, inelastic and orientated scar tissue that is very slow to be mobilized and remodelled into a thin, elastic, dynamic structure.

To produce something to match that which has developed in due course, along with the origins of life itself, for use as a medical treatment to short-cut the life process and provide treatments as and when required is a big ask. How big? Well, bigger than the body can manage to do itself naturally, which implies that it won't be the most efficient, rapid or safe process. In science and engineering terms these factors can be controlled so that the problem is manageable and therefore tangible in concept and application. Scientifically, the theory of tissue regeneration has been translated into the cell culture laboratory and the technical details of growing skin and laminar structures, vascular and tubular structures, and free-forming gel structures have been solved; the different tissues of the body and some of the critical secretory cells can be maintained and manipulated outside the body to form living multicellular structures that by definition can be called tissue.

The correct assembly of tissue and organs requires organization in terms of space and communication. Extracellular matrix (ECM) provides naturally for the correct space. This matrix is predominantly composed

of collagen. There are many types, most of which are fibre-forming, triple helix configurations that provide for complex three-dimensional architectures and which have orientation and mechanical properties to facilitate a tissue or organs function. These fibres can be orientated in many different and elegant ways, from simplistically parallel in tendons and ligaments to omnidirectional weaves in skin and bone. In life, the molecules required to create these structures effectively self-assemble, resorb and reassemble – it is a dynamic environment driven to work within the homeostatic limits of the body. Procollagens and matrix metalloproteinases (MMPs) – to name only two opposing groups of molecules that form part of the rich palette of molecules for tissue formation – play out a rich and complicated process to form functional tissue. The ECM provides the molecular, cellular and tissular triggers for cell signalling as well as the physical structure on which to hold cells and maintain the tissue function. Communication between cells and their environment happens by *touch and taste*, that is to say, cells have some very special previously secret handshakes with each other, or they post a message into the fluidic transport system – locally the extracellular and interstitial fluids, and globally the lymphatic and cardiovascular systems. These chemical signals can be processed internally or presented externally on their plasma membranes. Ligands, integrins, receptor expression, up regulation, down regulation, RNA and peptide sequences all become key terminology in the scientific language to translate the dialogue of cellular interaction and communication.

From blinded mittened origins we can now delicately dissect and interact with this world within – exciting does not begin to touch where we stand in terms of understanding life and working with it rather than making the best of it. The next steps should all work with life; clearly we can already make safe and provide function, but to regenerate will require integration not just implantation. We can implant many functional augmentations and analogues but the tyre tracks and physical devastation are evident after our departure. Scarring is not only skin-deep and is clearly the line between implantation and integration: this physical and physiological line must disappear. Skin perfectly epitomizes the future issues before us. To regenerate will not be enough – we can do that and we can grow tissues. We will have to seamlessly integrate what we can produce with its environment. To do that learning the language is a good start and the induction phase is over.

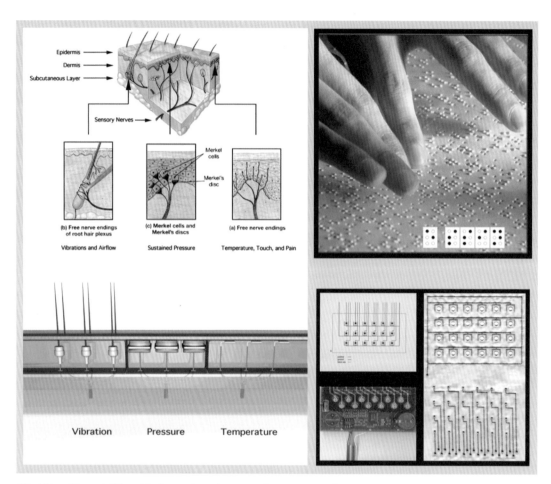

Mimicking skin modalities with electronics and our new electronic circuit based on Braille, 2004.
© D. Bisig and J. Scott

e-skin: Research into Wearable Interfaces, Cross-modal Perception and Communication for the Visually Impaired on the Mediated Stage

Jill Scott

Today our cultural events are dominated by visual information based on sight and sound, but hardly at all on the combined senses of touch and sound. Very few theatre, dance or art events take place in which visually impaired people can participate. While compensating audio-description or talking books are standard products that these people can buy to imagine feature film stories or decide what is happening on the stage, computer interfaces, which promote communication between impaired actors, are seldom designed by art and science teams. Nor are they designed to allow them to navigate and control audio-visual information on the digital stage, or present cultural events to sighted audiences. Our research group is interested in addressing these problems by constructing ergonomic human–computer interfaces (HCI) that can explore the above problems, including research into orientation, cognitive mapping and external audio-visual device control. Furthermore, the unique cross-modal potentials of human sensory perception could be augmented by electronic devices, which in turn might communicate with sighted audiences. Consequently, we are implementing our discoveries in artificial systems that can communicate with people on the real digitally mediated theatre stage.

THE E-SKIN APPROACH

e-skin is a set of wearable interfaces, which comprise our attempts to electronically simulate the perceptive modalities of the human skin: pressure, temperature, vibration and proprioception. These four somatic modalities constitute our biggest human organ, constantly detecting and reacting to environmental realities. Our research team is engaged with the mimicry of these skin-modalities and their receptive cognitive associations. We use extensive user testing to explore three broad areas of research: 1) the cross-modal potentials of tactile and acoustic feedback, 2) the enhanced orientation of cognitive mapping, and 3) the need to embody the interaction in the digital environment.

Cross-modal interaction is the label used in neuroscience to describe how certain features or objects perceived by one's sensory cortex are complemented by features in another sensory area of the brain. For example, the perceived modalities of pressure and sound, temperature, volume or proprioception and vibration may be processed in more than one cortex. Our combined artistic and scientific aim is to explore the results of combining tactile perception with acoustic perception, and whether the mediated stage itself can be used as a feedback loop or 'visual substitute' for reactions between these two related cortices.

By using methods such as touch perception, movement improvisation, electro-stimulation of the skin itself, gesture and relief differentiation, perhaps some answers to this inquiry can be uncovered. Usually cognitive mapping exercises focus on tests about the composition of acquired codes, stores, recalls and decodes. However, we are also interested in adding determinative relative locations and attributes in the spatial environment of the stage itself.

Currently, our mediated stage is a hybrid platform using surround sound and three screens with related potentials of communication, movement and gesture as well as audio-visual response and control. This requires that the participants wear electronic augmentation on their bodies, although stand-alone RFID sculptural elements may also be used for interfaces on the stage. In all cases embodied interaction is one of our major aims, but as Paul Dourish suggests, *embodied interaction* is not so easy to achieve without taking into account physical and social sensorial phenomena, which unfold in 'real time' and 'real space' as part of the particular environment in which the user is situated.[1] Therefore our impaired users' growing relationship to the stage layout, the objects on the stage and their own consequent levels of skin perception over time are very important. Although Dourish posits that embodied interaction can replace the screen, we are interested in how the screen can be re-incorporated because digital screens and sound monitoring are integral parts of our current cultural environment. Thus we aim to combine both real and simulated realities.

Unfortunately, the development of HCI in the realm of impaired applications on mediated platforms such as ours is often hindered by other complications. First, most commercial enterprises consider interfaces for the visually impaired in cultural environments to be uninteresting investments, due to small market value. Secondly, communication difficulties often occur when research initiatives cross-discipline between the arts (cultural production) and the sciences (basic research). Our small team, which consists of two artists, two scientists and one psychologist and our visually impaired participants, struggles on because we find the subject and the embodied potential use of *e-skin* challenging for us and empowering for the users. Our methodology has been to develop and test prototypes for use in mediated audio-visual stages and then invite our impaired users to test them. By utilizing off-the-shelf sensors and wireless protocols to transport electronic tactile and sound cues, virtual communication between visually impaired participants was increased. We now assume that these cues could develop into a type of communication code, which can be easily learnt and would allow for tactile and sound combinations to be shared through visual associations with non-impaired audiences. In other words, codes from tactile stimulation and acoustic feedback by an impaired actor could be transferred into visual stimuli for a sighted audience. Basically there are two possibilities here: sound feedback can be transferred by electro-stimulation onto the human skin itself, or wearable circuits can be embedded with micro sensors, actuators, wireless technologies and pocket-size computers to enhance communication, navigation and orientation between impaired actors. We are still in the middle of conducting workshops with visually impaired people in order to explore both options. For example, through these workshops we have found that both electro-tactile and sound feedback can definitely improve the cognitive mapping of mediated spaces, especially if complemented by a set of stored metaphorical associations. These associations can be linked to personal preferences in music or nostalgic sound cues from childhood, thus constituting a set of customized sound cues. Therefore our art and science team combines basic and applied research, with constant user testing as inspiration for further development.

PREVIOUS RESEARCH

Our previous research was conducted in two prototype stages and then in related specialized workshops. The *e-skin* interface prototypes were called *Smart Sculptures*.

1 Paul Dourish, *Where The Action Is: The Foundations of Embodied Interaction* (Cambridge, MA: MIT Press, 2001).

Prototype 1: *Controlling the mediated stage with 3 interfaces based on 3 skin modalities, pressure, vibration and temperature,* 2005.
© D. Bisig and J. Scott

These shell-like shapes were built using basic wireless portable PICs or programmable micro-controllers, body temperature sensors, vibration sensors, and pressure pad sensors. The modality of proprioception was mimicked by infrared technology and tilt sensors also imbedded in these interfaces, which were all linked to a central Linux server and three client Mac computers running Javascript. Through these interfaces and clients, the users interacted in real time with three screen images and sounds distributed through a six-channel surround sound system. The content on the screens depicted the molecular and neural layers of real human skin and the participant was able to navigate though the layers in real time. The pressure sensors triggered sounds, the temperature sensors variegated their volume, and the tilting of the interface shifted the image. The vibration sensors controlled the speed and response of animated figures on the screen. Two visually disabled people, one with 10 per cent vision and another with 2 per cent vision, were invited to test the interfaces inside this mediated stage.

Orientation was actually enhanced by dividing tactility into four portable modalities and combining these attributes with acoustic feedback. Furthermore, blocking the ears severely hampers navigation, and tactile vibration and pressure augmented their orientation, leaving the ears free for navigation. Many visually impaired people often create a type of tongue-clicking sound, which bounces off solid objects and helps them navigate. Once they had learnt the associative relationship between the visual database and the sound files, they enjoyed manipulating the visual information on the screens, but they definitely preferred to customize their own sound samples. From these results, we then designed two new mediated stages, which might incorporate more relational sound with artefacts on the stage, and our focus turned to the potential of tagging objects, so that they could be identified through sound and tactile feedback.

One such artefact is entitled *Derma-tone*. It is a media sculpture that provides an experience of stereo sound and visual layering so that both non-impaired and visually impaired people can use it. It can either be used in the workshops or displayed as an artwork. The title *Derma-tone* is derived from the scientific term 'the Dermatomic area'. This area features the cervical part of the spinal column and the related efferent and afferent processes that directly relate to the skin on the back of head, legs, neck and arms. The Dermatome is the most somatic-sensitive area of human perception. Five film layers directly representing the five image maps inside our cerebral cortex are shown. The viewers touch embroidered circuits and trigger image projections embedded in the sculpture as well as animations and sound associations for these five maps. These films do not resemble scientific illustrations but relate to interpretations about cultural difference and the codes of translation in our brains on a molecular scale. They represent how the layers of the cortex's sensory sub-modality interpret the texture, shape, stretch, translate and association of touch though various pathways – such as the rapidly adapting receptors, the deep pressure receptors, the muscle stretch receptors with

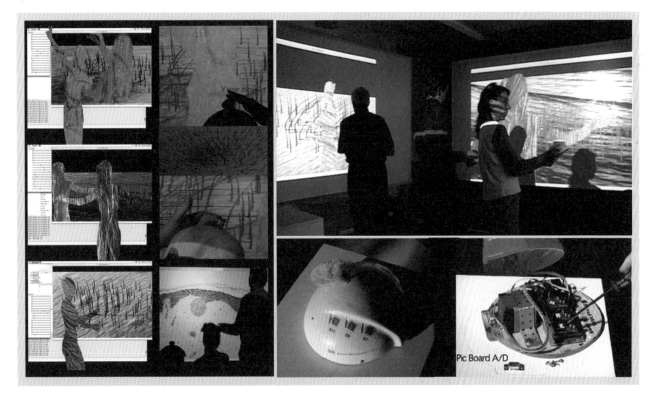

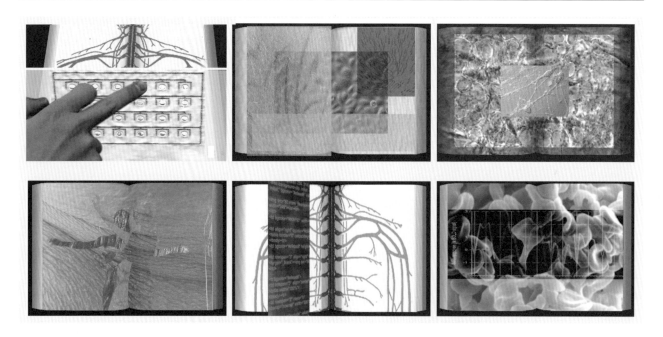

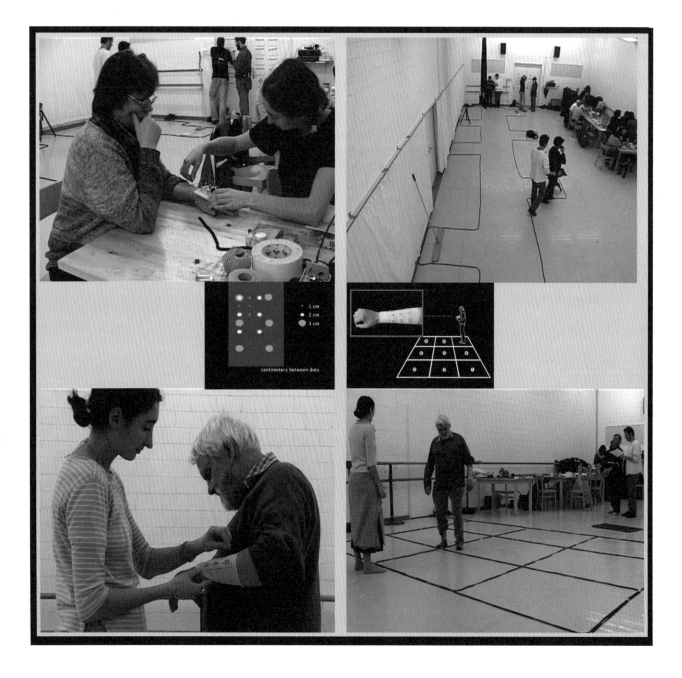

the cutaneous receptors, the Thalamus gland and also the associations from the cross-modal interaction process.

These layers are projected on a stretched skin in the shape of an open book because this is the way the dorsal and ventral analysis of nerve growth in the spine are actually analysed in neuroscience. The layers represent the fact that in both visually impaired and non-impaired cognition there is an exact and precise representational mapping of the external body surface onto the cortical surface. However, this layered somato-sensory map is not really an exact representation but a distortion of reality. The human fingertips, for example, are allotted a much greater cortical area than the human back and so *Derma-tone* focuses on the use of the fingers to manipulate the sound and the related images in and around the media sculpture. Such representational concepts of the spatial cortex were inspired by our workshops with eight visually impaired users. Five of the participants were congenitally blind and the others had been impaired by early accidents. The age range was from 20 to 60 years old and the participants had to fulfil four tasks. These tasks were divided into a set of problems based on touch, tactile substitution as well as sound and movement/navigation.

Electro-touch sensitivity and pattern recognition. In this task we measured the visually impaired participants' touch sensitivity levels using electronic skin stimulation as a cue for orientation. We noticed that each participant had a different idea about the importance of touch, culturally and functionally. However, there was general agreement about the recognition of patterns though direct skin stimulation. They all agreed that a type of Braille electro-pattern-stimulation code on the arm could be easily learnt as a form of augmented communication but they did have difficulties recognizing patterns with dots less than 2 cm apart.

Sound and navigation. In this task we were interested in two questions. First, could the creation of customized sound cues in relation to individual metaphors not only help mobility and deter obstacle collision, but be utilized as a communication protocol for the server on the digital stage? From a conducted questionnaire about sound cue preferences we found that this control was an essential request. While speech plays an important role in directional guidance, abstract and discrete sounds are much more preferable. Ultrasonic frequency modulation or alarms were also problematic in comparison. Secondly, we tested the potentials of bone-phone sound substitution. Bone-phone transducers were preferred as they were able to discretely transmit sounds through the skull and of course they kept the ears free for natural environmental augmentation.

Results like these gave us a clearer idea of how the next stage of the *e-skin* interface should be designed. Visually impaired people have to deal with ever-changing models of modern devices such as mobile phones, and the control of these audio-visual devices may also be able to benefit from the use of more intuitive electro-tactile and acoustic response interfaces like *e-skin*. Currently our *e-skin* research goals are to create more flexible skins for the cross-modal activity of sound and tactility, to increase the communication with the mediated stage and its audiences, and to augment navigation and orientation aids in a cultural environment. The overall aim is to develop interfaces that allow visually impaired actors to design and control their own stage and its content.

COMBINATIONS OF ART, AI AND NEUROPHYSIOLOGY
e-skin requires a combination of art and science practitioners working both on the basic and the applied

Dermatone-Electronic circuit interface and the 5 interpretations of the layers represented in the somatic sensory cortex, 2005.
© J. Scott

Workshops with impaired participants: Andrea Kuehm, Freddy Gromme, Diego Metzger, Pascal Leinenbach, Helen Larcher, Claudia Gatti, Martin Meier, Peter Fisler.
© J. Scott

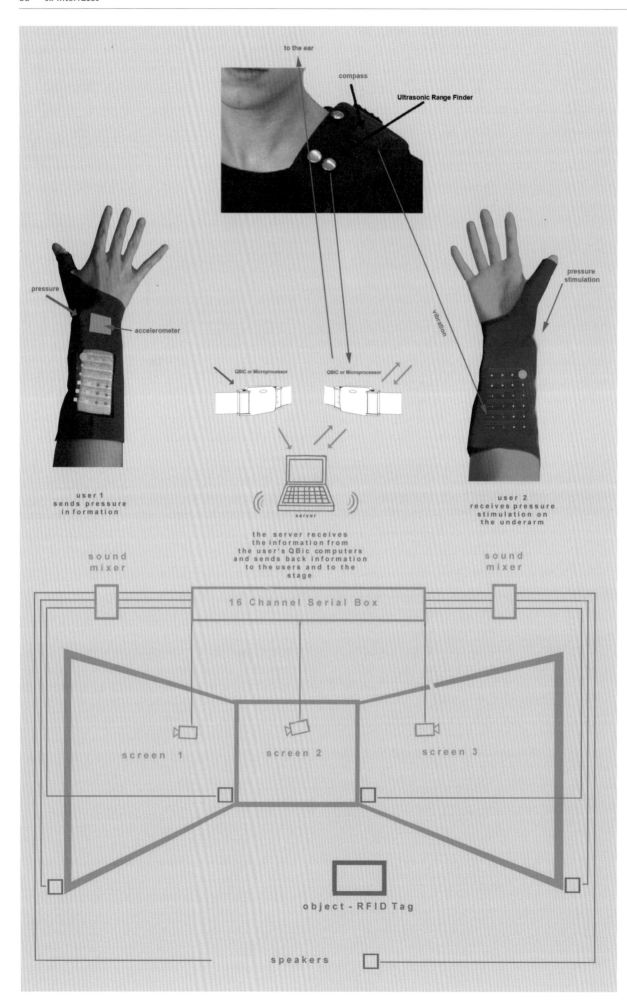

levels. On the basic level we are developing touch sensors in the form of embroidered circuits, which can give and receive tactile feedback. As Dourish suggests, our cognitive patterns derived from the sense of touch are an essential component of embodiment and we believe that real-time digital actuation might help us to understand these patterns. In terms of communication, gesture recognition from actuators placed on the electronic circuit would capture gestures and also loop through to the digital feedback onto the stage. Our current circuit has been designed with two layers so as to maximize the levels of resistance between them. The ergonomic challenge is that *e-skin* should feel like an interactive second skin rather that an extra costume component. On the applied level we are working with systems integration and users in workshops as well as developing objects and designs for mediated stage. With our prior history of designing immersive mediated environments,2 we are concentrating on two stages of systems integration with the mediated stage. We consider that the user workshops are part of the integration. Our users expect a real possibility that this third stage of *e-skin* will come closer to the concept of embodied interaction as we are working towards the development of a device that 'talks their language'.

With our first two prototypes we have discovered that electronically enhanced perception from combinations of tactile and sound perception can complement visual forms of interaction for the visually impaired on the digital stage. We feel that this can be achieved by augmenting the participant's movement, communication, navigation and control skills but also by working with the potentials of cross-modal education. *e-skin* is based on the 'universal human' aspects of acoustic and tactile feedback and customized metaphorical associations, but our main aim is to 'humanize technology' for the visually impaired. In addition, through the output potentials of the audio and visual information, non-visually impaired persons in the audience could gain more insight into the world of the visually impaired. Perhaps even the essential transfer of visual information codes from impaired persons to a sighted audience already constitutes a 'kind of script'. In this light, we are also beginning to explore different types of appropriate content that can be used as educational themes for the development of theatre scripts. Thus this third stage of *e-skin* might empower both participant and audience member with a deeper level of perception and communication. This is the 'embodied way' for HCI: one that focuses on ubiquity, tangibility and most of all shared awareness, intimacy and emotion.

A more extensive version of this paper was recently published in *The Journal for Digital Creativity* 18.4 (2007), published by Routledge.

Acknowledgements: Other contributions to this paper include: Daniel Bisig, Senior Researcher, Artificial Intelligence Lab, University of Zurich; Andreas Schliffler, physicist/electronic engineer, PhD candidate Z-node; Valerie Bugmann, media artist, PhD candidate Z-node; Peter Schmutz, Masters candidate, Institute of Neuro Psychology, University of Basel. With special thanks to our continuing group of impaired participants: Andrea Kuehm, Freddy Gromme, Diego Metzger, Pascal Leinenbach, Helen Larcher, Claudia Gatti, Martin Meier and Peter Fisler. Collaborators in Zurich include: Wohnheim für Blinde und Sehbehinderte, Ergonomie and Technologie GmbH, Tanzhaus Wasserwerk, Restaurant Blindekuh.

2 Marille Hahne, *Coded Characters. Media Art by Jill Scott* (Ostfildern-Ruit: Hatje Cantz Verlag, 2003).

e-skin: Current designs showing the wearable interfaces and their connections to the mediated stage.
© J. Scott

→ separator
Zane Berzina, *Topology of Skin II,*
2007, drawing.

Courtesy of the artist

Feel Me, Touch Me: The *hymNext* Project JULIA REODICA

The hospital and its antiseptic culture have been a big part of my upbringing and thus have informed my science/art practice. I have become both attracted and repulsed by human skin-to-skin contact, fascinated by the conflicting urges involved in efforts to get close to someone. The *hymNext Project* represents the conflicting affair between art and science, interior and exterior body, person-to-person connections. The stylized hymens are made from mammalian epithelial cells scavenged from the abattoir, the lab and/or myself. The hymen tissue cultures are a combination of my vaginal cells, rodent smooth muscle tissue, bovine epithelial cells and bovine collagen scaffolding grown in nutrient media. My body tissue and rodent tissue coexist in the same space *in vitro*. My cells are part of the sculptures because I want myself to be new art media, thus 'giving myself away' to the art process. In each sculpture with my cells, my DNA is a personal signature.

Replacement hymens confront the cultural and traditional functions of the thin membrane. The act of reproducing my vaginal cells gestures towards the one-time occurrence and breakage of the biologically virginal hymen. The hymen is neither inside nor outside the vaginal canal. In philosophy, 'hymen' is a stance between two discursive positions, without tendency to one side. In biological and philosophical modalities, I am, like the hymen, between the artistic and scientific disciplines. The resulting art pieces are a conjuration of new symbols to encourage discussion about scientific research and body politics.[1]

Biologically, the hymen assists the maturing female to propagate beneficial flora.[2] Ironically in the social realm, knowledge of the biological function has become less important than the enforcement of the cultural meanings of the inconspicuous thin skin. The social context of the hymen as a sign of purity is based solely on gender control and familial economics in traditional cultures around the world. The consequences of an absent hymen in strict traditional cultures can range from family shame to even the death of the female who is deemed a non-virgin. In the *hymNext Project* the celebration of the recreated hymen is emphasized – and repeatable if desired. The *hymNext* hymen symbolizes the united front for both parties involved in the sexual and discursive act, a barrier that is broken down to begin a relationship or open a channel of communication between two people regardless of sexual assignment or preference. By creating hymens that are based on the remnants of traditional cultures, antiquated gender rules are disengaged, new iconographies are associated, and the symbolism once again goes into flux. It is symbolic and linguistic flux within a progressive society that allows the general perceptions of the skin to be re-examined, challenged and to evolve into new meanings.

I regard skin equally from both the social and medical aspects in research and practice. The same organ that separates the internal and external worlds is also subjected to the interpretation/perception of visual and sensual cues. Cues are separate from biological functions of the skin and are cultural constructions based not just on texture or colour, but deriving also from the person who inhabits the fleshy outfit. The creative intent is to work with the skin or tissue separate from the gendered body; therefore the work process and the final piece challenge or de-emphasize the idea of assigned gender. The technical research and manipulation of cells in a novel environment does not include gender at all, but treats the cell purely as a living, architectural being.

In the scientific realm, the skin was explored in wound management in ancient times and is widely addressed in contemporary medical research. Three thousand years

1 See also my contribution to L. Davis and D. Morris (eds), *Biocultures manifesto* (New Literary History, 38; Baltimore: The Johns Hopkins University Press, 2007).

2 A. J. Hobday, L. Haury and P. K. Dayton, 'Function of the Human Hymen', *Medical Hypotheses* 49.2 (1997), 171–73.

3 A. Herman, 'The History of Skin Grafts', *Journal of Drugs in Dermatology* 1 (2002).

4 R. N. Pierson et al., 'Xenogeneic Skin Graft Rejection is Specially Dependent on CD4+ T Cells', *Journal of Experimental Medicine* 170 (1989).

5 A. S. Rosenberg and A. Singer, 'Evidence that the Effector Mechanism of Skin Allograft Rejection is Antigen-Specific', *Proceedings of the National Academy of Sciences of the United States of America* 85.20 (1988), 7739–42.

6 R. Barthes, 'The Rhetoric of Image', in *Image, Music, Text*, trans. Stephen Heath (New York: Noonday Press, 1964).

ago, Hindu surgeons used the buttock skin of criminals to reconstruct their noses after they were disfigured by the punishment for their crime. In the mid-1500s, Tagliacozzi of Italy was considered to be the pioneer of plastic surgery because of his work in applying skin grafts to the wounds of soldiers.[3] In these examples with autologous skin, the donor and recipient are the same person – there is no risk of organ rejection and this is therefore a blessing to wound therapy. On the other hand, xeno- or allo-graft skin originating from the same or different species has a higher chance of rejection as a result of the recipient body's own immune system activating the T-cell response to foreign bodies.[4] Rejection or acceptance on a molecular level depends on the communication between cells in determining compatibility or incompatibility.[5] This cellular language is sometimes beyond human control and therefore dictates the experiment or procedure. In research, the skin continues to be a useful tool in testing chemical and environmental effects, which ultimately leads to safer products and pathological understanding of human reaction to substances. Again, cell compatibility and rejection are driving factors in these studies. Skin that it is grown *in vitro*, without a human host, eliminates the exposure of actual human subjects to dangerous materials. In the medical and scientific professions, skin is highly valued as a protective and versatile barrier, but feared when it becomes the cause of contamination or disease. Therefore, the viability of a replaceable hymen as a possible skin graft was conceptualized in the *hymNext Project* as a novel body adornment.

The skin, especially in the act of prejudgment, allows the viewer to weigh up the worth of its owner. Human behaviour consistently uses a personal filter with regard to the world to decide what is agreeable or disagreeable. As a visual cue in literature, writers such as Shakespeare used the extremity of skin colour to insinuate the type of character portrayed: black represented danger or abjectness and white stood for innocence or virtue. This literary paradigm became a fundamental formula in literature. Roland Barthes divides the use of symbolic language into three stages of information transference with reference to the meaning of an image.[6] In the case of skin, linguistically it is described by the author and words or messages are attached to form a definition; the denotative statement is regarded as a perceived truth shared by the collection of readers; and connotatively, the meaning permeates into the culture and is accepted as a rule of measurement when applied to other subjects. Of course, the so-called rules are malleable cross-culturally. It is through this process that stereotypes, archetypes and anomalies are divided to form social opinions.

With thanks to Jens Hauser, Kerstin Schmidt and Peter Dickinson for the chapter published here.

← Unisex hymen, 2005–2007. Artist's vaginal cells, rodent smooth muscle cells, bovine collagen matrix, nutrient liquid media, 25mm diameter x 2 mm.

Unisex hymen and ceremonial box from the *hymNext Project*, 2005–2007.

Courtesy of the artist

In the Face of the Victim: Confronting the Other in the Tissue Culture and Art Project ADELE SENIOR

Fleshing... the flesh and fatty tissue under the hide is removed by a fleshing machine before the hides are loaded into drums

This statement does not describe the way in which the Tissue Culture and Art Project (TC&A) creates *Victimless Leather* but rather the process by which the hide, the skin of an animal, is treated in the manufacture of leather. Undeniably, the production of leather involves acts of violence that are captured in the language used to describe this process by the companies that manufacture it.[1] However, we rarely witness the 'attack' this process involves or that which it 'destroys'. We are certainly not faced with it when we stroll into the shoe shop or browse through the wallets and handbags on display in the local market. Our gaze is removed from this hidden production process, much like the animal's flesh and blood, but while the experience of leather remains at a distance, our hypocrisies remain unchallenged. Indeed, the re-staging of the words used to describe and sell such a process, within the following pages, re-enacts an important concern which TC&A seem to be responding to in *Victimless Leather* and in the *Victimless Utopia* series more generally, albeit through negation. It is a concern for confronting, in the flesh, the violent process by which the other inevitably and systematically becomes 'victim'.

Soaking... the hides are washed to remove dirt and blood from the surface

In *Victimless Leather: A Prototype of a Stitch-less Jacket Grown in a Technoscientific 'Body'* the spectator is faced with what TC&A's artists Oron Catts and Ionat Zurr refer to as 'a miniature leather-like jacket grown out of immortalized cell lines (a mix of human and mouse cells)'.[2] This jacket is another example of the 'subject/object' which has become a signature feature of their artistic practice and which they refer to as the 'Semi-Living'. These Semi-Livings are created using tissue and stem cell technologies. Living tissue is grown over/into three-dimensional scaffolds within an environment that emulates the body of the complex organism from which the tissue originally derives. The scaffolds used are artificial biodegradable and bioabsorbable polymers which are seeded with living cells or tissue that has been taken from animal bodies killed for the purpose of scientific research or butchered for consumption. In *Victimless Leather*, however, already established cell lines are used: 3T3 (mouse) and HaCat (human).[3] The artists keep these Semi-Living 'sculptures' alive and assist their growth with nutrient solution, an appropriate temperature and sterile conditions. The sculptures are exhibited, both alive and dead, in galleries and other public spaces to prompt 'the re-evaluation of what life is and our treatment of other life forms'.[4]

Hair Removal... the hair is attacked by the chemicals and breaks off at the surface

Indeed, the naming of the work as 'victimless' is deliberately ironic since tissue technology as the seemingly victimless alternative to traditional forms of making leather is an illusion. The victim in TC&A's Semi-Living version is in fact the embryonic calves that were sacrificed to provide the serum for the nutrient medium that promotes the growth of cells and tissues *in vitro*, that is, outside the body. This foetal bovine serum supplies the appropriate growth hormones for the cells or tissues being cultured. Removal of the

1 The italicized text is taken from one of many publicly available documents produced by leather manufacturing companies.

2 Oron Catts and Ionat Zurr, 'Towards a New Class of Being: The Extended Body', *Intelligent Agent* 6.2 (2006), 5.

3 HaCaT and 3T3 cells were used in the first staging of *Victimless Leather* at the John Curtin Gallery, Perth, as part of the exhibition *The Space Between* in 2004. However, the work can be staged with other co-cultured adherent cells.

4 Oron Catts and Ionat Zurr, 'Are the Semi-Living Semi-good or Semi-evil?', *Technoetic Arts: A Journal of Speculative Research* 1.1 (2003), 53.

victim occurs at the level of the laboratory here, since the calves that provide the serum are not sacrificed by the artists or scientists who work with tissue culture. Instead, the serum is usually ordered online and arrives at the laboratory in a bottle which retains only a visible trace of its donor on its label.

Liming... the hide structure swells as the fibres in the hide absorb water

The co-culturing of the human and mouse cell lines in *Victimless Leather* is a reminder that the status of victim is potentially shared by human and non-human animals alike. Moreover, the wet interspecies material that the spectator is confronted with in the installation alludes to the undecidability of a Semi-Living which is already 'located at the fuzzy border between the living/non-living, grown/constructed, born/manufactured, and object/subject'.[5] Where a skin ordinarily separates the human from the mouse, the self from the other, the Semi-Living here comprises co-cultured cell lines from *both* human *and* mouse, confusing these apparent boundaries. Of course, referencing the human torso in the structure of the Semi-Living and calling it leather plays on the popular assumption that leather pertains to the animal whereas its 'living' equivalent – skin – pertains to the human. Instead, this Semi-Living leather-like skin neither protects nor contains; it is neither (fully) living nor (fully) dead, since it deteriorates over the period of the installation, decomposing before the spectators' eyes.

De-liming... the hide shrinks as the alkalinity is reduced and water is released

Victimless Leather is one of three pieces from TC&A's *Victimless Utopia* series, which takes as its starting point technology's illusory promise of a utopia without victims. The other installations are *Disembodied Cuisine* (2000–2003) and *DIY De-Victimizers* (2006). For *Disembodied Cuisine*, TC&A cultured *in vitro* what they refer to as a Semi-Living steak using frog skeletal muscle. The installation was exhibited as part of the *L'Art Biotech* exhibition at Lieu Unique in Nantes in 2003 and concluded with a feast in which the steaks were cooked by a French chef and served to volunteers from the audience as a nouvelle cuisine style dinner. One of the intentions of the project was to confront the hypocrisies practised by humanity 'in order to be able to love and respect living things as well as to eat them'.[6] In particular, the artists were playfully responding to the 'French resentment towards engineered food and the objection by other cultures to the consumption of frogs'.[7]

Bating... enzymes are added which clean up the grain surface and further destroy any remaining hair roots and pigments

In *Disembodied Cuisine* no attempt to hide the victim is made. Indeed, the artists have suggested that the animal providing the cells for the steaks would be present in the installation space where the tissue-cultured fragments of its body were offered up for consumption.[8] The presence of frogs next to the table is a reminder of the process by which the steaks are produced. The animal is not absent here, as it is when leather is sold. Neither is it hidden, as in the description of industrial production where the uneasy acknowledgment of the characteristics shared by human and non-human animals is avoided by favouring terms such as 'cattle' rather than 'animal' and 'hide' rather than 'skin'. Instead, in *Disembodied Cuisine* the dinner table becomes a site/sight of abjection, where the frogs' bodies and the steaks, in the presence of one another, deny the illusion

5 Catts and Zurr, 'Semi-good or Semi-evil?', 47–60. For a response to this article and a detailed exploration of the Derridean notion of undecidability in relation to the Semi-Living see Adele Senior, 'Towards a (Semi-) Discourse of the Semi-Living; The Undecidability of a Life Exposed to Death', *Technoetic Arts: A Journal of Speculative Research* 5.2 (2007), 97–112. In the first part of this article I argue that the artists' discourse signals the undecidability of the Semi-Living in its appeal to the both/and logic of the Derridean deconstructive event; that is, the Semi-Living is *both* living *and* non-living, thus disrupting the either/or logic of Western philosophical thought.

6 Catts and Zurr, 'Semi-good or Semi-evil?', 57

7 Oron Catts and Ionat Zurr, 'The Ethical Claims of Bioart: Killing the Other or Self-Cannibalism?' (2003), www.tca.uwa.edu.au/publication/TheEthicalClaimsofBioart.pdf (accessed 16 October 2007), 13

8 Oron Catts and Ionat Zurr, 'The Art of the Semi-Living and Partial Life: Extra Ear – ¼ Scale', (2003) http://www.tca.uwa.edu.au/publication/TheArtoftheSemi-LivingandPartialLife.pdf (accessed 17 October 2007), 12; Catts and Zurr, 'The Ethical Claims of Bioart', 13.

of self-containment that the frog's skin seems to promise. In this respect, the feast can be read as an attempt to return the Semi-Living to its bodily processes of becoming.

Pickling... water, sulphuric acid and salt are added. After penetration of the salt and acid the hides are in a preserved state

The term 'disembodied' in the title engages with the penetrating violence presupposed by eating and consumption more generally. In this respect, the feast component of *Disembodied Cuisine* stages the impossibility of not eating the other, since the other is always presupposed by eating. Eating the Semi-Living is thus an extension of the killing ritual which has become a prominent motif in TC&A's installations, that is, the event in which spectators are encouraged 'to touch (and be touched by) the sculptures'.[9] Touching and eating – activities which are intimate in their own ways – depend on a very personal and individual engagement for the participant who puts the Semi-Living to death. He or she undertakes a singular event of engagement, a decision – to kill or not to kill – that cannot be taken up by anyone else, since to kill one must touch the Semi-Living. A paradox of respect and violence seems to be captured in this moment, since the artists tell us that the Semi-Living will not have anyone to care for it, to provide the appropriate nutrients and environment so that it may stay alive following the installation. The participant is invited to take up the 'responsibility which lies on us (humans as creators) to decide upon [the Semi-Living's] fate'.[10] Shadowing this act, it seems, is Jacques Derrida's notion of ethics as a relationship of responsibility to the other, a relationship which involves a paradox of being both responsible and irresponsible.[11] Since to respond absolutely and singularly to the call of the wholly other one must not respond to the 'other others'.[12] To which other are the spectators responding? To the particular Semi-Living they are faced with? Or to the artists' call to take up (that) responsibility in the face of other humans? Similarly, in *Disembodied Cuisine* the participant at the dinner table is asked to physically consume the Semi-Living, an activity in which one (or the other) is not *removed* but potentially moved by what appears to be a visceral act at both a symbolic and literal level. Are we to read this as an act of exploitation or respect?

Tanning... converts the hide into a stable material which will not putrefy or be attacked by bacteria

The killing of the Semi-Living is initiated by the bacteria and fungi we have on our hands, as well as by the bacteria in the air. To prevent contamination and therefore the eventual death of the Semi-Living during their installations, TC&A contain the sculptures in a sterile environment, which acts as a (second) skin to protect the Semi-Living from the external environment. In *Victimless Leather* this second skin echoes the structure of the human torso which is assumed by the Semi-Living jacket; a reminder of the human carers and killers of this Semi-Life. In *Disembodied Cuisine* the spectator who looks onto the feast through the transparent structure which contains and divides this celebration is confronted with the notice 'You are a biohazard. Do not enter', bringing the violence with which our bodies can harm other (semi-)living things to the fore. Similarly, the *mise-en-scène* of the feast re-stages the demands of tissue culture on the artistic process: the inevitability of there always being a victim in tissue culturing and the need to separate the self from the other, specifically when confined to the scientific laboratory where boundaries must be maintained. However, the installation, with its associated rituals, also confronts the paradox of establishing a hierarchical relationship with the Semi-

9 Oron Catts and Ionat Zurr, 'Artistic Life Forms That Would Never Survive Darwinian Evolution: Growing Semi-Living Entities' (2003), http://www.tca.uwa.edu.au/publication/Artisticlifeformsthatwouldneversurvive.pdf (accessed 16 October 2007), 3.

10 Catts and Zurr, 'Artistic Life Forms', 3.

11 Jacques Derrida, *The Gift of Death*, trans. David Wills (Chicago: University of Chicago Press, 1996).

12 Derrida uses the example of Abraham's sacrifice. In responding singularly and absolutely to the call of the wholly other which in this case is God, Abraham must transgress his ethical duty to his family, and any ethics justifiable before humans or the law, because in choosing to be faithful to his own son he would be betraying God, the absolute other.

Living, coercing it to grow into a particular shape and, at the same time, being a slave to the process of supplying fresh nutrient solution, maintaining the required temperature and ensuring it does not become contaminated, with the hope (and not the guarantee) that it will live for another day.

Sammying... excess moisture is squeezed out of the hides by passing them through large rollers under pressure

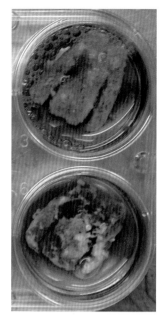

For *DIY De-Victimizers* (2006) the artists used off-the-shelf items to create a mock tissue culture facility where parts of deceased bodies could be maintained alive and potentially proliferate. The facility, or *DIY De-Victimizer Kit* (DVK), was constructed 'to allay some of the guilt people feel when they consume parts of dead animals (as food, for aesthetic reasons or any other purpose) or cause the accidental death of a living being (by a car, a lawnmower, or any other piece of technology)'.13 Again, as the artists remind us, the nutrients required to maintain the parts alive are animal-derived. The performance involved a demonstration in which the victims of human technology were 're-lifed' using the *De-Victimizer Kit* and the audience was invited to assist the artists in taking care of the living fragments. This is another of TC&A's motifs referred to as the 'feeding ritual' in which the spectator observes or is invited to take part in a process which involves supplying the Semi-Living with fresh nutrients. According to the artists, the spectator/participant was asked to make an ethical decision with regard to which tissue they would choose to kill, which in the case of the performance that took place in Barcelona was either the tissue obtained and grown from a bull – which the artists frame as a reference to the bullfighting ritual – or a McBurger. The artists follow that '[a]s an homage to the fighter bull, we relifed its tissue and grew it over a miniature replica of a tourist-shop figurine in the shape of a bull'.14

13 Catts and Zurr, 'Towards a New Class of Being', 6.

14 Catts and Zurr, 'Towards a New Class of Being', 6.

Splitting and shaving... the hide is split through the middle to a required thickness for end use. Any further correction of the thickness is done by shaving off any fleshy material not wanted

The contradiction inherent in TC&A's *Victimless Utopia* series may at times be too subtle for recognition. The rhetoric of a victimless utopia, the artists tell us, has been employed by New Harvest, a non-profit organization which funds university-based research into the use of tissue-cultured meat as an alternative to meat that involves animal death.15 The animal rights organisation PFTA (People for the Ethical Treatment of Animals) even proposed collaborating with TC&A.16 Of course, what is at stake when artists use biotechnologies such as tissue culture to produce 'victimless leather' is that their work is likely to be read in relation to scientific research and commercial production. This reading is arguably intensified when the victim is not explicit in the installation, since the victim's absence contributes to an uncritical acceptance of TC&A's supposedly 'victimless' claim. Unlike *Disembodied Cuisine* and *DIY De-Victimizers*, where the victim appears to be visible in the installation and in the artists' written discourse on the projects, the 'donors' for *Victimless Leather* are present only in the form of established cell lines, for example HaCat and 3T3. HaCat is a cell line developed from adult human skin taken by surgical excision from a 62-year-old male patient with skin cancer.17 3T3 cells originate from mouse embryos and are used as 'feeder cells' to enable the growth of other cells – human cells in this case.18 While growing these cells together may be read as an attempt to move away from 'speciesism',19 the poetic and literal dependence that occurs at the

15 Catts and Zurr, 'Towards a New Class of Being', 5. See also http://www.new-harvest.org/default.php

16 Catts and Zurr, 'The Ethical Claims of Bioart', 13.

17 P. Boukamp et al., 'Normal Keratinization in a Spontaneously Immortalized Aneuploid Human Keratinocyte Cell Line', *The Journal of Cell Biology* 106 (1988), 762.

18 G.J. Todaro and H. Green, 'Quantitative Studies of the Growth of Mouse Embryo Cells in Culture and their Development into Established Lines', *Journal of Cell Biology* 17 (1963), 299–313.

19 Ionat Zurr and Oron Catts, 'Victimless Utopia or Victimless Hypocrisy?', unpublished manuscript (2007), 1. See also Richard D. Ryder, *Victims of Science: The Use of Animals in Research* (London; Davis-Poynter, 1975). The term 'speciesism' was coined by Ryder to refer to the 'widespread discrimination that is practised by man against the other species'.

← Untitled, study for the *Victimless Leather* project.

→ A layer of pig mesenchymal cells (bone marrow stem cells) grown for 6 weeks. Grown as part of Oron Catts & Ionat Zurr residency as Research Fellows at the Tissue Engineering and Organ Fabrication Laboratory, MGH, Harvard Medical School 2000-2001.

Courtesy of the Tissue Culture & Art Project (Oron Catts & Ionat Zurr)

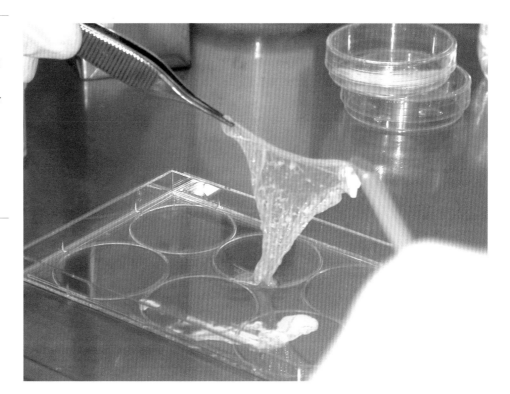

level of the cells is paradigmatic of the inevitable exploitation that occurs at the level of body-to-body interaction, playing out the popular scene of the laboratory mouse which supports scientific research conducted in the name of humanity. However, unless one is science-literate or has access to information on these cell lines (which often depends on an institutional affiliation) this potential reading may be lost.

Buffing... for hides which have a damaged, faulty or uneven grain surface, this can be smoothed by mechanical sanding

While it may be easy to recognize the Semi-Living as victim, as a figure of exploitation and consumption in the victimless series, to what extent can the cells and tissue of tissue culture and tissue culture art be considered victims? Is it important to note that many cells inevitably die in the process of creating a Semi-Living? According to its etymological origin, 'victim', from the Latin *victima*, pertains to a person or animal that is sacrificed. In fact the term 'sacrifice' is used in the scientific laboratory as a technical term to describe the process of killing a specimen, although one would not speak of sacrificing cells or tissue within this context.[20] Perhaps this is indicative of a hierarchical structure that categorizes the different levels of life being dealt with in the laboratory – from cell to tissue to body. Furthermore this selective use of the term 'sacrifice' prompts the question of who/what is permitted the status of victim. A victim then can be conceptualized as someone or something that is *perceived* to have been injured, harmed or destroyed in some respect. Perception thus plays an important role in determining who/what is attributed the status of victim and should not be taken for granted in any context, artistic, scientific or otherwise. For those of us who rely on the artists' documentation of the event, it is important to note that the cell line used for creating the steaks for *Disembodied Cuisine* was actually developed in the late 1980s from the skeletal muscle cells of a tadpole of an aquatic toad,[21] despite earlier suggestions that the cells were taken from the animal featured in the installation.[22] While the decision to use a cell line rather than a biopsy may have been a pragmatic one and the gesture of 'having the healthy frogs living alongside

20 For more on the notion of sacrifice in relation to the Semi-Living see Senior, 'Towards a (Semi-)Discourse of the Semi-Living', 104–12. Here I consider the Semi-Living in relation to a figure of Roman archaic law, *homo sacer*, 'sacred man', as discussed by Giorgio Agamben in *Homo Sacer: Sovereign Power and Bare Life* (Stanford, CA: Stanford University Press, 1998). I argue that the Semi-Living shares with *homo sacer*, 'a life exposed to death' but unlike *homo sacer* who '*may be killed and yet not sacrificed*', according to ritual practices, I suggest that the Semi-Living can only ever exist in ritual.

21 Zurr and Catts, 'Victimless Utopia', 2.

22 Catts and Zurr, 'The Ethical Claims of Bioart', 13.

as part of the installation'[23] still retains its symbolic significance, our perception of who the injured party is needs to be constantly reassessed. Likewise, even though the use of an already established cell line avoided taking a biopsy and therefore prevented possible injury to a frog, we must remember that a cell line still has a victim.

Embossing... is a further process which stamps an artificial grain pattern onto the surface of the leather if required

Confronted with a jacket that can only survive in a technoscientific body, a steak that requires the serum provided by one whole calf in order to grow to the size of a small coin, and a kit that can 're-life' the victims of aesthetic/food consumption and accidental death using animal-derived nutrients, we are reminded that the promise of developing technologies to provide an alternative should be treated with caution: in many cases the victim is simply further abstracted or removed from sight. This concern is often captured in TC&A's Semi-Living sculptures which are not quite unrecognizable accumulations of cells and not quite organisms or bodies. Whether or not we face the victim in TC&A's work – of course the other may not have a face – is debatable. The wet material sculptures and their associated rituals certainly gesture towards the bodily and visceral experience which is absent, or literally cleaned up, when one buys meat or tries on a pair of leather shoes. But these are the obvious examples. What about the others we unintentionally kill through the very act of walking or driving, whether we are travelling to the butchers or the shoe shop or not: the trampled insects, the life which suffers from our pollution, or the victims of roadkill? And what of the living vegetables we consume, perhaps in protest against the harm done to animals in meat production? Of course, one of the victims of this printed text is the once-living tree from which this paper is made. To that end this text engages in a subversion of the framework within which there is *always* a victim, presenting an interpretation of the victimless series with the inherently violent description of the leather-making process. Neither of these texts should be considered victimless but, in their juxtaposition, perhaps they begin to perform the central concerns of the victimless series, and, more importantly, open it up for reinterpretation at the various levels at which it may be received.

23 Catts and Zurr, 'The Ethical Claims of Bioart', 13.

Secularism

Preface from Michel Serres,
The Troubadour of Knowledge

Back from the inspection of his lunar lands, Harlequin, emperor, appears on stage, for a press conference. What marvels did he see in traversing such extraordinary places? The public is hoping for wonderous eccentricities.

"No, no," he responds to the questions that are fired at him, "everywhere everything is just as it is here, identical in every way to what one can see ordinarily on the terraqueous globe. Except that the degrees of grandeur and beauty change."

Disappointed, the audience cannot believe its ears: elsewhere must surely be different. Was he incapable of observing anything in the course of his voyage? At first silent, dumbfounded, they begin to stir once Harlequin pedantically repeats his lesson: nothing new under the sun or on the moon. The word of King Solomon precedes that of the satellite potentate. There is nothing more to be said, no need for commentary.

Whether royal or imperial, whoever wields power, in fact, never encounters in space anything other than obedience to his power, thus his law: power does not move. When it does, it strides on a red carpet. Thus reason never discovers, beneath its feet, anything but its own rule.

Haughtily, Harlequin looks the spectators up and down with ridiculous disdain and arrogance.

From the middle of the class, which is becoming unruly, a true and troublesome wit rises and extends his hand to designate the Harlequin's cape.

"Hey!" he cries, "You who say that everywhere everything is just as it is here, can you also make us believe that your cape is the same in every part, for example in front as it is on the back?"

Shocked, the public no longer knows whether to be silent or to laugh; and, in fact, the king's clothing announces the opposite of what he claims. A motley composite made of pieces, of rags or scraps of every size, in a thousand forms and different colors, of varying ages, from different sources, badly basted, inharmoniously juxtaposed, with no attention paid to proximity, mended according to circumstance, according to need, accident, and contingency – does it show a kind of world map, a map of the comedian's travels, like a suitcase studded with stickers? Elsewhere, then, is never like here, no part resembles any other, no province could be compared to this or that one, and all cultures are different. The map-cum-greatcoat belies what the king of the moon claims.

Gaze with all your eyes at this landscape – zebrine, tigroid, iridescent, shimmering, embroidered, distressed, lashed, lacunar, spotted like an ocelot, colorfully patterned, torn up, knotted together, with overlapping threads, worn fringe, everywhere unexpected, miserable, glorious, so magnificent it takes your breath away and sets your heart beating.

Harlequin Coat ORLAN

Harlequin Coat is the prototype of a composite biotechnological coat, consisting of a custom-made bioreactor and cultured, *in vitro* skin cells embedded in a coloured life-size mantle with diamond-shaped patterns, symbolizing cultural crossbreeding. By mixing cells of different colours, ages and origins, this long-term project continues my previous investigations into hybridization, using the carnal medium of skin cells.

I have always viewed life as an aesthetic phenomenon that can be taken over, and my body as the primary material available to me. I have used my body and/or the representation of my body for practically all my works. As Christine Buci-Glucksmann so aptly puts it, 'working on the body, and on one's own body, is to bring together the private and the social. Feminist struggles have taken the obvious fact that the body is political right to the core of historical issues.'[1] I myself belong to a generation for whom showing one's body or talking about one's sexuality and pleasure was not obvious, and for whom neither contraception nor abortion were no-brainers. Our bodies were not our own, and this is precisely the context in which I decided to create with that medium and that relationship. My body is one *material among other materials*, oscillating between the subject and my own object, and between object and subject. My works are mixed in with my life. For each series of works, the idea is to make a new entry, your own entry, to take a fresh look at yourself, and also create intense moments for yourself and other people. I changed my face by putting *figure*, i.e. *representation*, on my face. We might say about this figural effect that the new face is like the eye of my discourse showing itself.

I have worked from my DNA with Copenhagen police.[2] I have sold my artist's kisses.[3] I sell my flesh in my *Reliquaires* series. I have sold my blood in my *Saint-Suaires*. All of this without the sky falling down around my ears. I acted fearlessly and felt in no way influenced or threatened by this collective, ancestral fear of interfering with the integrity of the body, by this anachronistic feeling born from the idea that the body, formerly viewed as God's masterpiece, is sacred and untouchable, not to be transformed. Thus, my *Reliquaires* are made with my own flesh, and contain a fragment from *Laïcité*, a text by Michel Serres, translated into several languages. I also read this piece of writing in the operating theatre during my fifth surgery performance entitled *Opération-opéra*, wearing a Harlequin hat.

What could the running tattooed monster – ambidextrous, hermaphrodite, and crossbred – show us now beneath its skin? Yes, blood and flesh. Science speaks of organs, functions, cells, and molecules, finally admitting that it's a long time since anyone referred to life in laboratories, but science never mentions the flesh, which

1 Christine Buci-Glucksmann, *ORLAN triomphe du baroque* (Marseille: Images en Manoeuvres, 2000), 37.

2 Nikolaj Church Contemporary Art Centre, *Nemo*, curated by Elisabeth Delin-Hansen, Copenhagen, 1996.

3 *ORLAN: De L'Art charnel au Baiser de l'artiste* (Paris: Jean-Michel Place & Fils, 1997).

specifically designates the mixing – here and now, in a given part of the body – of muscles and blood, skin and hair, bones, nerves, and various functions, combining what pertinent knowledge analyses...

For me this text is the logical follow-on from my own *carnal art* manifesto written in 1989. Michel Serres uses the Harlequin figure in the preface to his book *The Troubadour of Knowledge*.**4** The idea of 'laïcité' is usually translated into English as 'secularism' but is not adequately captured by this English label as it subcutaneously points to its anti-clerical history based on the respect of freedom of thought and the subsequent separation of church and state. Here, the Harlequin metaphor conveys the idea of multiculturalism and the acceptance of the other within oneself, within or without religious frameworks. I again read this text in a performance that hybridized and recycled my wardrobe to turn it into a collection of garments in unique pieces. And I read it one last time in Perth during the biopsy on my skin cells, a medical procedure that was a prerequisite to producing my installation *Harlequin Coat*.**5**

The central element of the *Harlequin Coat* is a custom-made tissue culture bioreactor designed and built for a gallery environment, in which the environmental conditions necessary for cell growth and nourishment are recreated. It contains three polymer structures on which three cell types are co-cultured live. In the first stage of the installation I used my own skin cells which were collected during the biopsy, WS1 type skin fibroblast cells from a 12-week-old female foetus of African origin, and fibroblast muscle cells from a marsupial, a fat-tailed dunnart. The WS1 skin cells were obtained from the US-based American Type Culture Collection and shipped frozen to Australia, having been deliberately chosen after querying the online classification system of that tissue bank – I found it striking that gender and 'black' ethnicity were considered valid scientific criteria for cells in their catalogue. The marsupial cells came from an animal leftover within the context of scientific research conducted at the University of Western Australia. All cells are staged in their process of potential hybridization on the polymers located in the bioreactor, which effectuate mechanized up and down movements.

Being the central part of the installation, the bioreactor constitutes the head of the *Harlequin* body figure in which the coat and hat are made out of different coloured diamond-shaped Perspex. The Petri dishes embedded in these diamond shapes contain polymers with fixed (dead) cells. The whole coat is lit by a back projection of accordingly diamond-shaped still images, or animated time lapse cell movies. The cells in the Petri dishes and those projected overlap. The live cells in the projection comprise the three growing and hybridizing cells present in the bioreactor, but also human

Powerful and flat, speech, monotonous, reigns and vitrifies space; superb in its misery, this improbable garment dazzles. The derisory emperor, who chatters like a parrot, is enveloped in a world map of badly bracketed multiplicities. Pure and simple language or a composite and badly matched garment, glistening, beautiful like a thing: which to choose?

"Are you dressed in the road map of your travels?" says the perfidious wit.

Everyone titters. The king is caught out and discomfited.

Harlequin quickly figured out the only escape from the ridicule his position invites: all he can do is to take off the coat that belies him. He gets up, hesitating, looks, gaping, at the panels of his outfit, then, devoutly, looks at his public, then looks again at his coat, as if seized with embarrassment. The audience laughs, a bit foolishly. He takes his time, everyone waits. The Emperor of the Moon finally makes up his mind.

Harlequin gets undressed; after much grimacing and graceless contortion, he finally lets the motley coat drop to his feet.

Another iridescent envelope then appears: he was wearing another rag beneath the first veil. Disconcerted, the audience laughs again. Thus it is necessary to start again, because the second envelope, similar to the coat, is composed of new pieces and old bits. It's impossible to describe the second tunic without repeating, like a litany, tigroid, iridescent, zebrine, studded.

Harlequin keeps getting undressed. Another shimmering dress, a new embroidered tunic, then a kind of striated veil appear successively, and still another colorfully patterned body stocking spotted like an ocelot ... The audience guffaws, increasingly stupefied; Harlequin never gets to his last outfit, while the one before last resembles the antepenultimate as closely as could be desired: motley, composite, torn up ... Harlequin is wearing a thick layer of these harlequin coats.

Indefinitely, the naked retreats beneath the masks and the living beneath the doll or the statue swollen with bits of cloth. Certainly, the first coat makes the juxtaposition of pieces visible, but the multiplicity, the overlap of successive, implied envelopes shows and also conceals it. Onion, artichoke, the Harlequin never ceases to shed his layers or to peel off his knotted capes; the public never stops laughing.

All of a sudden, silence; seriousness, even gravity, descends on the audience – the king is naked. Discarded, the last screen has just fallen.

Stupefaction! Tattooed, the Emperor of the Moon exhibits a colorfully patterned skin, more a medley of colors than skin. His whole body looks like a fingerprint. Like a painting on a curtain, the tattooing – striated, iridescent, embroidered,

4 Michel Serres, *The Troubadour of Knowledge* (Ann Arbor, MI: University of Michigan Press, 1997) (first published in French as *Le Tiers Instruit* [Paris: Gallimard, 1992]).

5 *Harlequin Coat* was developed as a mixed media installation during my residency at SymbioticA, the art and science collaborative research laboratory at the University of Western Australia. The piece was first exhibited at BEAP, the Biennale of Electronic Arts Perth, in September 2007 as part of the *Still, Living* exhibition curated by Jens Hauser, with the generous support of FACT/Liverpool and SymbioticA.

→ TOP LEFT ORLAN in harlequin costume on the biopsy table, University of Western Australia, Perth, 2007. Costume: Lucas Bowers, ericaamerica.

TOP RIGHT Between the surgeon's armpit and ORLAN's groin.

BOTTOM The operating-room during the biopsy.

Photos: Tony Nathan © ORLAN

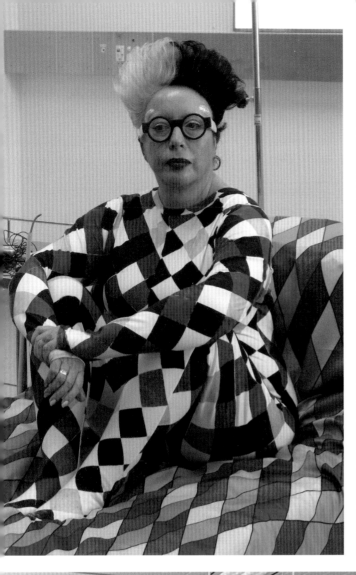

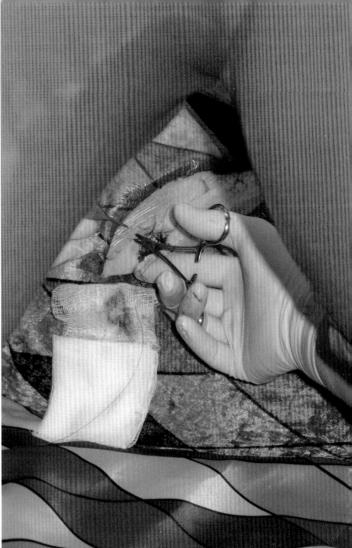

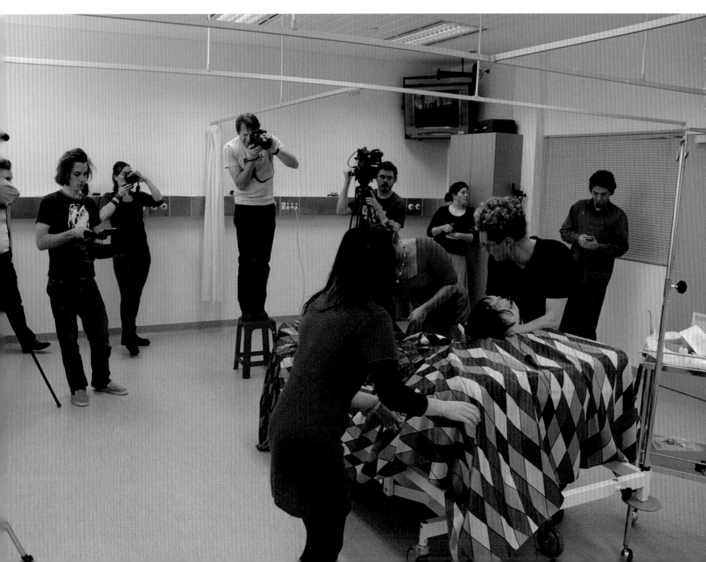

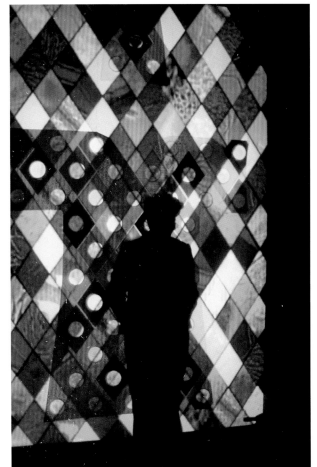

TOP LEFT Transfer of ORLAN's skin cells after biopsy, University of Western Australia, Perth, 2007.
© ORLAN

TOP RIGHT ORLAN during her residency at SymbioticA/Perth, August, 2007.
Photo: Jens Hauser

BOTTOM LEFT *Harlequin Coat* installation with ORLAN's shadow at the *Still, Living* exhibition curated by Jens Hauser, Bakery Artrage, Biennale of Electronic Arts Perth (BEAP), September 2007.
Photo: Raphael Cuir © ORLAN

BOTTOM RIGHT *Harlequin Coat*, installation detail, plexi coat and petri dishes. *Still, Living* exhibition curated by Jens Hauser, Bakery Artrage, Biennale of Electronic Arts Perth (BEAP), September 2007.
Photo: Tony Nathan © ORLAN

damasked, shimmering – is an obstacle to looking, as much as the clothing or the coats that fall to the ground.

Let the last veil fall and the secret be revealed; it is as complicated as all the barriers that protected it. Even the Harlequin's skin belies the unity presumed in what he says, because it, too, is a harlequin's coat.

The audience tries to laugh again, but it can't anymore: perhaps the man should strip himself – whistles, jeers. Can someone be asked to skin himself?

The audience has seen, it holds its breath, you could hear a pin drop. The Harlequin is only an emperor, even a derisory one, the Harlequin is only a Harlequin, multiple and diverse, undulating and plural, when he dresses and gets undressed: thus named and titled because he protects himself, defends himself, and hides, multiply, indefinitely. Suddenly, the spectators, as a whole, have managed to see right through the whole mystery.

Here he is now unveiled, and delivered, defenseless. to intuition. Harlequin is a hermaphrodite, a mixed body, male and female. Scandalized, the audience is moved to the point of tears. The naked androgyne mixes genders so that it is impossible to locate the vicinities, the places, or borders where the sexes stop and begin: a man lost in a female, a female mixed with a male. This is how he or she shows him/herself: as a monster.

Monster? A sphinx, beast and girl; centaur, male and horse; unicorn, chimera, composite and mixed body; where and how to locate the site of suture or of blending, the groove where the bond is knotted and tightens, the scar where the lips, the right and the left, the high and the low, but also the angel and the beast, the vain, modest, or vengeful victor and the humble or repugnant victim, the inert and the living, the miserable and the very rich, the complete idiot and the vivacious fool, the genius and the imbecile, the master and the slave, the emperor and the clown are joined? A monster certainly, but normal. What shadow must be cast aside, now, in order to reveal the point of juncture?

Harlequin–Hermaphrodite uses both hands; he is not ambidextrous but a completed left-hander. You could see this clearly; when he undressed, his capes twirling on both sides, he was adroit even on the left. The charms of childhood combined with the wrinkles proper to the old made one wonder about his age: adolescent or dotard? But above all, when the skin and flesh appeared, the whole world discovered his mixed origin: mulatto, half-caste, Eurasian, hybrid in general, and on what grounds? Quadroon, octoroon? And if he was not playing the king, even as comedy, one would have the urge to say bastard or mongrel, crossbreed. Mixed blood, mestizo or mestiza, diluted.

What could the current, tattooed, ambidextrous monster, hermaphrodite and half-breed, make us see now under his skin? Yes, flesh and blood. Science speaks of organs, functions, cells, and molecules, to admit finally that it's been a long time since life has been spoken of in laboratories, but it never says flesh, which, very precisely,

blood cells, mouse connective tissue and muscle cells, goldfish neurons, cells from the human brain (cerebral cortex), lactating breast, cervix, menstrual endometrium, lip, skin (thin, thick scalp), umbilical cord and vagina, as well as monkey eye (retina), primate ovary, rabbit tongue (fungiform and filiform) and sheep tongue (vallate). The installation is designed to evolve over the course of the forthcoming exhibitions. At each step, newly grown cells of mine will be co-cultured together with cells of other origins. Little by little, the Petri dishes will be filled. I was obviously delighted to have this chance to work at such an outstanding place as SymbioticA. I see most of all in this broadening of my artistic vocabulary to biotechnology an obvious sequel to, and consistent with, my previous works between the body and surgery, the body and medicine, art and science. Skin culture is nowadays a common way of treating major burns, so growing my own skin is a 'commonplace' gesture. What is less commonplace is to cultivate it highly symbolically along with cells from a black woman's foetus sold on the Internet, and in the context of the city of Liverpool, with its loaded past in connection with the tragedy of the slave trade.6

Scientifically speaking, the experiment might leave the impression that it was a foregone conclusion that the young 'black' foetus cells would win out against my over-sixty's cells. Would it be once again the conventional observation of this routine victory, just another victory of the powerful over the weak? I am interested in checking this relationship, notably because leading skin culture specialists7 were telling me just how many varied criteria, impossible to predict with any accuracy, could still change the outcome of the experiment. Likewise, I knew in advance that the hybridization of skins of various origins would definitely not develop a different skin colour. But this – modifiable – attitude of observing follows on logically from my surgery performances. More than a readymade, I am laying claim to a *modified readymade*; for a tiny modification to the readymade, a subtle alteration to the body, changes its meaning. The body – for me – is no longer this readymade that just needs you to sign it, as Piero Manzoni did in the 1960s. The *modified readymade*, by contrast, transforms the body into a forum for public debate, in the way I hijacked the techniques of plastic surgery by implanting two little bumps in my temples, although these now routine implants are more commonly used to lift the cheeks.

Harlequin Coat is moreover a work that is not for sale. The cells taken from my body, and the other cells used, are no longer mine and I could not sell them as art. So this unsaleable and almost unshowable work is costing me a fortune. Thus it is a sideways step in order to feel free to create, study and become passionately involved outside of the market's takeover of the works. I see here a resonance with my performance work *Le Baiser de l'Artiste*. The artistic devices created with the help of biotechnology are to do with performance art to the extent that there is a staging of an act of life whose intensity is only visible for a brief instant of sharing, of emotion and innovation. The frail position of the living is placed at the heart of

6 A circumstance that ironically echoes my original intention to begin developing the *Harlequin Coat* project as part of the *L'Art Biotech* exhibition in 2003, at Nantes – another city with a heavy slave-trading past to live down.

7 My special thanks to Dr Fiona Wood for our rewarding discussions.

designates the mixture of muscles and blood, skin and hairs, bones, nerves, and diverse functions, which thus mixes what the relevant disciplines analyze. Life throws the dice or plays cards. Harlequin discovers, in the end, his flesh. Combined, the mixed flesh and blood of the Harlequin are still quite likely to be taken for a harlequin coat.

Quite some time ago, a number of spectators left the room, tired of failed dramatic moments, irritated with this turn from comedy to tragedy, having come to laugh and been disappointed at having to think. Some, doubtless specialists in their field, had even understood, on their own, that each portion of their knowledge also looks like Harlequin's coat, because each works at the intersection or the interference of many other disciplines and, sometimes, of almost all of them. In this way, their academy or the encyclopedia formally joined commedia dell'arte.

Now then, when everybody had his back turned, and the oil lamps were giving signs of flickering out, and it seemed that this evening the improvisation had ended up being a flop, someone suddenly called out, as if something new were playing in a place where everything had, that evening, been a repetition, so that the public as a whole, turned back as one, all looking toward the stage, violently illuminated by the dying fires of the footlights:

"Pierrot! Pierrot!" the audience cried, "*Pierrot Lunaire!*"

In the very same spot where the Emperor of the Moon had stood was a dazzling, incandescent mass, more clear than pale, more transparent than wan, lilylike, snowy, candid, pure and virginal, all white.

"Pierrot! Pierrot!"cried the fools again as the curtain fell.

As they filed out, they were asking:

"How can the thousand hues of an odd medley of colors be reduced to their white summation?"

"Just as the body," the learned responded, "assimilates and retains the various differences experienced during travel and returns home a half-breed of new gestures and other customs, dissolved in the body's attitudes and functions, to the point that it believes that as far as it is concerned nothing has changed, so the secular miracle of tolerance, of benevolent neutrality welcomes, in peace, just as many apprenticeships in order to make the liberty of invention, thus of thought, spring forth from them."

← *Harlequin Coat*, video projection and bio-reactor with ORLAN's skin cells, black woman's cells and marsupial cells at the *Still, Living* exhibition curated by Jens Hauser, Bakery Artrage, Biennale of Electronic Arts Perth (BEAP), September 2007.

Photo: Tony Nathan © ORLAN

the installation, like Harlequin's face becoming a bioreactor, the place of the dramatic passing from life to death, Harlequin like a *memento mori*, framed by video shows showing at once the representation of living, dead or dying cells in these diamond shapes sutured by the white light of all the colours combined. With each new exhibition, the cultivated cells will be immortalized and displayed in the coat's Petri dishes. This is an installation in process.

This Harlequin coat taken from the theatre – a trompe-l'œil imitating curtains opened out onto the sides – is a restaging of the text included in my *Reliquaires*, which ends with a sentence on the comedy of art, while at the same time facing up to the drama of the life and death of our cells, mine included, in the bioreactor. This drama is being played out inside the bioreactor, but invisibly to the naked eye, in spite of the appearance of an aquarium containing this reddish-pink liquid medium in which three cell types move around seeking shelter on the three polymers. In response to most of my works, which show the body opened up by these images and which blind the public, this particular work is caught between the folly of wanting to see and the impossibility of seeing. As a biotechnological work, the *Harlequin Coat* installation confronts us with the bodily limits to visual perception, which is extremely limited when it comes to perceiving anything small. This represents the real challenge for artists accustomed to visual practices, and so it is a battle of giants to contrive to show something when there is nothing to see without a microscope. The practices of biotechnological art appear to replicate the dilemma of performance art, in that they are connected to video and photographic recording techniques. But I also feel that works drawn from performance art are works in their own right, and not just traces or documents. Did anyone view the *Anthropomorphies* of Yves Klein or the paintings of Jackson Pollock as mere documents or traces of their performances? By the same token, my hybrid digital photography work for *Omniprésence* recorded the self-portrait produced 'naturally' by the body-machine and displayed in the form of a photographic installation showing 'what a body can do'. Here biotechnology is being taken out of the laboratory and turned into a spectacle, through the *commedia dell'arte* character of Harlequin and the cells from ORLAN which play an actor's role in both the theatrical and the linguistic sense of the word.

Harlequin Coat was devised and produced like a real Harlequin coat, that is, with bits added on and brought in from various origins, from several different people and practices. ORLAN wishes to thank the people without whom the work could not have come about: the SymbioticA team (Oron Catts, Ionat Zurr, Jane Coackley, Guy Ben-Ary, Amanda Alderson, Stuart Bunt and Miranda Grounds); Phil and Dawn Gamblen for making the bioreactor; an anonymous surgeon for the biopsy; Tony Nathan, Raphaël Cuir and Christophe Canato for the photographic work; Lucas Bowers, ericaamerica, for the costume; Ben Young, Steven Hughes, Dominic Pearce, Adrian Higgins, Steven Lloyd and Raphaël Cuir for the video images; Stephen Hughes and Dominic Pearce for the projection; Simon Giraudo for the image rendering and the assembling of the coat including the Petri dishes; her assistant Luisa Miceli; Paul Thomas; and Jens Hauser, curator of the *Still, Living* exhibition as part of BEAP 2007.

The Fusional Haptics of Art Orienté objet MARION LAVAL-JEANTET

1 Research carried out from 1995 at Rosalind Picard's Laboratory at MIT, aimed at producing a computer that responds to affective stimuli from the user.

Our skin-deep reactions are often a sign of something wrong much deeper down. This is a fact that the least hang-up takes on the task of reminding us of through unforeseeable cutaneous eruptions that unmask us... I have been working with Benoît Mangin since 1991, going by the name of Art Orienté objet. When we first met, the violence of the event was such that he found himself covered from head to foot with itchy red blotches. This was a regular occurrence during our shared artistic life, whenever we had a particularly emotion-filled moment, so much so that he became a kind of barometer of our creative relations. In 1994 it became clear that we were going to have to tackle this business head-on. For the umpteenth time, Benoît had just come out in a rash that required a tedious series of allergy tests to establish the cause. And what was causing it finally turned out to be in all likelihood psychological. OK, Benoît was allergic to the world around us, but the thing was that he was only like this at times of crisis with himself! Noticing this led us to produce *Karma*, a chimerical photographic work where an allergy test gives a positive result for the stimulus 'human'. This view was absolutely counter-intuitive since an allergy is by definition a reaction to substances that are foreign to the human body. Only it seemed clear to us that many human beings were more toxic to themselves than anything foreign could ever be. The foreign, or more precisely the moving borders of our awareness of the foreign, then became our pet subject. And it had a broad definition: foreign meant anything that was outside our mortal coil and could get inside. But of course the ambiguity lay in the fact that often the foreign seemed more familiar to us than we did.

In 1996, while we were studying our physiology amid the cohort of scientists at Framingham Massachusetts to shoot an interactive film for the 'affective computers'[1] at MIT, we came into contact with the skin biology laboratories at Cambridge University that produced the first skin cultures on a well-nigh industrial scale with a view to experimenting with repair surgery and cosmetics. We became really curious and would not stop until we had entered into their research protocol to cultivate our own skins for artistic purposes. To produce artists' skin cultures we felt was a big issue: not only was it a matter of integrating contemporary technical capabilities into the artistic language, but beyond that, the idea was to transgress the question of the artwork medium by proposing a living medium that was none other than the artist in person. We went deep into questions of categories such as conceptual art, body art and performance art, but most of all we proposed literally a new commitment of the conceptual artist in his work. The work was conceptual, but beyond that it also assumed its status of an *in-corporated work*. This 'work in skin' was truly a way of solving, albeit momentarily, the conflict going on inside us, Benoît and myself, as contemporary artists, and which seems to be going on inside Western culture, whereby metaphor is in opposition to relevance, just as the image's *encasing powers* are in opposition to its *transformative powers*. I refer here to the writing of Serge Tisseron[2] who dates the split between 'conceptual' art and 'carnal' art back to a time when the battle of theologians opposed the iconoclasts and the iconophiles (ninth century) as to whether the power of the image lay in its possibly containing Christ's body – in which case it was impious because only the host was allowed to contain Christ's presence – or whether it lay in its evocative ability, in the psychic operation taking us from the object to the image and vice versa.[3] This latter power seems to have the edge in the art of today, creating a dissociation that is probably illegitimate and hard to resolve. This is precisely the dissociation which exploded in the design of *Artists' Skin Cultures*, since the fetish-work that we were producing contained our existence and handed down the myth,

2 Serge Tisseron, *Le bonheur dans l'image* (collection Les empêcheurs de penser en rond; Paris: Institut Synthélabo, Le Plessis-Robinson, 1997), 132–34.

3 The same topic is addressed by Marie-José Mondzain in *L'image naturelle* (Paris: Nouveau Commerce, 1995).

through the scientific self-portrait. The work was at once conceptual and carnal, almost alive, which we would call an *active object*.

But we wanted more than that, and the technique forced us to make more of it. The thinness of the skin culture obtained was such that with its transparent quality it did not look much like skin... not enough at any rate to convince viewers from a culture filled with the impressions of opaqueness, thickness, smoothness that we associate with the idea of 'skin'. Even its preservation as an art object was illusory, not to mention the poverty of its texture. So we came round to the idea that it would have to be grafted onto a 'foreign' derm, a pig's for instance. This was something biologists were doing all the time. They actually test our skin's ability to grow on immune mice, like the ones we had kept as pets for a short while rather than see them euthanized. So we grafted cultures of our epidermis onto pig derm, and, convinced that the result was still not very evocative, we tattooed them with mythical animal figures, chosen from the top American animal tattoos in 1996. Only on the culture where samples of both our skins had managed to grow together – in *Première Peau [First Skin]* – did there appear a different kind of tattoo: that of Epsilon, one of the immune mice that had received a sample of my skin. These final art objects broke through a number of barriers that our minds try to set up for balance: those of autonomy, identity, genus, species... and they proved all the more active in our view because they were capable of plunging the visitor into gut-wrenching doubt over these concepts. With the innocence of their prettily coloured animals, these trans-gender and trans-species cultures appeared as miniature bombs for the human awareness of each of us, convinced of our strong individuation.[4] These real enough *Artists' Skin Cultures* were also the projection of a hybrid world where xeno-transplants would be common currency, and the distinctions between different living species would be blurred until they finally disappeared altogether. The world dreamt up by artists for whom the emotional climax to be reached would be fusional haptics,[5] the perception of the physical body in the environment up to fusing, including with the animal.

← *Karma*, 1994.

↓ *Cultures de Peaux d'Artistes /* Artist skin culture 1996-1997.

Courtesy the artists

4 To quote a Jungian term; c.f. Carl Gustav Jung, *The Relations between the Ego and the Unconscious* (Zurich, 1928).

5 Haptics or tactile-kinaesthetic perception refers to the science of touch (see the tactile theories of the psychologist Geza Revesz).

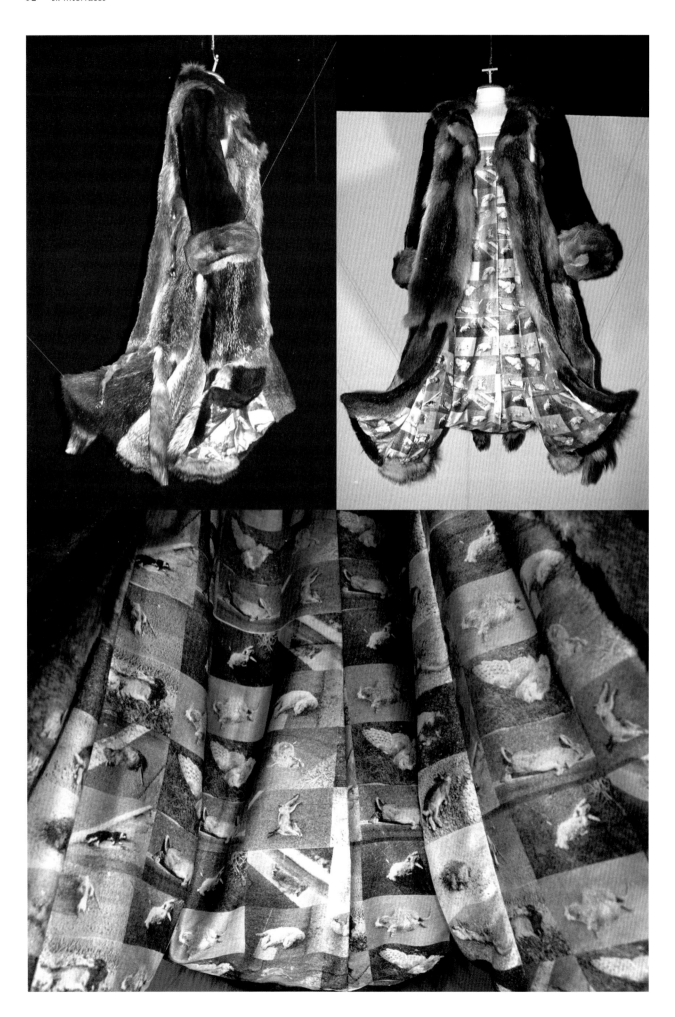

6 Vladimir Makanin, *Long Road Ahead* (New York: Ardis Publishers, 1996).

I have lived with the awareness of the living 'other' represented by the animal since I was very young, at an age when my grandmother from the shamanist world of Corsica taught me to feel various animalities in an exercise that she called 'donning the animals'. This exercise developed a special sensitivity, a trace of which I have only found in the amazing science fiction novel *Long Road Ahead* by Vladimir Makanin,6 in which affectivity with respect to animals has reached the stage where man has no alternative but to try to produce artificial steak without killing anything. Sadly this is impossible both today and in the immediate future where this book by Makanin takes us. He ties together several destinies, including that of a man afflicted by animals lying by the roadside after being run over. At the time, I too suffered from this affliction whenever we came across roadkill – not nearly so often these days given the animals' depletion – and would systematically stop and pick the bodies up. What else could we do, given the magnificent rarity that we got this opportunity to see once it was dead? With these corpses we made *Roadkill Coat*, a coat made entirely from wild animals stupidly run over on the roads of France.

When we put this roadkill coat on show, the first thing the public saw was its symbolic meaning, and hence the political statement. The coat's lining, a silkscreen print of photographs of the run-over animals, offered the key to interpreting the coat itself, and so the public immediately understood that the coat had been carefully constructed from animals picked up off the road and then dissected, that this waste was to my mind intolerable, and that this was something we were denouncing in a work that proclaimed its environmentalist stance. But the object that we produced from this waste also contained a formulation of its transcendence: the meticulous care that went into making it showed the great respect we had for animal beauty – a respect that invalidates any cynical assumption. Lastly, the film *Roadkill Coat* showed the whole sequence of the ritual of collecting, making and also repairing, because in it you see me facing a road, the skins of the victims revived through me by my walking about near their arch-enemies, cars. The whole work, combining the coat object and the film, gives us an idea of the therapeutic importance – which is equally symbolic inasmuch as it functions according to magic principles – that I gave it by following the family shamanist tradition. But you only have to see the coat to perceive the affective charge that is deliberately placed in it for therapeutic purposes. Moreover, the film, which can also be viewed on its own, is an additional offering, the definitive expression of the request for redemption already contained in the recovery of the animal skins that make up the coat. For us it was a matter of conveying a quality of empathy, and then a consoling or mending world view; an artistic design that might toe the line of the cathartic view of the cinema as stated late on by Jean-Luc Godard: 'the cinema is made to cure diseases, insofar as it conveys a thought that must cure social diseases and help to think how to cure physical ailments'.7

7 Jean-Luc Godard, *Ecrits, documents et entretiens* (Paris: Cahiers du Cinéma, 1998).

It is this same search for an image capable of modifying and maybe mending our awareness of reality that led us to take an interest in the so-called Kirlian effect. The Kirlian effect is the photographic result of the physical manifestation of high-frequency waves radiated by the human psyche. These waves were recorded for the first time by Semyon Kirlian in 1939 using electrophotography, a photographic process that converts the non-electrical properties of an object into electrical properties by means of a high-voltage electric field. On the strength of the observation that living bodies emitted radiation corresponding not only to their visible parts, but also to parts that had become invisible such as amputated limbs, Kirlian established in the 1960s the link between this radiation effect and the experimenter's physiological and psychological state. Today very fashionable in the United States, where Kirlian photography is used to diagnose the energy state of patients with long-term diseases (cancer, depression, etc.), this process,

← *Roadkill Coat*, 2000.

often called *aura photography*, is now being revolutionized by its new applications in digital video. Indeed, if we consider the idea that the electromagnetic aura given off by bodies changes with the psychic state of the experimenting subject, we can imagine the fantastic surprise of seeing this modification taking place directly on screen. Far from the question of the scientific probability of such ideas, what fascinated us as artists was its fantastic aspect, of even imagining being able at last to visualize on a large screen the plausibility of telepathy not just with a human being but better still with an animal with which communication is reduced to estimation. So we thought up a device that has two videographic stations to calculate the Kirlian effect, functioning simultaneously. On one side, the artist is in front of the viewer, connected to a biosensor box, filmed continuously by the device's camera, with the box and camera connected to the software calculating the electrical field coming from from him. The data transcribed by the software is then projected live, by video, onto a wall opposite the viewers, and with the software reading grid you can interpret the experimenting artist's psychic state. On the other side, an animal of similar weight to a human, and used to the artist's presence, is also connected to an equivalent device, producing the unexpected image of an animal aura on an adjacent wall. The artistic performance is then set up: the artist tries to communicate with the animal through the emotions, with no words exchanged, in the hope that the effects of this exchange will show up directly on the two projections. This *Telepathic Video Station* is an attempt to convey to the public the emotional content of the man and the animal through the electromagnetic emanation from the skin. It initially requires a scale of recorded values to be established on various animals, and the images produced as part of this exhibition are so many *research notebooks* aimed at finalizing this goal. And already these images are a source of fascination for us, because they give us some idea of a very special carnal animal vitality.

Hadji's aura, 2006.

Courtesy the artists

This vitality is also central to our latest artistic experiment in progress, *Que le cheval vive en moi* [*Let the horse live in me*]. This is an attempt at 'Bio Art' and extreme body art in which the animal foreign body, here the horse, is hybridized with the human body by means of an injection of horse's blood. But far from a fatal intrusion, such as that of the mythological hero Midas who was said to have committed suicide by drinking bull's blood,[8] the idea is to carry out genuine therapeutic research whereby the horse's blood is made compatible and has a saving effect. For this purpose, I am trying out different horse tissue immunoglobulins one by one on my own organism in order gradually to adjust to the injection, which will contain several. Early results show that the horse immunoglobulins recognize the targeted tissues and induce a functional regulation of these tissues that is specific to them. Already I am no longer completely human! I am, of course, not the only person trying out this experiment. Some very ill patients are using it to improve the state of their immune system, but I am doing it in the full awareness of this intrusion of a foreign body under my own skin, in the full awareness of the *hybridization*, and beyond a purely symbolic gesture. For me it is about broadening my bodily feelings and understanding, in my flesh, the specificity of animal experience, which clearly has a different rhythm and energy.

As far back as I can recall, I have known that I never dissociated the logic of therapy and the logic of creativity. As Maurice Fréchuret explains in *L'art médecine*,[9] there have always been artists who have viewed the pursuit of art in terms rather of mending than of breaking. One of the greatest art historians ever to make an incursion into the field of anthropology, Aby Warburg, thought exactly the same. Thus, in his book on the snake-dance ritual,[10] he claims to be able to clarify the irrational character of the images through having himself experienced insanity. But he also states that on the contrary, once

8 According to Strabo, *Geography* I.21.

9 Maurice Fréchuret and Thierry Davila, *L'art médecine* (Musée Picasso, Antibes; Paris: RMN, 1999).

10 Aby Warburg, *Images from the Region of the Pueblo Indians of North America* (Ithaca, NY: Cornell University Press, 1997).

analysed, these irrational images become therapeutic tools for himself, as they construct cultural systems of self-control. Thus the 'snake ritual' he talks about, in which the animal the Pueblos hold to be the most frightening becomes an object of control, being held in the dancer's mouth before being released, highlights in Aby Warburg's eyes a therapeutic social anxiety control technique. Indeed, the image of the snake, likened to that of the lightning flash, makes it possible by transposition, if it is controlled, to control in return the anxiety caused by the possible lack of rain... The anxiety gives rise to symbols to which an activity is attributed, and controlling them is then to control the anxiety itself. In a way, his analysis written in 1923 may be regarded as one of the very first 'ethnopsychiatric' analyses[11] in history. In his case, it is the theorization of this idea that turns out to be therapeutic, because a second transposition takes place which, from the example of the ritual of empathy, will produce Warburg's rescue device: the controlled exposition of his theory. The *Que le cheval vive en moi* project comes close to the logic set up by Aby Warburg, as here the performance also functions as an attempt to master the anxiety of the exogenic living element, which is an artistic projection for any person who has to undergo this type of intervention in the future.

The utopia of the cure through art is not to be taken lightly, there is a real link between the way certain artists operate and how their work is received by the public. And this utopia is primarily an ethical choice. Joseph Beuys did not let methodological concepts get in the way when responding to the question of meaning in his creation: 'You can say that I am practising medicine with none of the formalities'.[12] It is this same meeting with a shamanist culture that enabled him partly to resolve the question of German cultural identity suffering post-war trauma, by restoring a link between the experienced/embodied and ideology/the political. And I would be tempted to say, from the experience of the construction of a work that seeks to be therapeutic, that this meeting takes place all the more for the work being constructed in this *experimentation on oneself* which reconciles the 'encasing function' of the container, of the image (or the object) with the 'transformative function' of the vector. As mere observation ultimately only allows the existence of the 'transformative function', the artist is more and more tempted to take upon himself, to take within himself, to absorb the world, to view it as a field for experiment to be incorporated, to restore a modified state of awareness of it. And maybe this is an inevitable adaptation?

11 'transcultural psychiatry' is the standard English translation of 'ethnopsychiatrie' commonly used in French.

12 Clara Bodermann-Ritta, *Joseph Beuys, Jeder Mensch ein Künstler. Gespräche auf der Documenta 5* (Vienna, 1972), and Axel Hinrich Murken, *Joseph Beuys und die Medizin* (Münster: F. Coppenrath, 1979), 145.

Marsyas – beside myself KIRA O'REILLY

Action 1
Art gallery.
Two leeches are placed on my back.
They feed until sated.
They drop off.
Audience drink red wine.
Bite wounds bleed continuously down back.

Action 2
Hotel function room
A birthday party
Guests drink brandy.
The brandy glasses are heated with a flame and placed over open cuts on my back.
The vacuum sucks out blood, which mixes with saliva.
Guests eat birthday cake.

Action 3
Private back room in a pub
Deep cuts are made into the skin.
22 glass fire cups are placed on cuts.
Skin is pulled and bleedings made.
Some one gets faint and chocolate melts in my hand.
Everyone drinks G and Ts afterwards and gets a bit pissed.

Action 4
A very large room during a very hot night
I sit opposite you on a chair.
I position a grid of surgical tape on legs and torso.
With a scalpel I make a diagonal cut into each square.
I am 'cut like a French summer doublet'[1]
I bleed opposite you.
The following night during hotel sex the newly scabbed cuts crunch and tear underneath.
Diagonal grid blood prints on sheets.

Action 5
Another Art Gallery.
I position a grid of surgical tape over walls.
Over 5 days I make a diagonal mark with blood from my body into each square.
Metronome counts 72 beats per minute.
Viewers are told *do not lick the walls*.

Action 6
The bathroom at HOME.
Her mother runs a bath.
A print of lace stencilled in her blood edges the bath and covers a wall.
She gets into the bath.
Body dislodges water to precisely cover lace blood, it dissolves.
Eureka.
The other people in the room press around the bath.

Action 7
A disused bomb shelter.
They come in alone, one at a time.
They sit next to me.
They wear latex gloves and hold a surgical scalpel.
I tell them *do not do anything you do not want to do*.
About half of them make a cut into my body with the scalpel.
I ask them to hold me.
We look into camera and monitor and watch ourselves watching ourselves in anxious pietàs.

How to have a body?
How to be a body?
How to be a body NOW?

Marsyas
The Greek myth of Marsyas became a popular vehicle in European Renaissance art with which to express both the anxieties and excitement of accelerated anatomical exploration. Marsyas, a satyr, lost in a competition of musicianship to Apollo, and as punishment was flayed alive, becoming 'one whole wounde'[2] and rendered 'into the matter of art',[3] a destabilized body of alterity.

These themes echo the contemporary speed of innovations within the biotechnical and biomedical and are reflective of the concerns my research of *how to be a body, how to have a body – now*.

My practice considers the body as a site in which narrative threads of the personal,

inthewrongplaceness, HOME, 2005.

Photo © Manuel Vason

1 Thomas Nashe, *The Unfortunate Traveller*, quoted in J. Sawday, *The Body Emblazoned* (London: Routledge, 1996).

2 Ovid, quoted in Sawday, *The Body Emblazoned*, 186.

3 Sawday, *The Body Emblazoned*, 185.

sexual, social and political knot and unknot in shifting permutations. The materiality or fabric of the body, as well as its specificity investigated within a constant flickering between The Body and *my body*. The relationships between bodily interior/exterior spaces are explored as a continuum; the permeable boundaries of the skin membrane defy it as an impenetrable container of a coherent or fixed 'self'.

Running out of skin

Extract from a Wellcome Trust sciart research and development application, 2003: 'Within the context of engaged artistic and scientific collaboration that SymbioticA provides, the proposal is to re-evaluate the body as site and as material working with tissue culturing and engineering skin grown from Kira O'Reilly's body. Previously O'Reilly has dealt with the trace and residue of the body, therefore to work with a bodily materiality that originates from *her* body but has a continued *living* existence and proliferation *in vitro* presents an entirely new set of possibilities.'

Lace – generating tensions

'O'Reilly has been interested in processes being pioneered in attempts to grow artificial organs that bear resemblance to fine art print making techniques,[4] leading her to consider growing skin in 2-dimensional patterns, in this case a simplified lace design. Making lace involves a generation of tensions into patterned networks, gaps and loops. Its associations suggest the domestic, the intimate, the private, the personal, undergarments, the feminine, the excessive, precious and precarious.'

PIG SECTION

First skin biopsy of pig: MAKING A PIG'S EAR OF IT

Action 8

Large animal facility and PC2 laboratory.
Sterilize outside of pig with 70% ethanol
Cut ear off with knife.
Put in sterilized bag.
Place inside sterile hood.

4 A. Ananthaswamy, 'Light Works for Organ Engineers', *New Scientist* (4 January 2003), 19. C. Choi, 'Replacement Organs Hot off the Press', *New Scientist* (25 January 2003), 16.

Remove small sections of skin separating dermis and epidermis.
Go for dermis. Epidermis v. thin with keratinized cells.
In dermis will get fibroblasts, some stem, maybe some viable keratinocytes.
Place tissue in dish
Trim away unwanted tissue.
Leave in dish with P/S for 30 mins.
Wash with suitable solution, e.g. PBS
Mince tissue working in PBS
Put in DMEM with 10% P/S and fungizone.
Put in Primary culture flask (with stirrer)
Add trypsin (25% trypsin solution in PBS)
Incubate on stirrer plate and monitor disaggregation, agitating periodically checking every 5–10 mins.
Maybe 15 mins.
No longer than 30–40 mins.
Not everything will disassociate, don't worry.
Add medium with serum to inhibit trypsin.
Pass through filter to remove lumps
Centrifuge x 2. 1600 rpm for 12 mins.
The pellet at the bottom is the goodies.
Remove.
Add cells to medium – 20% FCS in DMEM.
Add fungizone.
Minuscule amount.
1 drop per 50 mls.
Put in T.C. flask
Leave overnight.
Check next day

I dream I am laying next to pigskin, pig alive but skin open to no interior.
I am stroking the ears closely.

When I cut pig I have an urge to delve both hands into the belly, to meld into her warm flesh, my blood to her blood, for a moment the same temperature before one lowers cataclysmically.

When my clumsy blade accidentally tears her gut I see pig's breakfast spill. In my mind's eye I see my breakfast spill.

Following the pig biopsy I feel deeply ashamed.

You stupid, stupid cow.

The primary culture of pig dermal fibroblast proliferate with abundance.

Tissue culture point of view

Dr Honour Fell was one of the most prominent scientists working with tissue culture at Strangeways Laboratory, Cambridge UK from 1926. She lectured and wrote about the 'tissue culture point of view', a reconceptualizing of life and death and the body and the impact of tissue culturing onto research.

> Tissue culture often suffers from its admirers. There is something rather romantic about the idea of taking living cells out of the body and watching them living and moving in a glass vessel, like a boy watching tadpoles in a jar. And this has led imaginative people to express most extravagant claims about tissue culture . . . [5]

I start to conceive of these primary cell cultures within a moving matrix of a softly shifting emphasis, be it the actions of changing nutrients, the plastic wear, the consumables, the contextual space, the laboratory furniture and myself moving along the vectors of life/non-life.

I am left with an undercurrent of pigginess and fantasies of mergence, interspecies metamorphoses.

The narrator of the novel *Pig Tales* confides the beginning of her own porcine transformation:

> I'd put on weight – four or five pounds, perhaps – because I'd started feeling constantly hungry, and I could see in the mirror that these pounds had distributed themselves nicely around my figure. Without sports, without any particular exercise, my flesh had become firmer, smoother, plumper than before. Now I understand that this extra weight and the wonderful quality of my flesh must have been the very first symptoms.[6]

Pig 4

Boo does a pig bone biopsy.
I assist.
As with all the others it's from a pig that has been sacrificed for research, its lungs extracted for asthma research.
Another female pig.
I plunge my hand inside a gouged cut in the back leg.

A doubting Thomas moment.
The flesh is warm, dying around me.
Erotic frisson.
Scenarios jostle together contesting the piggy meat flesh.
My fingers seek out the hipbone to feel the smoothness.

The pig leg goes to the sterile hood for the bone marrow to be extracted and cells harvested.
Then to Oron's desk as food for Herman, his dog
Then the rapid realization that it's pumped full of 'non recoverable anaesthetics'.

The play of form, signs and signifiers within the shifting contextual fabric of the science institution. Non-human animal, partial object, flesh, bio art resource, meat, food, and finally – biohazard.

How not to have a biopsy (driving the wrong way)

I, ___Kira O'Reilly___hereby consent to the surgical procedure of taking a spit skin biopsy and that it has been explained to me.
I understand the following are possible risks involved:

- Pain
- Bleeding
- Infection
- Scar formation
- Persistent redness
- Increase or decrease of skin pigmentation
- Local nerve damage or numbness
- Severe allergic reaction to the local anaesthesia, dressing.

I have been given the opportunity to ask questions regarding the procedure and its risks.

Appointment with surgeon for biopsy, 11.20 a.m.

I spend all morning preparing consumables and transportation of cultures.
Everything is ready.

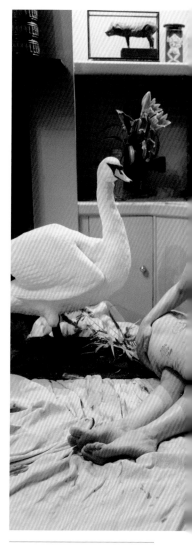

inthewrongplaceness, HOME, 2005.

Photo © Manuel Vason

5 Quoted by Susan Merrill Squier, 'Life and Death at Strangeways: The Tissue-Culture Point of View', in P. Brodwin (ed.), *Biotechnology and Culture: Bodies, Anxieties, Ethics* (Bloomington: Indiana University Press, 2000), 33.

6 Marie Darrieussecq, *Pig Tales. A Novel of Lust and Transformation* (London: Faber & Faber, 1997).

Protocol for obtaining epidermal keratinocytes from skin biopsy

1. Wash skin thoroughly with cold sterile PBS
2. Treat skin with Fungizone (diluted 1:100 with PBS) for 15 mins at RT
3. Dissect skin into 1 x 2 cm pieces with scalpel
4. Incubate skin with 2.4U/mL dispase (grade II) at 37 °C for 30 mins
5. Monitor separation of epidermis from dermis
6. When two layers start to separate at edges, stop reaction by washing skin with serum-free media
7. Separate epidermis from dermis using two fine curved forceps
8. Place epidermis in 50mL falcon tube
9. Incubate in 0.2% trypsin and 0.05% EDTA for 10 mins at 37°C
10. Wash cells in serum-free media x 2
11. Determine cell viability using trypan blue staining

Primary culture of epidermal keratinocytes

Seed keratinocytes at high density (1–5 x 10^5 cells/cm^2) in collagen-coated dishes containing medium + 5–10% serum for initial adhesion.

Leave lab at 11.05 to drive short distance to clinic for 11.20 a.m. appointment.

We turn left.
And left, and the wrong left and the
 wrong right.
We get lost.

I phone.
Too late.
Can't reschedule.

Email to friend

Dear Guy,

I am beside myself.

How can I write about the body and bio art and a shuttling of desire to extend 'oneself' through the process of biopsy, cell isolation and cultivation, through an appropriation and elaboration of a technology, and then to lose sight of oneself because that

extended presence cannot be considered any more 'one's self'.

And then to complicate matters, performing or rather rehearsing that scenario four times with a pig's cadaver; using the pig as dummy, stand in, double, twin, other self, doll, imaginary self; making fiercely tender and ferocious identifications with the pig, imaginings of mergence with the pig, co-cultured selves, and to cultivate and nurture pig bits for months. Taking a cutting of 'something' that felt like someone dying and keeping a little bit of it living and proliferating – like a plant.

You stupid, stupid cow.

Then the non biopsy of myself, to have what seemed like the final moment, the cutting off of me, the minuscule flaying of my skin by 'the surgeon', deferred ad infinitum.

Stunned surprise stunned out of language, stung out of body, mouth open, agape with stunning silence.

This stuff moves all the time, between actual, imagined, lived, living, day dreams and other dreams, all other living things that I have planted in tissue culturing flasks in dark warm spaces.

Best,

K

SCALE

Losing sight

The cells' cultures tip over the threshold of sight into the microscopic. In his *Book of Skin*, Steven Connor refers to notions of extreme delicacy, untouched by hands and worked from a distance with instruments, 'hay spun into gold, the elf fingers sewing shoes',[7] invoking a materiality that invokes the aseptic rituals of containment, and – frequently – invisibility within the laboratory.

In *The Third Policeman* Flann O'Brien's main character encounters Policeman MacCruiskeen, who has crafted a succession of elaborately carved wooden boxes that fit inside one another in proportions diminishing into infinitesimal tininess.

7 Steven Connor, *The Book of Skin* (London: Reaktion, 2004), 287

He says:

> ...What he was doing was no longer wonderful but terrible. I shut my eyes and prayed that he would stop while still doing things that were at least possible for a man to do.
>
> When I saw the table it was bare only for the twenty-nine chest articles but through the agency of the glass I was in a position to report that he had two more beside the last ones, the smallest of all being nearly half a size smaller than ordinary invisibility.
>
> 'Number twenty-two [Policeman MacCruishkeen says] I manufactured fifteen years ago and I have made another different one every year since with any amount of nightwork, overtime and piecework and time-and-a-half incidentally.'
> 'I understand you clearly,' I said.
> 'Six years ago they began to get invisible, glass or no glass. Nobody has ever seen the last five I made because no glass is strong enough to make them big enough to be regarded as truly the smallest things ever made. Nobody can see me making them because my little tools are invisible into the same bargin. The one I am making now is nearly as small as nothing. Number one would hold a million of them at the same time...'[8]

TIME

On seeing the palimpsest of fading cuts, disrupted skin architecture of scars on my body during a talk recently, a Hong Kong artist said 'you work with time'.

Biotechnology routinely offers another time, the topographical time of Michel Serres' handkerchief that crumpled and torn in the depths of a pocket allows metric, linear time to collapse into an unexpected topography of proximities and distances where other connections are made and events pulled backwards and forwards in the same time at the same place. Immortalized cell lines and cryofreezing cultures create another mapping of bodies' absence and presence. Serres tells the story of some brothers who

as old men attend the funeral of their father whose body is frozen into youth, recovered from a mountain where it had disappeared in an accident and frozen a long time ago when he was a young man.

LACE

Western Australia, Lace Guild meeting.

Mount Helena, Perth.

Lots of tea and cake.

I have been invited there to speak about my research and to ask for their help in constructing lace scaffoldings for skin cultures to be seeded onto.

I tell them about Alexis Carrel, a pioneer of tissue culture technology, developing blood vessel suturing techniques inspired by his mother's embroidery skills and those of Madam Leroidier with whom he studied.

I talk about tissue culturing of skin, which they know about because of Perth-based Dr Fiona Wood's life-saving work generating skin cultures for the treatment of many of the Bali bombing victims of 2002.

84-year-old Olive can no longer see well enough to make lace but she watches my laptop monitor whilst a 3T3 time-lapse movie plays.

'What are they?' She asks me. 'They are mouse cells', I reply, 'from a mouse that lived a long, long time ago.'

We play it again and again and watch fibroblasts migrate, connect, spindle gaps loops and connections.

She is enchanted.

She tells me she wishes she could make lace like that. 'You have your lace already,' she says.

I tell them I'm getting OK at tissue culturing but that my fingers refuse lace making.

They speak of webs and spiders, leaf lattices, cross stitches, whole stitches, half stiches, and mathematical engineering of gaps and holes into garters, handkerchief edges and tissue.

inthewrongplaceness, HOME, 2005.

Photo © Manuel Vason

8 Flann O'Brien, *The Third Policeman* (London: MacGibbon and Kee, 1967), 73–74.

They make me tiny lace out of cotton and Vicryl absorbable sutures to seed with fibroblast, pig skin cells, my skin cells.

They have the raffle and ask me to draw the ticket.
I draw my ticket number.

I win an embroidery kit for beginners.

POST SCRIPT

inthewrongplaceness
(version I)

Action 9

The pig is called Kill no. 000053

She weighs 48.5 kg
Before coming into the room one person at a time, audience members read:

You will have approximately ten minutes in the room
You may move around the space or sit
You may touch the human animal and the non-human animal.
Before doing so:
Put on the gloves
Spray the gloves with the ethanol using the sprayer in the room
Do not do anything you do not want to do

My head inside her rib cage.
Inside her death, contemplating a career change.

The scent of lilies fills the space around and inside me and her, invisible architectures of chemical edifices, mathematical and exquisite against the cool minimalist tempo of ethanol.

I didn't see his face.
He put the gloves *on*
and proceeded to *touch*, to feel out, was I flesh, meat, body, lover, carcass, piece of meat, who knows and what was she?
He stayed off erogenous zones, *just about*.
Latexed and ethanoled hands opened her between my legs with expert determination,
touch and gaze merged in squeeze, caress, stroke and pulling of both of us.

Bits of flesh falling off.
Eyelashes.
Tiny eyes.

Stroking the ear softly.
Me being stroked softly.

Warm and cold.

Her skin draping around me.
Her unrelenting flesh and weight.
Wearable space.
Corporal pocket.

I carry her and carry her and carry her in absurd and futile efforts to achieve some kind of animation,
disappearing inside of her, out of her.

This little piggy went to market.
This little piggy stayed at HOME.

I hear someone burst into tears softly as they leave the room?

I weep my head inside her

Little cells, piggy cells and mine to make a supple, soft articulating sheen of a skin, to (h)ear myself inside myself.

Cavernous piggy, soft internal organs removed

My eyes fall – on the piggy body, rolling away from me over curves of body

I am beside *my – self*

You stupid, stupid cow.

This text is a revised version of a piece originally written to be read at the *Bio Difference* conference, Biennale of Electronic Arts Perth, 11 September 2004.

Thank you to: Jens Hauser, FACT, SymbioticA and HOME, London, the original commissioners of *inthewrongplaceness*.

Extra Ear: Ear on Arm STELARC

A project for an *Extra Ear* as a soft prosthesis was proposed in 1996. Originally it was modelled on the side of the head, but anatomically this was not a suitable site for the surgical construction of an ear. The skin of the scalp is very tight and the site was too close to the jaw bone and facial nerves, such that any surgery performed might have caused partial paralysis. So the positioning of the ear had to be reconsidered.[1] In 2002, with the encouragement of Dr Stuart Bunt, and in collaboration with the Tissue Culture & Art project at SymbioticA, a series of small replica ears of the artist using living cells were grown. *Extra Ear: ¼ Scale* was first exhibited in 2003 using human donor cells. It was also later grown with mouse cells and the cells of the HeLa cell line. Using tissue culture and biodegradable scaffold techniques meant that only small replicas could be grown. The result was thus a partially living construct, but one that could not be prosthetically attached to the body. An incomplete organ without a body.[2]

An extra ear is presently being constructed on my forearm: a left ear on a left arm. An ear that not only hears but also transmits. A facial feature has been replicated, relocated and will now be rewired for alternate capabilities. Excess skin was created with an implanted skin expander in the forearm. By injecting saline solution into a subcutaneous port, the kidney-shaped silicon implant stretched the skin, forming a pocket of excess skin that could be used in surgically constructing the ear. A second surgery inserted a Medpor scaffold with the skin being suctioned over it. Tissue cells grow into the porous scaffold, fusing it to the skin and fixing it in place. At present it is only a relief of an ear. The third surgical procedure will lift the helix of the ear, construct a soft earlobe and inject stem cells to grow even better definition. The final procedure will implant a miniature microphone that, connected with a Bluetooth transmitter, will enable a wireless connection to the Internet, making the ear a remote listening device for people in other places. This additional and enabled ear effectively becomes an Internet organ for the body.

JH: What does it mean to move from the artistic use of hard prostheses to soft prostheses?

S: Well, you quickly realize that the body is a living system which isn't easy to surgically sculpt! The body needs time to recover from the surgical procedures. There were several problems that occurred: a necrosis during the skin expansion process which necessitated excising it and rotating the position of the ear around the arm. Ironically, this proved to be the original site that the 3D model and animation visualized! Anyway, the inner forearm was anatomically a good site for the ear construction. The skin is thin and smooth there, and ergonomically locating it on the inner forearm minimizes the inadvertent knocking or scraping of the ear. During the second procedure a miniature microphone was positioned inside the ear. At the end of the surgery, the inserted microphone was tested successfully. Even with the partial plaster cast, the wrapped arm and the surgeon speaking with his face mask on, the voice was clearly heard and wirelessly transmitted. Unfortunately it had to be removed. The infection caused by the implanted microphone several weeks later was serious. In fact, being admitted into ER with an ear infection took some convincing of the triage nurse! It resulted in an operation to extract the microphone, to insert additional tubing around the ear, and a week in hospital tethered to an IV drip. To try to completely eradicate the infection we had to flush the site every hour on the hour during my hospitalization and I was on industrial strength antibiotics for about three months.

1 The original proposal can be seen at http://www.stelarc.va.com.au/extra_ear/index.htm

2 For images and information see http://www.stelarc.va.com.au/quarterear/index.html

JH: *Since the early Suspension pieces the stretching of skin in your work stands for stretching the definition of what a body is. Once this notion is stretched, what does growing add?*

S: The suspended body was a landscape of stretched skin. The body was seen as a sculptural object. In constructing the ear on the arm, the skin was also stretched, but this was in preparation for additional surgical reconstructive techniques and finally stem cell growth to give it more pronounced form. To fully realize the external 3D ear structure will require further operations to lift the helix of the ear. This will involve an additional Medpor insert and a skin graft. The Medpor implant is a porous, biocompatible polyethylene material, with pore sizes ranging from 100 to 250 mm. This can be shaped into several parts and sutured together to form the ear shape. Because it has a pore structure that is interconnected and omnidirectional it encourages fibrovascular ingrowth, becoming integrated with my arm at the inserted site, not allowing any shifting of the scaffold. We had originally considered mounting the ear scaffold onto a Medpor plate thinking that this might elevate it more, and position it more robustly to the arm. But this wasn't the case and this solution was abandoned after being tested during surgery. Now, implanting a custom-made silastic ridge along the helical rim would immediately increase helical definition but also would make room for later replacement of that ridge with cartilage grown from my own tissues. The earlobe will most likely be constructed by creating a cutaneous 'bag' that will be filled with adipo-derived stem cells and mature adipocytes. Such a procedure is not legal in the USA, so it will be done in Europe. It's still somewhat experimental with no guarantee that the stem cell growth will be smooth or even – but it does provide the opportunity of sculpturally growing more parts of the ear... and possibly resulting in a cauliflower ear!

JH: *You seem to consciously create a perceptive conflict between the slowness of the biomedical process and the plug-and-play use of the* Extra Ear *as an accelerating electronic body extension.*

S: Well, this project has been about replicating a bodily structure, relocating it and now re-wiring it for alternate functions. It manifests both a desire to deconstruct our evolutionary architecture and to integrate microminiaturized electronics inside the body. It also sees the body as an extended operational system, extruding its awareness and experience. When the microphone is re-implanted within the ear and connected to a Bluetooth transmitter, sounds the ear 'hears' will be wirelessly transmitted to the Internet. You might be in Paris, logging on to my website and listening to what my ear was hearing, for example, in Melbourne. Another alternate functionality, aside from this remote listening, is the idea of the ear as part of an extended and distributed Bluetooth system – where the receiver and speaker are positioned inside my mouth. If you telephone me on your mobile phone I could speak to you through my ear, but I would hear your voice 'inside' my head. If I keep my mouth closed only I will be able to hear your voice. If someone is close to me and I open my mouth, that person will hear the voice of the other coming from this body, as an acoustical presence of another body from somewhere else.

JH: *Therefore one would say that this concept of inter-face as inter-ference is the recurrent theme.*

S: We certainly need to undermine the simplistic idea of agency and the individual. This project links up in certain ways to my past work. In the performance *Fractal Flesh*3 my body was involuntarily moved by people in other places using a touchscreen interface system

3 *Fractal Flesh* was staged as part of the 1995 *Telepolis* event, with the main performance site located in Luxembourg. See http://www. stelarc.va.com.au/fractal/ffvid. html

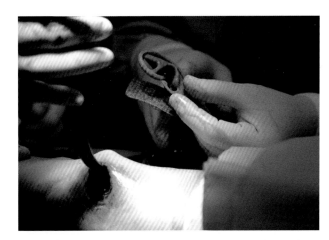

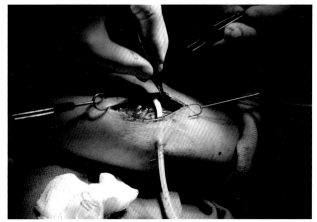

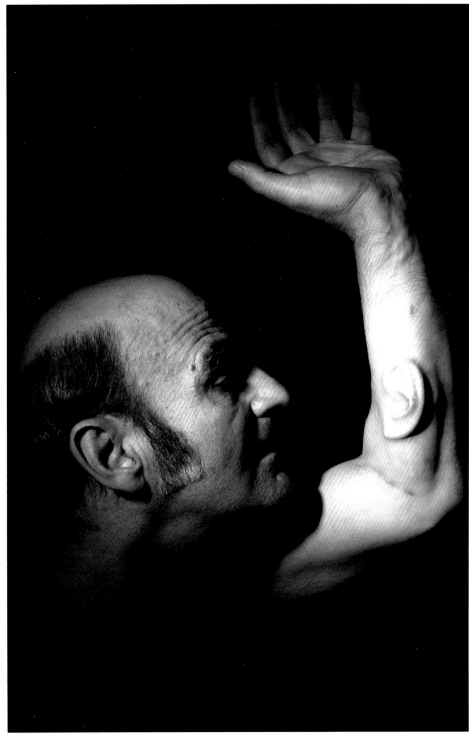

Extra Ear: Ear on Arm (Scaffold)
London, Los Angeles &
Melbourne 2006.

Photo © Nina Sellars

that controlled muscle stimulation equipment connected to the body. People in the Centre Georges Pompidou in Paris, the Media Lab in Helsinki and the *Doors of Perception* conference in Amsterdam remotely choreographed the body located in Luxembourg. Half of this body was controlled by people in other places, the other half could collaborate with local agency. It was a split body experience. Voltage-in (on the LHS) moving the body, voltage-out (from the RHS) actuating a mechanical *Third Hand*. So the notion of single agency is undermined, or at least made more problematic. The body becomes a nexus or a node of collaborating agents that are not simply separated or excluded because of the boundary of our skin, or through having to be in proximity. So we can experience remote bodies, and we can have these remote bodies invading, inhabiting and emanating from the architecture of our bodies, expressed by the movements and sounds prompted by remote agents. What is being generated and experienced is not the biological other but an excessive technological other, a third other. A remote and phantom presence manifested by a locally situated body. And with the increasing proliferation of haptic devices on the Internet it will be possible to generate more potent phantom presences.

JH: *When Marshall McLuhan devilishly prophesied that 'in the electric age we wear all mankind as our skin' he might have referred to connectiveness both as increasing awareness of our media extensions and as a burden as well.*

S: It's certainly a condition that needs to be managed. What's also interesting is the observation that electronic circuitry becomes our new sensory skin and the outering of our central nervous system. The idea that technological components effectively become the external organs of the body. Certainly what becomes important now is not merely the body's identity, but its connectivity – not its mobility or location, but its interface. In these projects and performances, a prosthesis is not seen as a sign of *lack* but rather as a symptom of *excess*. As technology proliferates and microminiaturizes it becomes biocompatible in both scale and substance and is incorporated as a component of the body. These prosthetic attachments and implants are not simply replacements for a part of the body that has been traumatized or has been amputated. These are prosthetic devices that augment the body's architecture by constructing extended operational systems. The body performs beyond the boundaries of its skin and beyond the local space that it occupies. It can project its physical presence elsewhere. The *Third Hand*, the *Extended Arm* and the *Exoskeleton* walking robot are external machines and systems constructed out of steel, aluminium, motors and pneumatic systems. I was always intrigued about engineering a soft prosthesis using my own skin, as a permanent modification of the body architecture hopefully adjusting its awareness. Of course this architecture is still open to the systemic malfunctioning of the body, the possibility of contamination and infection and of course to the longevity of the body itself. The biological body is not well *organ-ized*. The body needs to be Internet-enabled in more intimate ways. The *Extra Ear: Ear on Arm* project suggests an alternate anatomical architecture – the engineering of a new organ for the body: an available, accessible and mobile organ for other bodies in other places. Locate and listen in to another body elsewhere...

Interview by Jens Hauser

Acknowledgments for *Extra Ear: Ear on Arm*: Surgical Team: Malcolm A. Lesavoy, MD, Sean Bidic, MD and J. William Futrell, MD; Stem Cell Consultant: Ramon Llull, MD; Project Coordination: Jeremy Taylor, October Films, London; 3D Model & Animation: The Spatial Information Architecture Lab, RMIT, Melbourne; Photographer: Nina Sellars.

The Telepresence Garment EDUARDO KAC

The *Telepresence Garment* (1995/1996) explores the ways in which technology envelops the body, suppresses self-control and shields the body from sensorial experience of the environment. Instead of a robot hosting a human, the *Telepresence Garment* presents a roboticized human body converted into the host of another human. Quite unlike utopian or escapist portrayals of the potential of networking technologies, the *Telepresence Garment* is a sign of their invisible implications.

A key issue which I explore in my work is the chasm between opticality and cognizance, that is, the oscillation between the immediate perceptual field, dominated by the surrounding environment, and what is not physically present but nonetheless still directly affects us in many ways. The *Telepresence Garment* creates a situation in which the person wearing it is not in control of what is seen, because he or she cannot see anything through the completely opaque hood. The person wearing the garment can make sounds but cannot produce intelligible speech because the hood is tied very tightly against the wearer's face. An elastic and synthetic dark material covers the nose, the only portion of flesh that otherwise would be exposed. Breathing is not easy. Walking is impossible, since a knot at the bottom of the garment forces the wearer to be on all fours and to move sluggishly. The garment is divided into three components. The transceiver hood has a CCD (charge-coupled device)[1] attached to a circuit board, both sewn to the leather hood on the left side, and an audio receiver sewn onto the right side. The CCD is lined up with the wearer's left eye. Underneath the garment, the wearer dons in direct contact with the skin what I call a transmitter vest, which is wired to the hood and enables wireless transmission of 30-fps colour video from the point of view of the wearer's left eye. Enveloping the body is an opaque 'limbless suit', so-called because one cannot stand or stretch one's arms, temporarily reducing or eliminating the functionality of the limbs. Instead of adorning or expanding the body, the *Telepresence Garment* secludes it from the environment, suggesting some of the most serious consequences of technology's migration to the body. Body sensations are heightened once the wearer removes the garment. This *prêt-à-porter* foregrounds the other meanings of the verb 'to wear': to damage, diminish, erode or consume by long or hard use; to fatigue, weary or exhaust.

Physical distance is at once erased and reaffirmed by new technologies. This condition raises the relevant question of how telecommunications technologies – including telepresence, the Internet and the coupling of both – affect the ways in which we acquire and create knowledge. Ultimately, the question is not how these technologies *mediate* our exploration of the world, local or remote, but how they actually *shape* the very world we inhabit. Any technology embeds cultural and ideological parameters that, in the end, give shape to the sensorial or abstract data obtained through this very technology. Telescopic and telecommunicative technologies are no exception. In science, the selection of a research topic and the extraction, accumulation and processing of data, as well as the interface through which the data are later explored, are themselves an integral part of the nature of the data. They are not a detached element which causes no interference in what is experienced. Quite the contrary: the knowledge we acquire through instruments and media is always modulated by them. They are not separable. While in science we observe the drive to build instruments capable of ever more 'precise' measurements, in art we can freely and critically explore the ways in which these instruments and media help define the nature of the reality thus produced. While in science the elimination of what is not repeatable produces the field where knowledge is possible, in art the irrepeatable

1 A charge-coupled device is the light-sensitive chip used as the imaging device in modern cameras.

is celebrated as the singularity that enables aesthetic knowledge. Clearly, artists working critically with scientific instruments must be aware of how meaning is created in the realm of science.

Increasingly, people, ideas, objects, influence and money move fluidly between two or more places. Acquaintances, colleagues, friends and family members dispersed around the world routinely employ email, chat and videoconferencing software to work together, express affection or simply stay in touch, thus reaffirming social and familial bonds. As a result, we have the notion that a community can exist and thrive as a dispersed but interconnected group in many places at once. We have also become acutely aware of the interconnectedness of world economies and ecologies. Glaring examples are the financial crashes that resonated across Asia, Russia and Latin America in the 1990s and the dramatic consequences of the geographic displacement of viruses and insects around the world as a result of increased travel and commercial shipments.

As we consider some of the vectors that shape the contemporary experience, an astounding list emerges: global economy, digital culture, online relationships, multiplicity of identities in cyberspace, integration of organic and artificial life, microchip implants, biotelemetry, reading and writing of new genes, plasticity of skin and flesh, DNA computers, satellite telephony, xenotransplantation, astrobiology, wearable technologies, neuroprosthesis, telepresence, piracy, patenting and commerce of foreign genetic material, new algorithmic and real viruses. New cartographies are being created as digital technologies generate world maps that show reconfigured contours based on arbitrarily defined shared systems (e.g., DVD region codes using the zone lock feature) and on special network links (e.g., MBone and Internet 2 topology diagrams based on connectivity of routers). Art can contribute to a larger cultural debate by appropriating tools employed in other social sectors (e.g., business, medicine, the military), exposing the fissures within standard approaches to these developments and proposing new models that foreground alternative ways of thinking.

Telepresence (i.e., the union of telecommunications and elements of remote physical action) emerges as a significant parameter in this complex environment. Telepresence is being developed both as a law-enforcement and a medical technology, as a tool for both science and entertainment.[2] We are undergoing cultural perceptual shifts as a result of the remote projection of our corporeal sense of presence. The dynamic, fluctuating interplay between presence and absence on telerobotic bodies creates new aesthetic problems and escapes from rigid formal dichotomies, such as figuration versus abstraction, or physicality versus conceptualism. Expanded through the synergy of organic and cybernetic systems, bodies (human, robotic, zoomorphic or otherwise) renew their relevance in contemporary art – beyond stylistic pictorial concerns and representation politics. Telepresence art offers dialogical alternatives to the monological system of art and converts telecommunications links into a physical bridge connecting remote spaces. Telerobots and teleoperated humans (which I call 'teleborgs') become physical avatars, as they enable single or multiple individuals to actively explore a remote environment or social context.

Telepresence art also shows us that from a social, political and philosophical point of view, what we cannot see immediately around us is equally relevant to what meets the eye. Our satellites probe with equal ease deep space and isolated regions of the earth, revealing unprecedented vistas that shed new light on our presence in the universe. Teleoperated aircraft fly over inhospitable zones to sense and gather valuable data. Telerobots handle explosive devices, excavate the ocean and clean up after nuclear disasters. Speculation about possible extraterrestrial life calls for remote control of telerobots to examine Mars

2 See 'Robo-Shots', *New York Times Magazine* (19 July 1998), 13; John W. Hill and Joel F. Jensen, 'Telepresence Technology in Medicine: Principles and Applications', *Proceedings of the IEEE* 86.3 (1998), 569–80; Samuel Rod and Allan Pardini, 'Telepresence and Virtual Environment Applications at Hanford', *Nuclear News* 39 (January 1996), 34–36; 'LunaCorp Flies Rover to the Moon', *Washington Post* (12 August 1997); Michael D. Wheeler, 'Robotic 3D Imager to Brave Chernobyl', *Photonics Spectra* (August 1998), 34, 36.

beneath the surface. Weather systems in the Pacific affect life in the Atlantic. An African virus could spread and kill in North America. The prospect of nanomachines working in our bloodstreams gives us the notion of our physical bodies as hosts of synthetic agents. Military battles are staged in networked immersive simulators. Hacking, or remote digital attacks through the network, continuously undermine the most secure data-protection systems. Smart bombs seek their targets and show us live video of the trajectory until the aseptic moment of impact. We are affected by the remote as much as we impinge upon the visually or physically absent by the consequences of our collective gestures.

Telepresence art undermines the metaphysical propensity of cyberspace through emphasis on the phenomenological condition of actual remote physical environments. By engaging precepts and effects that constitute the remote sensuous, telepresence evolves an aesthetics based on extending action in the absence of the actant. The distributed vision brought by telepresence art is that of integration of the familiar and the unconventional, towards a more harmonious acceptance of the differences that constitute the shifting ground under our feet and the turbulent air above our head. As optical fibres thread the soil like worms, and digitally encoded waves cross the air like flocking birds, a new ecology emerges. This new ecology conciliates carbon and silicon. To survive the imbalances created by increased standardization of interfaces (which promotes uniformization of mental processes) and centralized control achieved by corporate mega-mergers (which decreases choice), and to thrive emotionally and intellectually in this hostile mediascape, we need to do more than subsist as we adapt. Our synergy with telerobots, transgenics, nanobots, avatars, biobots, clones, digital biota, hybrids, webots, animats, netbots and other material or immaterial intelligent agents will dictate our ability to endure fast-changing environmental conditions in a networked world. Telepresence art can offer new cognitive and perceptual models as well as new possibilities for social agency in the digital network ecology.

In interactive telepresence artworks created since 1986, I have been investigating multiple aspects of this phenomenon. My telepresence work has never been about what it would be like if we could be *there* (i.e., at the remote site). Instead, it investigates how the fact that we are experiencing this remote site in a given way (i.e., through a particular telerobotic body, with a given interface and over a specific network topology) modulates the very notion of reality we conjure up as we navigate the remote space.

The *Telepresence Garment* was experienced publicly for the first time in the context of *Ornitorrinco in the Sahara*, a dialogical telepresence event which I presented with Ed Bennett at the Fourth Saint Petersburg Biennale, which took place in Saint Petersburg, Russia, in 1996. In the case of *Ornitorrinco in the Sahara*, the phrase 'dialogical telepresence event' refers to a dialogue between two remote participants who interacted in a third place through two bodies other than their own. Realized in a public area of a downtown building in Chicago, The School of the Art Institute, without any prior announcement to facilities users, the event consisted basically of three nodes linking the downtown site in real time to the Saint Petersburg History Museum and the Aldo Castillo Gallery in Chicago. Through these telecommunications ports of entry, human remote subjects interacted with one another by projecting their wills and desires onto equally remote and fully mobile, wireless telerobotic and teleborg objects. One of the Saint Petersburg Biennale directors, Dmitry Shubin, used a black-and-white videophone to control through a telephone link (from the Saint Petersburg History Museum) the wireless telerobot *Ornitorrinco* (in Chicago) and receive feedback (in the form of sequential video stills) from the telerobot's point of view. At the same time, my own body was enveloped by the wireless *Telepresence Garment*. The dispossessed human body was controlled, also via a telephone connection, by artist and

→ The *Telepresence Garment*, 1995–1996. Online telepresence work with wireless telerobotic clothes.

Collection Instituto Vaenciano de Arte Moderno (IVAM), Valencia, Spain

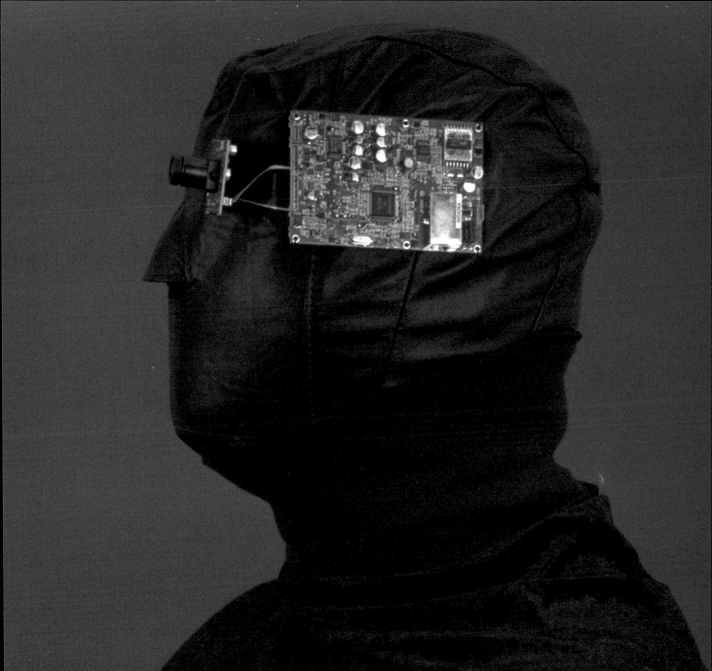

art historian Simone Osthoff from the Aldo Castillo Gallery. During the event, while both the telerobot and the teleborg were remote controlled, a unique dialogical telepresence situation unfolded.

With the *Telepresence Garment* the human subject was converted into a human object, becoming a direct conduit for a remote operator's commands. The human body could not see anything at all. It could barely hear, and only with great difficulty could it emit sounds. Locomotion on all fours was dramatically disabled by the limbless suit. With this garment, breathing became an exercise in patience, and as the temperature rose, sweat dripped incessantly, and most senses were either effaced or had their range and power reduced. The human body could only rely on instinct and the concern and cooperation of the remote agent. The feelings that emerged in this dialogical context were a sense of spatial unawareness and fear of getting harmed, an agonizing combination of feeling invisible and fragile simultaneously. Like a corpse revived by an external power, my motions were not *proprio motu*.

As Simone Osthoff controlled the behaviour of my body, I dreaded the moment when I would hit a wall or a pillar, accidentally find myself in the lift, or collide with passersby or the telerobot (which hosted Dmitry Shubin, from Saint Petersburg). Considerate of my sensorial deprivation, Osthoff spoke slowly and paused intermittently, commanding the body as if via a telempathic sense of touch,[3] as when someone enters a dark space and tries hesitantly to touch surrounding objects, hoping to regain spatial awareness of the environment. At first completely unaware of what he was contemplating, Shubin alternated the behaviour of his telerobotic host between propelling himself down the hall to navigate other areas of the space and engaging me (i.e., Osthoff on my body) directly. On occasion, physical contact between the two occurred, reiterating the tangible reality of this vicarious encounter.

Telepresence works create dialogical and multilogical telepresential experiences. They suggest the need to nurture a network ecology with humans and other mammals, with plants, insects, artificial beings and avian creatures. Network ecology, with its latent expansion of human potentialities, is a motive power of our digital nomadism. It is imperative to assert alternatives that promote digital-analog integration and that lead to unprecedented online, multimedia and post-biological experiences. Telepresence is one such alternative. Escaping from rubrics that categorize past contributions to contemporary art -– such as body art, installations, happenings, video art, performance and conceptual art – telepresence works have the power to contribute to a relativistic view of contemporary experience and at the same time create a new domain of action, perception and interaction.

3 I coined the word *telempathy* to designate the ability to have empathy at a distance.

This essay is a modified version of a text originally published in *YLEM* 17.9 (September/October 1997). Republished in Eduardo Kac, *Telepresence and Bio Art – Networking Humans, Rabbits and Robots* (Ann Arbor, MI: University of Michigan Press, 2005), 198–202.

World Skin: A photo safari in a land of war MAURICE BENAYOUN

Armed with cameras, we are making our way through a three-dimensional space. The landscape before our eyes is scarred by war-demolished buildings, armed men, tanks and artillery, piles of rubble, the wounded and the maimed. This arrangement of photographs and news pictures from different zones and theatres of war depicts a universe filled with mute violence. The audio reproduces the sound of a world in which to breathe is to suffer. Special effects? Hardly. We, the visitors, feel as though our presence could disturb this chaotic equilibrium, but it is precisely our intervention that stirs up the pain. We are taking pictures; and here, photography is a weapon of extinguishment.

The land of war has no borders. Like so many tourists, we are visiting it with camera in hand. Each of us can take pictures, capture a moment of this world wrestling with death. The image thus recorded exists for no one any more. Each photographed fragment disappears from the screen and is replaced by a black silhouette. With each click of the shutter, a part of the world is extinguished. Each exposure is printed out. As soon as an image is printed to paper, it is no longer visible on the projection screen. All that remains is its eerie shadow, cast according to the viewer's perspective and concealing fragments of future photographs. The farther we penetrate into this universe, the more strongly aware we become of its infinite nature. And the chaotic elements renew themselves, so that as soon as we recognize them, they recompose themselves once again in a tragedy without end.

I take pictures. Through what I do – first aggression, then feeling the pleasure of sharing – I rip the skin off the body of the world. This skin becomes a trophy, and my fame grows with the disappearance of the world.

Here, being engulfed by war is an immersion into a picture, but it is a theatrical performance as well. In the sequence of events that characterize the story of a single person, war is an exceptional incident that reveals humanity's deepest abyss. It promotes the process of reification of another human being. Taking pictures expropriates the intimacy of the pain while, at the same time, bearing witness to it.

This has to do with the status of the image in our process of getting a grasp on this world. The rawest and most brutal realities are reduced to an emotional superficiality in our perception. Acquisition, evaluation and understanding of the world constitute a process of capturing it. Capturing means making something one's own; and once it is in one's possession, that thing can no longer be taken by another.

In French, 'prise de vues'. Shooting, taking. In the case of a material storage medium, 'taking' something is the equivalent of taking it with you. Photography captures the light reflected by the world. It constitutes an individual process of capturing and arranging. The image is adapted to the viewfinder.

The picture neutralizes the content. Media bring everything onto one and the same level. Physical memory-paper, for example, is the door that remains open to a certain kind of forgetting. We interpose the lens ('objectif' in French) between ourselves and the world. We safeguard ourselves from the responsibility of acting. One 'takes' the picture, and the world 'proffers' itself as a theatrical event. The world and the destruction constitute the preferred stage for this drama-tragedy as a play of nature in action.

The living are the tourists of death. If art is a serious game, then so is war. War is a game in which the body is placed at risk as an incessantly, unremittingly posed question of the reduction of existence to its bare remains.

← *World Skin* screen shots, 1997.

Courtesy of the artist

The printed trace is the counterpart of forgetting. A 'good conscience' is a contradiction of a 'good memory'. One knows what one has retained, but one does not know what one has struck out from one's memory.

Here, the viewer/tourist contributes to an amplification of the tragic dimension of the drama. Without him, this world is forsaken, left to its pain. He jostles this pain awake, exposes it. Through the media, war becomes a public stage – in the sense in which a whore might be referred to as a 'public woman' – and pain reveals its true identity on this obscene stage, and all are completely devoured. The sight of the wounded calls to mind the image of a human being as a construct which can be dismantled. Material, more or less. The logic of the material holds the upper hand over the logic of the spirit, the endangered connective tissue of the social fabric.

War is a dangerous, interactive, community undertaking. Interactive creation plays with this chaos, in which placing the body *at (the) stake* suggests a relative vulnerability. The world falls victim to the viewer's glance, and everyone is involved in its disappearance. The collective unveiling becomes a personal pleasure, the object of fetishistic satisfaction. I keep to myself what I have seen (or rather, the traces of what I have seen). To possess a printed vestige, to possess the image – inherent in this is the paradox of the virtual, which is better suited to the glorification of the ephemeral. The soundtrack is there to enable us to go beyond the play of images and to experience this immersion as real participation in the drama. In sharp contrast to the video games that transform us into passionate warriors, here the audio unmasks the true nature of apparently harmless gestures and seeks rather to provide a form of experience than a form of comprehension. Some things cannot be shared. Among them are the pain and the image of our remembrance. The worlds to be explored here can bring these things closer to us – but always simply as metaphors, never as a simulacrum.

While the planet moves on from the stage of global village to that of global body, *World Skin* plays on this ambiguity between the surface of things and the world's skin. Photography deletes memory in the very process of creating it – like the characters in Adolfo Bioy Casares' *The Invention of Morel* (1940), who lose their skin after being caught up by a memory machine, a forerunner of virtual reality. I had been fascinated with the idea that the hero was willing to pretend to have a part in a recorded scene out of love for a character, although knowing that it would cost him his skin: the *mise-en-scène* he works out to lend weight to his pretended encounter, turning a fiction into a trace beautiful enough for him to sacrifice his life for it. Behind the light reflected by the world, the skin of things, lies the reality, ghostly in *World Skin*, of a world of appearances where becoming-an-image shuts out the pain in a spectacular sea of a universal clear conscience.

Thanks

Conception: Maurice Benayoun. Music: Jean-Baptiste Barrière. Software: Patrick Bouchaud, Kimi Bishop, David Nahon. Production: Z.-A. Production, Ars Electronica Center Future Lab. Special thanks to CITU – Université Paris 1 and ARCADI

Why *Immolation*? CRITICAL ART ENSEMBLE

Immolation is a video installation concerned with the use of incendiary weapons on civilians after the Geneva Convention and the *Protocol on Prohibitions or Restrictions on the Use of Incendiary Weapons* of October 1980. This video chronicles the major war crimes of the United States involving these weapons on a (macro) landscape level, and contrasts it with the damage done to the body on the (micro) cellular level. To accomplish this task, CAE grew human tissue at the SymbioticA Art and Science Collaborative Research Laboratory in Perth, Australia, and using their micro-imaging laboratory shot the micro footage. In addition to this imagery, CAE uses film footage of present and past wars that have used immolation against civilian targets as a strategic choice for the sole purpose of terrorizing entire populations. The goal is to provide a different way of imaging, viewing and interpreting the human costs of these war crimes, in contrast to the barrage of media imagery to which we have become so desensitized.

The members of Critical Art Ensemble (CAE) always hoped that we could complete our collaboration without ever having to produce a work about war. We hoped never to hit viewers over the head with the blunt object of this topic, and were sure that more fascinating, undeveloped subject matter was readily available. Unfortunately, the current situation in the USA and its involvement in the Middle East have made impossible CAE's humble desire to escape the issue of war. The neoconservatives are attempting to create a military state designed to undertake a series of imperial invasions and to end democracy at home. Two wars have already begun (Afghanistan and Iraq), along with the media campaign for a third with Iran, and more wars (Lebanon and Syria) are on the way if the neoconservatives can engineer them in time. In this context, CAE came to believe that all our efforts, from small everyday life gestures to complex projects, had to aim at undermining the anti-democratic agenda and the war actions of the neoconservatives, and to reinforce the emerging understanding among the American public that the neoconservatives are totalitarians of an order that has not been seen in the West since the Second World War.

CAE's first major effort in this area was to examine the consequences of a lesser known initiative in the USA – the illegal reinstatement of the germ warfare programme. The re-emergence of this programme has come at the expense of a productive global health policy. Many of the resources that were used to address emergent infectious disease were hijacked by the State Department and US military, and instead of serving the public interest, they now serve the military's. The military is not interested in any of the current health crises in infectious diseases (AIDS, TB, malaria, hepatitis, etc.), but, rather, with weaponizable 'scary' germs such as Ebola, anthrax and smallpox.[1] Limited resources once used to fight ongoing health crises killing millions worldwide are increasingly used instead as means to explore paranoid and ill-informed military fantasies. From our projects based on these observations, CAE came to understand that if one was selective in examining the many microcosms of war and warfare one could create compelling points of cultural resistance rather than duplicating generic stop-the-war campaigns.

We have now turned our attention to bombs. Not those that grab all the headlines like suicide bombers, improvised explosive devices, nuclear bombs, or even laser-guided smart bombs (or was that the last Gulf war?), but those that keep a low profile. *Immolation* is our first instalment in this series. We don't hear much about firebombs, but they are being used on a regular basis in the Middle East. From the point of view of the military, one can understand why, as they have always been real morale crushers. People have a primal

1 For a complete analysis, see *Marching Plague: Germ Warfare and Global Public Health* (New York: Autonomedia, 2006).

→ *Immolation* (video stills). Two channel video installation, 2007.

Courtesy of the artists

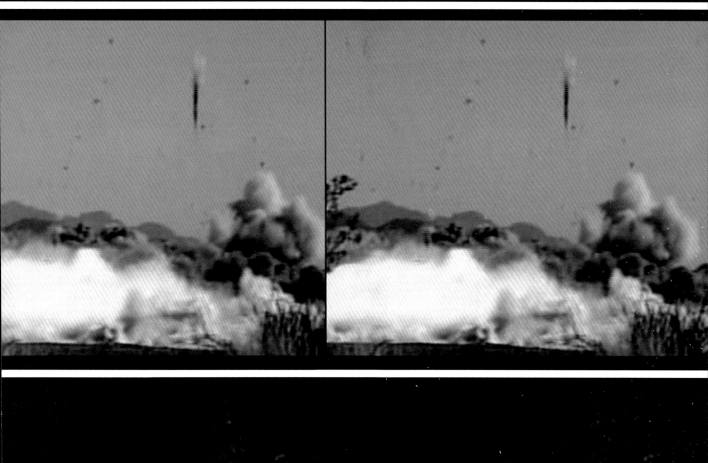

Disintegrating human tissue cells

Disintegrating human tissue cells

fear of being burned alive, so while they are functionally not the most lethal bombs in the arsenal, they command a terrifying emotional economy, and sometimes that is just the kind of hammer believed necessary to pound an enemy (there cannot be 'shock and awe' without them). However, what boosts this unnecessary practice beyond barbarity and into raw criminality is that firebombs are being used to immolate civilians and destroy civilian property. The USA has consistently refused to sign any international treaty that bans the use of incendiary weapons against civilians.**2** The protocol for this treaty is quite simple; do not use them against civilians. An army can use incendiary weapons against the enemy and its resources, it can produce as many of these weapons as it wants and it may stockpile them, but that is not good enough for the USA: it requires time-honoured favourites such as napalm (new recipe and name; same effect) and white phosphorous to bomb civilians.

But for CAE, the real question was how to represent this unfortunate series of occurrences. Currently, a flood of war representation is blasting the American public from all major media sources – most of which are not particularly helpful to the cause of peace or else are outright propaganda. Whether one is watching the evening news, or Hollywood war films, or the latest Public Broadcast documentary, the dominant ideological position (contradiction) is 'We hate the war, but we love our heroic troops'. The old aphorism from Gandhi 'Hate the sin; love the sinner' is as fresh as ever. This is the bait and switch rhetoric that was identified by Roland Barthes as cultural 'inoculation':**3** represent the war as horrible and unjust, and the troops as flawed people just trying to survive a terrifying ordeal by any means they can. But once this confession is made, reverse the rhetoric and say that in fact, for doing this, they are heroes, and that in order to support them, war must be tolerated and/or perpetuated and any culpability for the horror must be indefinitely deferred. Add that if one does not uphold this position one is not 'supporting the troops' (a platitude of political hackery that presents itself as self-evident and unchallengeable, but in reality only serves the political interests of the warmongers as opposed to anyone in an actual war). The twisted anti-logic of this position is truly indicative of a deep ideological sickness. Perhaps this moment of self-deception is a 'necessary fiction' that could help to heal the wounds of past wars on an individual level, but it will do so only at the cost of perpetuating the current wars.

The representations that carry this ideological virus all participate in a common set of characteristics. First, they revel in their construction of the real. What is the sound of a specific model of machine gun firing from one hundred metres away? How does blood spatter when a soldier is shot in the chest by a sniper's rifle of a given model from a particular angle? Those producing the fictional or recreated images know the answers to these questions and attempt to reproduce this knowledge in image/sound form with great fidelity.

Secondly, the stories should occur on a human scale, and the storyteller should avoid the grand narratives of the clash of civilizations. Humanizing war is very important if it is to be forgiven in the end. These stories cannot be told with abstractions, numbers or with larger-than-life characters. If sympathetic inhumanity is to be achieved (and this is an impressive visual effect) an intersubjective relationship between the viewer and his digital counterpart has to be established. Viewers must find themselves identifying with inhumanity, and thereafter must call it human so as not to absorb the guilt and the horror themselves. In war, to be human is to be an imperfect victim who is a hero.

This was the style from which CAE was trying to distance itself when we made *Immolation*. We had to find a way in which this series of images could not be infiltrated and contaminated by 'Support the Troops'. We hoped to deliver a different experience of

2 See signatories to the Certain Conventional Weapons Convention (CCW), Protocol III (*Protocol on Prohibitions or Restrictions on the Use of Incendiary Weapons*, Article 2, points 1–4). While the USA at times claims to have signed, it has put so many qualifications on the protocol as to render it useless.

3 Roland Barthes, *Mythologies* (New York: Hill and Wang, 1972), 150.

war imagery that maintained the terrible alienation of war while still allowing viewers to personally imagine themselves in the narrative, but not through a sympathetic or empathetic identification with the humanity of the inhumane. Thus, the first element we eliminated was human scale, along with humans themselves, replacing them with grand landscapes of destruction and micro visions of cellular health followed by decimation to the point of disintegration.

CAE's use of micro vision is unusual in origin. During the peak of AIDS activism in the USA, CAE had a poster with images of a healthy and an unhealthy T-cell. Over the healthy T-cell was a caption that read, 'Imagine this'. In our presentation, CAE is asking viewers to imagine their own healthy cells dehydrating and bursting after being hit with napalm or white phosphorous. While we wanted to establish the possibility of a personal connection with the images, we did not want it to be one extending from identification with the soldier/criminal/victim/hero, but, rather, a concern for one's own body established through the metonymic sign of the exploding cell.

The second element we eliminated was sound. We were not going to replicate the cacophony of war yet again, nor would we produce any screaming cells. Rather, we hoped that we would have a less anxious space so that the focus could be just as much on the viewer's unsettling inner experience as the images themselves. In keeping with this goal, CAE liked the idea of a black box screening. Unfortunately, museum ritual, design and architecture generally work against our tactics of mediation (on death or otherwise). Museums and gallery networks are cultural candy stores, and people are in a hurry to try to gather as many sweets as possible. The austere minimalist aesthetic that rules the design, much like McDonald's fibreglass furnishings, does not encourage loitering. CAE has always argued that in such a context interested viewers are only going to give about five minutes of their time before moving on. CAE has always believed in keeping videos short, but this situation made it an imperative.

There seems to be no point at which crimes against humanity reach such a degree of intensity and outrage that they propel everyone to struggle for peace. For surely we have already reached that point, if indeed there is one. CAE will nevertheless continue to expose, document and, to the extent possible, subvert this resurgence of radical militarism overseas and at home. In so doing, every tool counts, and cultural production is a very important one that unfortunately seems all too often to do the devil's work for him.

The Office of Experiments' Truth Serum Threat:
Notes on the Psychopharmacology of Truthfulness NICOLAS LANGLITZ

The Office of Experiments' project *Truth Serum* is a response to the arrest of the American artist Steve Kurtz in 2004 and the subsequent lawsuit against him. Kurtz was detained for extended questioning on suspicion of bio-terrorism one day after waking up next to the lifeless body of his 45-year-old wife. The emergency medical team reported her untimely death to the police, associating it with suspicious laboratory equipment in the artist couple's home. As members of the Critical Art Ensemble – an artists' collective dedicated to exploring the intersections between art, technology, radical politics and critical theory – they had been involved in a series of performances problematizing life science-related issues. For an art project on biological warfare, Steve Kurtz had obtained two strains of harmless bacteria, which had been used in bio-warfare simulations in the past. However, in the wake of the terror attacks of September 11, 2001, and the subsequent mailing of anthrax spores to political representatives of the United States, new bio-safety rules had been established subjecting the use of microbiological materials to rigorous policing.[1] In the political atmosphere of the years after 9/11, the Critical Art Ensemble's activities were not endorsed unanimously. Hence, in the controversy following Kurtz's arrest, his prosecution was mostly presented as an infringement of the freedom of art, prompting a wave of solidarity from the art community.[2] In support of Kurtz, the Office of Experiments produced a video reflecting upon the aesthetics of terrorist messages: Disguised as a dark clown, the anonymous spokesman of a radical 'Bio Art' cell threatens that the self-experimentation unit of the Office of Experiments will conduct mass self-experimentation with truth drugs unless legal action against Steve Kurtz is discontinued immediately. The theme of truth drugs is also taken up in a performance in which members of the audience are subjected to an interrogation procedure to test whether they are fit to join the Office of Experiments. As members they are expected to wear truth serum patches ensuring that they will always speak the truth, thereby complying with the high level of moral integrity that the Office claims. This artistic intervention into the debate over the freedom of art in the security regime that has emerged since 9/11 draws from the cultural history of so-called truth drugs and the recent discussion over their use in the interrogation of suspected terrorists.

Rise and fall of the psychopharmacology of truthfulness

In the performance of the Office of Experiments, subjects are interrogated under the influence of scopolamine applied through commercially available transdermal patches today used to treat nausea and motion sickness. At the beginning of the twentieth century, scopolamine was employed to induce a state of 'twilight sleep' during childbirth. During the period of intoxication, the women suffered less from labour pains, but experienced somnolence, drowsiness, disorientation, hallucinations and amnesia. However, in 1916 a rural Texan obstetrician, Robert House, noticed that the drugged women were nevertheless able to answer questions accurately. House had asked a patient's husband for the scales to weigh the newborn. When the man could not find them his wife, still in a semi-conscious limbo, said 'They are in the kitchen on a nail behind the picture'. Although the location of the scales was hardly a secret, House concluded that 'without exception, the patient always replied with the truth. The uniqueness of the results obtained from a large number of cases examined was sufficient to prove to me that I could make anyone tell the truth on any question.'[3] Consequently, he suggested using the substance to facilitate

1 According to the US PATRIOT Act, the possession of 'any biological agent' for any reason except 'prophylactic, protective bona fide research or other peaceful purpose' is prohibited. As this does not necessarily prohibit the artistic use of innocuous micro-organisms the allegation against Kurtz was soon changed to wire and mail fraud – based on the fact that the bacteria had been ordered by a geneticist friend of Kurtz's for his laboratory, not for use in an art studio or exhibition.

2 George Annas, 'Bioterror and "Bioart" – A Plague o' Both Your Houses', *The New England Journal of Medicine* 354.25 (2006); Robert Hirsch, 'The Strange Case of Steve Kurtz: Critical Art Ensemble and the Price of Freedom', *afterimage* (2005); Anna Munster, 'Why is Bioart not Terrorism? Some Critical Nodes in the Networks of Informatic Life', *Culture Machine* 2007.7 (2005). Whether this conflict is correctly described as a clash between biosecurity and artistic freedom, as a case of outright political oppression, or simply as the lawful prosecution of an offence (after all, even artists are not above the law) remains for a future historian of 'Bio Art' to decide.

3 Robert House, 'The Use of Scopolamine in Criminology', *The American Journal of Police Science* 2.4 (1931), 332–33. This is a reprint of House's original 1922 publication: Robert House, 'The Use of Scopolamine in Criminology', *Texas State Journal of Medicine* 18 (1922).

the interrogation of suspected criminals. In 1922 this was tried out on two convicts from the Dallas county jail who volunteered as test subjects to demonstrate their innocence. One of the prisoners afterwards confirmed House's hypothesis: 'After I had regained consciousness I began to realize that at times during the experiment I had a desire to answer any question that I could hear, and it seemed that when a question was asked my mind would center upon the true facts of the answer and I would speak voluntarily, without any strength of will to manufacture an answer.'[4] Even though the prisoners had only repeated their claims of innocence, now, with the blessing of pharmacology, they appeared all the more trustworthy. This, in turn, supported House's original hypothesis. In his report on the experiment, he stated that under the influence of scopolamine a subject 'cannot create a lie' because the drug 'will depress the cerebrum to such a degree as to destroy the power of reasoning'.[5] The automatic unthinking discourse was supposed to reveal truths otherwise cunningly concealed. This conception of automatism was also at the basis of the use of entranced mediums as instruments for observing otherwise inaccessible phenomena, as well as the psychotherapeutic and artistic practices of *écriture automatique* and free association. By suspending his will the drugged interrogatee would lie open like the 'book of nature'. Here the epistemological ideal of 'mechanical objectivity' (as the attempt to capture nature with as little human intervention as possible)[6] and the moral norm of truthfulness were supposed to coincide.

The term 'truth serum' was coined shortly afterwards in a newspaper article on the experiment in the *Los Angeles Record* and soon gained currency – even though scopolamine was neither a 'serum' (a word that refers to bodily fluids taken from animals to make vaccines) and nor was there unambiguous evidence that it allowed the extraction of 'the truth' from any subject, as House was claiming.[7] Nevertheless the term was soon applied to a whole range of pharmacologically rather disparate substances. Barbiturates such as sodium pentothal, a class of sedative drugs widely prescribed as sleeping pills and anaesthetics, were introduced to facilitate police interrogations. By the 1930s, this practice of 'narcoanalysis' had become a common means of eliciting confessions in American police departments.[8] After rumours that the Nazis had tried out mescaline on inmates of the Dachau concentration camp to make them give away their innermost secrets, the CIA and the US Army extensively explored the potential of various hallucinogens such as mescaline, LSD and cannabis as speech-inducing agents in the 1950s and 1960s. In the infamous MK-ULTRA project exploring the behavioural effects of several drugs, including their effects on interrogation, CIA agents not only engaged in self-experimentation with LSD, but dosed their unwitting colleagues as well as unknowing American citizens in a CIA-financed brothel. The purpose of these experiments was to test how people responded to such dramatic alteration of consciousness if they were unaware of what was happening to them and did not know that this quasi-psychotic state would wear off. Eventually, during the Vietnam War, interrogators exploited the anxiety-provoking qualities of LSD known from so-called 'bad trips', threatening to keep subjects in a crazed, tripped-out state forever unless they 'spilled the beans'.[9]

However, the gradual association of truth serums with squeezing confessions from recalcitrant subjects deviated from their original purpose. As the historian of science Alison Winter points out,

> House himself regarded the serum as an important tool for compelling honesty in institutions as much as individuals. The vindication it could offer to the falsely accused would, he thought, force transparency on a corrupt criminal justice system poisoned by a culture of graft and private deals. House offered 'truth serum' as a

4 Quoted in House, 'The Use of Scopolamine in Criminology', 332

5 House, 'The Use of Scopolamine in Criminology', 332, 334

6 Lorraine Daston and Peter Galison, *Objectivity* (New York: Zone Books, 2007), 115–90.

7 Alison Winter, 'The Making of "Truth Serum"', *Bulletin of the History of Medicine* 79.3 (2005), 515.

8 Winter, 'The Making of "Truth Serum"', 530.

9 Martin Lee and Bruce Shlain, *Acid Dreams. The Complete Social History of LSD: The CIA, the Sixties, and Beyond* (New York: Grove Press, 1992), 3–43. See also Martin Lee, 'Truth Drugs', *Cannabis Culture Magazine*, 29 November 2002, www.cannabisculture.com/articles/2603.html.

kind of social astringent to a society deeply concerned about corruption, particularly in members of powerful institutions, both public and private.**10**

At the time of the Prohibition (1920–1933), when the high profits that could be gained from the illicit alcohol trade seriously compromised the integrity of the police and the judicial system, the invention of truth serums promised a scientific and humane way of obtaining honest testimony – unimpaired by bribery and the brutality all too often exercised in police interrogations at the time to wring confessions from suspects.

In spite of the good reformatory intentions of truth serum advocates such as House – and the less benign popularity such substances came to enjoy among interrogators in the police, the military and intelligence services – truth serum-derived information was denied formal admission as legal evidence. From its inception onwards, narcoanalysis was met with scepticism in courtrooms. The drug-induced impairment of mental faculties called into question the truth-value of the testimonies it produced. What good is truthfulness if it does not reveal the truth? Furthermore, the legal validity of such evidence was disputed by those who regarded the application of truth serums as a mild form of torture invalidating all confessions made under its influence.**11** Eventually, this view was confirmed by the Supreme Court in the case of *Townsend v. Sain* in 1963. When treated for his heroin withdrawal symptoms, the accused had concomitantly been given scopolamine and a barbiturate after which a full confession had been extracted from him within less than one hour. But the Supreme Court ruled that such a confession could not be regarded as 'a product of a rational intellect and a free will' and was therefore not admissible in court.**12** As US law enforcement agencies usually refrain from means that jeopardize the use of the obtained evidence in court, this regulation henceforth excluded the employment of so-called truth drugs in forensic practice. Additionally, the bad publicity and poor results produced by the CIA's Project MK-ULTRA dampened the spy agency's enthusiasm for drug experimentation as well.**13**

Return of a phantasm: the truth serum debate after 9/11

Since the attacks on the World Trade Center and the Pentagon on 9/11, the reintroduction of truth drugs has been repeatedly called for. Two months after the terrorist acts, the magazine *Newsweek* published an article entitled 'Time to Think about Torture'. The subheading read: 'It's a new world, and survival may well require old techniques that seemed out of question.' The author not only suggested that torturing suspected terrorists was worth discussing, but also stated that 'Short of physical torture there is always sodium pentothal ("truth serum"). The FBI is eager to try it, and deserves the chance.'**14** Former CIA and FBI director William Webster also proposed to facilitate the interrogation of uncompliant al-Qaida and Taliban captives by administering truth drugs at Guantánamo Bay and elsewhere. He argued that using a short-term anaesthetic such as sodium pentothal might not count as torture. The Oxford English Dictionary defines torture as the 'infliction of severe bodily pain, as punishment or a means of persuasion; spec. judicial torture, inflicted by a judicial or quasi-judicial authority, for the purpose of forcing an accused or suspected person to confess, or an unwilling witness to give evidence or information.' Nothing could be further from the infliction of severe bodily pain than treatment with an anaesthetic, it seems. Hence, whether the administration of sodium pentothal constitutes torture remains an open question.**15** Even though the Bush administration publicly disavowed the employment of truth drugs, a 2002 memorandum to the President from the Department of Justice suggested that the use of drugs for interrogation purposes might be permissible.**16** When American agents got

10 Winter, 'The Making of "Truth Serum"', 523.

11 Winter, 'The Making of "Truth Serum"', 516–19, 525.

12 *Townsend v. Sain*, 372 US 293 (1963).

13 CIA Historical Review Program, *Project MKULTRA, the CIA's Program of Research in Behavioral Modification. Joint Hearing before the Select Committee on Intelligence and the Subcommittee on Health and Scientific Research of the Committee on Human Resources United States Senate*, vol. 2007 (Washington, DC: US Government Printing Office, 1977).

14 Jonathan Alter, 'Time to Think about Torture', *Newsweek*, 5 November 2001.

15 Kevin Johnson and Richard Willing, 'Ex-CIA chief revitalizes "truth serum" debate', *USA Today*, 26 April 2002. See also Lee, 'Truth Drugs'.

16 Jay Bybee, *Memorandum to Alberto R. Gonzales, Counsel to the President* (2002 [cited 28 October 2007]); available from http://news.findlaw.com/nytimes/docs/doj/bybee80102mem.pdf

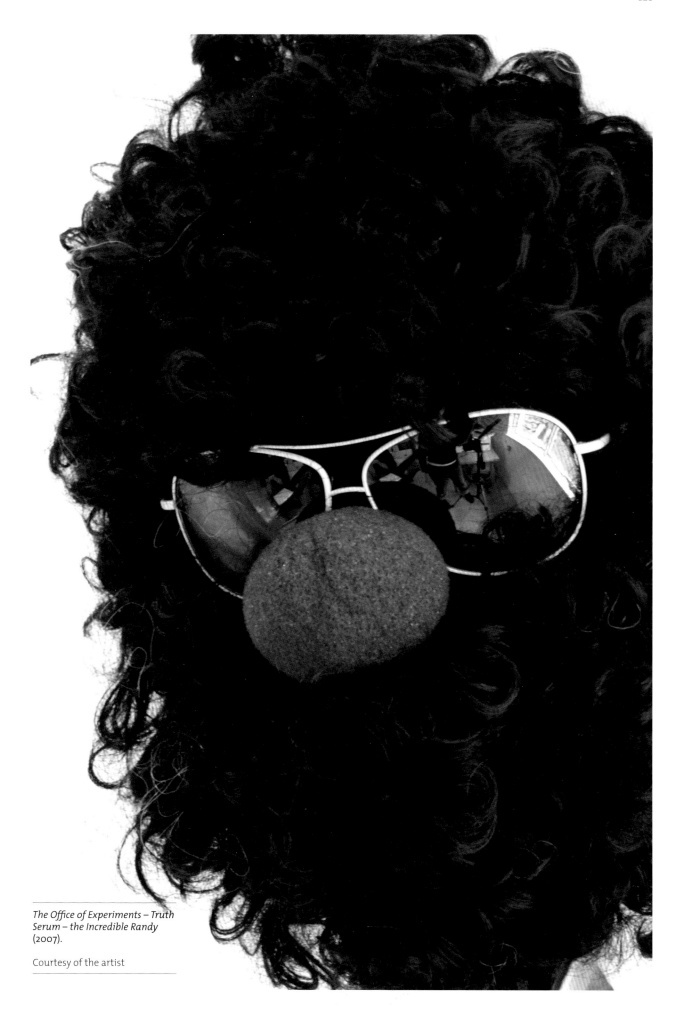

The Office of Experiments – Truth Serum – the Incredible Randy (2007).

Courtesy of the artist

hold of Abu Zubaydah, presumed to be the second-in-command of al-Qaida, the question 'Should he be tortured?' was openly discussed in the media. An investigative journalist later reported:

> Although Zubaydah was the highest-ranking Al Qaeda operative captured in the first six months following 9/11, and was also evidently the first to be given thiopental sodium, a decision had been made shortly after 9/11 that allowed the use of 'truth serums' on prisoners by FBI and CIA interrogators. Since the initial questioning was about imminent terror plots, the Bush administration believes that the Supreme Court has implicitly approved the use of such drugs in matters where public safety is at risk. A 1963 Supreme Court opinion of Justice Arthur Goldberg is cited frequently: 'While the constitution protects against invasions of individual rights it is not a suicide pact.'[17]

The Supreme Court decision that explicitly addressed the employment of truth serums in 1963 declared confessions extracted with the help of drugs to be inadmissible at trial. However, it did not address the use of truth serums for other purposes. As the lawyer Jason Odeshoo remarked in the *Stanford Law Review* in 2004, 'In the United States, no law at either the state or national level makes the use of truth serum a crime per se'.[18] After all, the logic underlying its application in the so-called War on Terror is not the logic of law, but that of security. Unlike narcoanalysis in police investigations in the first half of the twentieth century, here interrogation does not aim at conviction (or acquittal), but at the gathering of intelligence. When it comes to preventing future acts of terrorism priorities are set differently: Getting hold of valuable information is considered to be more important than criminal prosecution.

The ex-CIA chief's mentioning of Guantánamo Bay in this context is telling. The employment of truth drugs has been shifted into an extra-juridical space where national laws do not apply while a recategorization of captives in the global War on Terror as 'unlawful combatants' (instead of prisoners of war) has made them fall through the cracks of the Hague and Geneva Conventions. The Italian philosopher Giorgio Agamben has coined the term *homo sacer* for various forms of human life – from the ancient Roman outlaw to the inmates of Auschwitz and contemporary detention camps such as Guantánamo Bay – that are characterized by a legal suspension of their legal status forcing them into a grey zone between a normative order and crude facticity. Thereby, the *homo sacer* is reduced to the state of 'bare life': deprived of the legal and political rights enjoyed by free citizens.[19] Comparable to the slaves in ancient Greece who, unlike their owners, could be summoned to court for torture to force out truthful statements about events in their master's household, their bodies serve as 'the site from which truth can be produced', where 'an inaccessible, buried secret' is waiting to be unearthed.[20]

Things have changed since antiquity, though. The old Roman proverb *in vino veritas* dates back at least to the first century (it is usually attributed to Pliny the Elder), but in the nineteenth century the relationship between drugs and honesty was rearticulated in the vocabulary of psychophysiology. Alison Winter notes: 'Physiologists, researchers into altered states of mind, and early forensic innovators developed the notion that distinct physiological states of the body – distinct in the sense that they could be individually, precisely, and repeatably portrayed and produced – were coextensive with degrees and manners of truth-telling.'[21] From now on, it was the biologically conceptualized body of the other, especially the brain, which served as the locus in which truthfulness could be instilled and from where truth could be extracted.

Scopolamine.

Unknown source

17 Gerald Posner, *Why America Slept. The Failure to Prevent 9/11* (New York: Random House, 2003), 187–88. Of course, Posner's account is merely anecdotal and does not say anything about how common the use of truth drugs in interrogation is today. In his article 'Some Believe "Truth Serums" Will Come Back', the *Washington Post* journalist David Brown quotes a number of sources from the military and intelligence apparatus denying that more efficient truth serums are currently being developed. Brown, 'Some Believe "Truth Serums" Will Come Back', *Washington Post*, 20 November 2006.

18 Jason Odeshoo, 'Truth or Dare? Terrorism and "Truth Serum" in the Post-9/11 World', *Stanford Law Review* 57.1 (2004), 209–56.

19 Giorgio Agamben, 'An Interview with Giorgio Agamben (by Ulrich Raulff)', *German Law Journal* 5.5 (2006); Giorgio Agamben, *Homo sacer. Sovereign Power and Bare Life* (Stanford, CA: Stanford University Press, 1998).

20 Page DuBois, *Truth and Torture* (New York: Routledge, 1991), 6, 75.

21 Winter, 'The Making of "Truth Serum"', 503.

Scopolami

22 Robert Kaplan, '"The Interrogators" and "Torture": Hard Questions', *New York Times*, 23 January 2005.

However, despite persistent hopes of replacing torture with the pharmacological circumvention of the subject's will, laying bare the hidden contents of the other's mind with scientific accuracy and without the infliction of pain, interrogation continues to require a great deal of psychological flair and cultural knowledge.[22] The journalist Mark Bowden explains that

> interrogation is far more an art than a science. It essentially boils down to the skill of an individual interrogator reading the person that he's working on and pushing the buttons that he thinks will produce results. And I think we'll find that ultimately it will remain more of an art than a science. Some people will be better at it than others, and I don't believe that you'll ever be able to turn it into a science until you're able to turn human behavior into a science – which we haven't been terribly good at. The areas in which we have made extraordinary strides in psychology today are in brain chemistry and the use of drugs, and to my knowledge there exists no such thing as a 'truth serum' or a chemical that will relax a person's inhibitions. It seems that even though we do know a lot more about the brain, people are still very much in control of it.[23]

23 Mark Bowden, 'The Truth About Torture. Interview with Alexander Dryer', *The Atlantic Online* (2003). Available at www.theatlantic.com/unbound/interviews/int2003-09-11.htm

None of the drugs experimented with as truth serums – from wine to LSD and from scopolamine to the barbiturates – has proven to be a magic bullet. As was already stated at a hearing on the MK-ULTRA project in the US Senate in 1977,

> The results, though not definitive, showed that normal individuals who had good defenses and no overt pathological traits could stick to their invented stories and refuse confession [when administered a truth serum]. Neurotic individuals with strong unconscious self-punitive tendencies, on the other hand, both confessed more easily and were inclined to substitute fantasy for the truth, confessing to offenses never actually committed.[24]

24 CIA Historical Review Program, '"Truth" Drugs in Interrogation', in *Project MKULTRA, the CIA's Program of Research in Behavioral Modification*, 29.

To this day, unhindered access to 'the truth' concealed in another person's brain has remained a recurrent phantasm haunting times of widespread political distrust.

Interrogating the culture of paranoia

The artist Steve Kurtz is an American citizen protected by his civil rights. He was subjected to police interrogation, but he has never been administered any truth drugs. However, the connection between the Kurtz case, bio-terror and truth serums established in the Office of Experiments' *Truth Serum* project mirrors a set of associations created in the public debates following 9/11 – such as the link between germ warfare, Islamist terrorism and calls for more efficient interrogation techniques. Even though these connections have often been more fictional than factual (so far, for example, bio-weapons have not played a significant role in terrorist activities), the effects that these imaginaries have produced are real enough. The self-government of the life sciences responsibly regulating the risks emerging alongside new knowledge (implemented at the Asilomar Conference on Recombinant DNA in 1975) has recently been called into question.[25] Especially in the area of so-called dual-use technologies that can serve both peaceful and belligerent aims, the American state increasingly demands to have a say in the matter. As the Kurtz case shows, the tightening of biosafety regulations and the growing disquiet with respect to biological materials not only affect the work of life scientists, but also that of artists critically addressing biotech-related issues in the USA. Their status is even more precarious,

25 Judith Reppy, 'Regulating Biotechnology in the Age of Homeland Security', *Science Studies* 16.2 (2003).

(C₁₇H₂₁NO₄)

especially if they venture out into supposedly irresponsible applications outside scientific research institutions. At the same time, such forays – especially if they lead right into the courtroom – can generate a significant amount of media attention and public debate independent of their aesthetic quality. This raises the question of the norms and aims of such art projects.

The Office of Experiments' recruitment of hopefully healthy volunteers to self-experiment with scopolamine is presented as following a line in art's 'irrational' development through 'irresponsible' activity. Here, the use of the drug serves neither security nor health. Instead it is employed in a cultural experiment, probing an atmosphere of paranoia spreading since the events of 9/11. As if the honesty of attendees at the performance needed to be verified, they have to undergo an interrogation under the influence of a truth serum to become members of the Office. The self-experiment thereby confronts them with a number of questions. Do they believe that the truth serum will work? Will it make them give away more than they intend to? Which truths do they have to hide – and from whom? Can they trust the artist behind the mask? Will he use the drug on them responsibly? This artistic experiment makes its participants subjects and objects of paranoia alike. The experience of participation is meant to be transformative. Following its principles, the Office of Experiments uses the trial to collate materials 'in the non-verbal state' on participants' responses, but it refrains from an analysis based on methods of rational, informational or academic research, as if to mistrust this approach as the only route for the production of knowledge.**26**

This artistic, but not purely aesthetic, exploration of the present is related to the form of historical and anthropological inquiry into contingent rationalities on which this article is based. Both approaches depart from an interest in the conditions facilitating the reintroduction of truth serums into contemporary practice and imagination. In the 1920s Robert House conceived of scopolamine as an antidote to the rampant corruption that had come to affect the police and the judicial system during the Prohibition. In the 1950s and 1960s interest in truth serums reached a new peak in the context of the Cold War. Now they appeared as magic potions granting control over the enemy's mind. Historically, the truths that truth serums disclosed might have revealed more about the times and cultures fostering them than about the secrets of the subjects they were given to. What, then, does their reappearance in the War on Terror tell us about our situation today? While this text has addressed the matter by way of historiographic description and analysis, the Office of Experiments' project *Truth Serum* opens up an artistic and experimental approach to exploring the state of affairs.

26 Neal White, 'Let's Experiment with Ourselves: Key Relations – Art, Power, Trust, Viewer, Participant', in *Introspective Self-Rapports. Shaping Ethical and Aesthetic Concepts 1850–2006. Preprint 322*, ed. Katrin Solhdju (Berlin: Max Planck Institute for the History of Science, 2006).

The research presented in this article was originally meant to serve as a contribution to a project on biosecurity initiated by the Anthropology of the Contemporary Research Collaboratory. But it took the Office of Experiments' art project *Truth Serum* to return to the subject matter. I would like to thank Office clerk and artist Neal White for this inspiration, his personal support and comments on the article. I am also grateful to Carlo Caduff, Scott Vrecko and Jens Hauser for their helpful suggestions and constructive criticism as well as to Donya Ravasani who served as a most stimulating interlocutor throughout the writing process.

Wim Delvoye's *Sybille II* RALF KOTSCHKA

Soft colours, gentle lines, quiet music: this is the apparently imaginary landscape that Wim Delvoye wants to show us in his video, *Sybille II*. Whitish-yellowish objects erupt from beneath curved surfaces. Delvoye's landscape appears to be a desert: nothing is growing, nothing lives here, except, that is, for those worm-shaped objects forcing their way to the surface in ever new and more places. This combination alone of a seemingly dead landscape and the dynamic explosion of forms from beneath its surface has something very strange about it: these are foreign objects – at first, still unidentifiable, mere objects of comparison in the repository of our own visual experiences. Viewers, however, soon recognize the images as close-ups of skin surfaces and, if they have not already figured it out, they will finally know what they are looking at when the tip of a fingernail enters the picture: the content of sebaceous glands or blackheads, pushing its way through the skin's surface. In *Sybille II* we watch a ballet, a choreography of the movements of these peculiar, endogenous objects whose magic captures our fantasy and masks the reality of what is being shown.

For a long time now, notions of the skin as a boundary, as a mere outer cover, have been obsolete, replaced by notions of human skin as a bi-directional zone of exchange, as a medium itself. The metaphor of human skin as an interface lends expression to a desire for freedom from space-time limitations: spatially, to be able to be in more than one place simultaneously; and chronologically, to no longer be at the mercy of ageing (particularly visible on the skin) and the mutations of matter during replication. Ancient statues come close to the ideal of timeless existence, primarily through their smooth skin: there is an almost inhuman quality to their representation of the body as vessel. For a long time, the goal of art consisted in conveying a physical structure that was as anatomically accurate as possible, through the image of the bodily exterior. In another medium, oil painting, skin and physical modalities were transformed into subject matter. Already in the Early Modern period, artistic discourse on colour led to discussions of cultural and sexual differences under the keyword 'incarnate'. If, during the Renaissance, sight, as the primary sense, was a means of avoiding touch, a gaze has developed with the mechanization of visual tools that is analogous to touch itself. Film, as a forerunner of video, represents a technical means of expression, referred to in the Romance languages, oddly enough, with the term for skin – *pelicula/pellicule*. Contemporary art uses the subtle possibilities of video, meanwhile, to expose and challenge common semanticizations of skin colour and gender.

Wim Delvoye seldom works in the medium of moving pictures. In all, he has produced only four videos. This has less to do with an aversion to the medium than with his conviction that in *Sybille II* he had found a strong motif for his art – an art which noticeably often deals with the theme of skin. Since 1995 Delvoye has been tattooing live pigs – notably since 2004 on his China-based *Art Farm* – parodying the human desire for individualization through the carving of the skin. He creates an alternative life for pigs, perhaps not only because Delvoye raises the issue of vegetarianism, but also because he delivers these creatures from the fate of death for human consumption by incorporating them into the art market. In Franz Kafka's story, *The Penal Colony*, a machine tattoos the condemned prisoner's sentence onto the skin, a punishment leading directly to death: the skin functions in Kafka's story as a one-way medium. In *Sybille II* Wim Delvoye breaks through this one-way communication and allows the skin itself to speak as a multidirectional medium. He thereby expands the traditional artistic discourse on skin,

endowing it with a capacity for medial expression through physical secretions originating inside the body – the body expresses itself, 'communicates'. The body's insides have always been a source of repulsion which arises when we are confronted with formless matter exiting the body. An early childhood stage in which we were still familiar with this matter and which for a long time we thought we had overcome through civilization and socialization – in *Sybille II* this stage catches up with us again. For a long time Wim Delvoye has dealt with cultural constructions of the body; aside from the tattooed pigs, there is his *Cloaca* project, a series of eight digestion simulation machines. Even before the Viennese *Aktionskunst* [Actionisme] of the 1970s or Cindy Sherman's *Disgust Pictures*, we knew that the disgusting clearly possesses an aesthetic dimension. Here, too, a relationship immanent to our culture is symbolically represented by means of a shock aesthetic: the violent cutting of the body and its immediate external surface, the skin.

In connection with the nude female body, which serves in the philosophical tradition as an allegory for naked truth and knowledge, *Sybille II* presents the skin's puzzling messages as the interface between the subject and the external world, the corporeal surface as the site enabling contact and perception. The title *Sybille II* is not only an allusion to gender discourse but an onomatopoeic reference to the film *Bilitis*, David Hamilton's soft-core pornographic film from 1976. A frivolous story of the discovery of physical love among pubescent girls serves here as a pretext for projecting the bodies of naked girls – soft skin, budding breasts, smooth thighs, skin against skin – as the primary subject onto the middle-class cinema screen. *Sybille II* works similarly with the techniques of soft focus, contrast lighting and extreme close-ups. Only here, the skin bursts open. The body's inside is forced out, as in a splatter film, only there is no blood, there are no entrails – the new genre of *soft splatter art* appears to have been invented. The seemingly endless succession of nearly identical close-ups is like an obsessive review of pornographic tricks: in its aesthetic of breaking down distances at various levels, in the logic of parodic exaggeration, by breaking taboo in recycling the practices of classical cinema.

Wim Delvoye explains that he would have liked to have put Francis Lai's *Bilitis* soundtrack with his images but for financial reasons he finally produced the music himself. His superficial, easy-listening music is reminiscent of the everyday world of commodity consumption and, in this context, perhaps calls to mind precisely those cosmetic products with whose help the skin is said to attain the ideal qualities of antique statues – a smooth, immaculate and thus timeless surface with no history. Pores clogged with cream reduce the central function of this sizeable organ as the site of intimacy and communication to the empty formula of a long-term effect, to which the television image does more justice than does human contact.

If we see the opening of bodies in images as a way of increasing the flexibility of image-bodies, as it is in the age of digital images, the viewer of *Sybille II* will be reminded of Walter Benjamin's notion of the dialectic of shock and familiarization, which can be formulated epistemologically as an alternation between fascination and knowledge. The contemporary development of high-tech artificial skins – which as 'smart clothes' or 'intelligent textiles' expand the complex functions of the skin with other additional sensory functions – no longer denies the capacity of this organ to bridge distances: they take the body beyond its boundaries into the dimension of virtual reality. *Sybille II* presents the body's tentative attempts at making contact, its first attempts at removing the boundary, which are not, however, technologized but are nothing other than the potentially sibylline message of this work by Wim Delvoye: the deeply human desire for contact.

Immobile, Bleu… Remix! YANN MARUSSICH

Bleu Provisoire was a show premiered in 2001 – *Bleu Remix* takes it further. I hold it to be the first really motionless dance piece, and updating it turns it into a veritable manifesto for immobility. The idea is to stay absolutely still for one hour, with the only action being my secretions, which flow in succession and are blue in colour. So it is a journey through the skin. Operating with biomedical procedures is one way of understanding our inner workings, getting beyond the anatomical framework which for the dancer is given and familiar. While *listening* to my body, its muscles, its skin, I try to add to the notion of the *sight* of the body. What I am interested in is movement, the idea of movement and ideas capable of conveying a movement. For me everything becomes dance. A show with no visible drama. With no narration. With no abstraction. The naked man placed there like a mirror. Raw simplicity. Motionless sculpture. A bloodless flaying of the body. A hallucination of one's own body is mixed in with biological realities, endlessly confusing madness and concreteness. A choreography of the dance of the blue secretions. Blue, a banal colour and yet one with a rich history, gets us away from the idea of red blood. It produces a different relationship between the body and colour. I work with doctors in order to simulate a mutation of my body through biochemical transformations. My secretions turn blue. Everything is calculated; I become the subject of experiments. But poetic experiments with no wish to comment on humanity's biological future.

The challenge I am taking up is to do a show on motionlessness, trying to prove that it is central, the basis of any movement. I want to smash our way of viewing motionlessness. Make the motionless body a monochrome vibration that hints at the problem of the relationship between outward immobility and inner mobility. What is going on inside the body ahead of the visible movement. The pre-movement is written down in the body. My body. A single space, my body. With no affect. With no relation to any other body. With no plot, facing the audience, just there, offered up with all its complexity and with a biological form of simplicity. Standing stockstill is a trying experience, a task whose difficulty is not quantifiable. The blood flows down into the hands and feet, the blood circulation is poor, you get pins and needles in your arms and legs. It takes the utmost concentration to remain present and not lose yourself in bodily pain. I want to show, not suffering, but the strength that you can draw from your own suffering.

In the context of dance, immobility has never been anything but a posture close to mime and only ever used to colour an intention in a didactic way. The most convincing approach was that of the *butoh*, although it does not specifically work on immobility but on extremely slow movement. This approach brings man closer to the rhythm of nature. So it is an attempt to get outside imposed time, something more approaching a natural, almost plant-like rhythm. Here presenting the utter motionlessness of the dancer-man is not provocation, but very much to do with getting back to where it all starts. Presenting the dancer's body as a live monochrome, as pure vibration, is important. If I wanted to be even more extreme, I could just as easily show a lifeless body, but the crucial element would be missing: presence. Presence and the bubbling mobility of the inner body which are complementary to the image of the motionless body. Performance means a show without playing an accepted part, generally the part of someone else. The artist plays his own part. Art is no longer a *representation* but a continuous inner state *presented* before third parties.

Prologue

All this is a private personal story, universally recognizable at all times by anyone who likes to plunge through the (possible) bark of themselves this skin close to us that we keep nibbling this nothing that holds everything in this border that we cross with the passport of the bite this so fine and so impassable skin then often to seek to force a passage through the orifices but it is they that push us back I perforate myself graze myself in the invisible I gnaw at myself so that you can see me and slip into the architecture of my veins into the cathedral of my heart into the depths of my lungs into the night of my kidneys into the fountain of my furious bladder so that you can sing with me I am a child of the bile a child of the lymph a child with me I am talking to you I don't even know who you are an anonymous pagan miracle someone curious about your body it's me it's you it's the other even when it's my body I find it hard to believe that it's me I find it hard to believe in everything I doubt each fragment I doubt each entity I am wary of all these mind's eye views I am writing for you no I am writing for everyone ultimately for no one I write myself I erase myself I look for a shadow for my lungs for my arteries I stay motionless very close to that explosion that extraordinary word coined just for me I like to believe in this pointless lie just up to where am I my body? I will keep still so that you can get a good look at the details of my unbearable mutation if you can hold out if you don't look away I will make you lick my blue spleen the way you lick a mint-flavoured ice-cream you are a child no more than I am if truth be told each child thinks he's grown-up each grown-up sees himself as a child but one would also like to be a woman in the mirror and claim victory over one's double but our double's double is us which is female which is male couldn't give a damn it's midnight I want a cup of tea several days pass I keep on drinking tea with milk one of my latest habits with the silence what issues does my tea have in the stage performance? in the story? and yet I defend my tea with milk with plenty of sugar I still have my habits I am not mutating what mutation? I am a corpse on the table of time on the vertical dissection table my body is very clean smooth ready to be to peeled like a potato I am a rotten potato my son tells me and I tell him he's a squashed tomato laughter over our mineral games inedible soup served at the inn of our awareness so leave now says a voice eating with us *I am an animal* I turn into a rabies virus and rush at his saliva stop we are not in a cartoon but in a poem ouch mind what you're doing yann there's going to be a ban on it not profitable enough not explicit enough not readable enough doesn't abide enough by the rules you'll end up in the fridge in the box at the back on the forgotten rot shelf end of prologue

20.30 eyes closed I'm in my silence the public is coming in it's too late to go back out the silence is choking me I'm not thinking of the public the kaleidoscope of my eyes is turning and I am projecting myself in a whirl of modest images the steps I can hear are the steps of naked people walking silently the faceless public is stark naked like a worm naked like a virgin naked like a raw nerve

20.35 I'm looking for my tears I'm looking and I can't latch onto any sad memory because sad memories don't make me cry I cry inside and if I cry it is out of physical discomfort out of an invasion where I have to laugh to find tears I have to go insane laughing I have also read that to cry you have to think of love the shadow of my tears slips by you have to know how to get into my eye to guess at its lascivious snakes light on light drawings of childhood only barely glimpsed at hanging from the hooks of the original trauma

20.41 the dance of the snot oh blue flow from an idle volcano oh ulceration of my nasal fossae I shouldn't have ridden wild horses now I'll have to phone the vet for him to put

→→ *Bleu Remix*, Galerie Guy Bärtschi, Geneva, 2007.
Photo © Laurent Käser

Bleu Remix, Dampfzentrale Bern, 2007.
Photo © Marc Gremillon

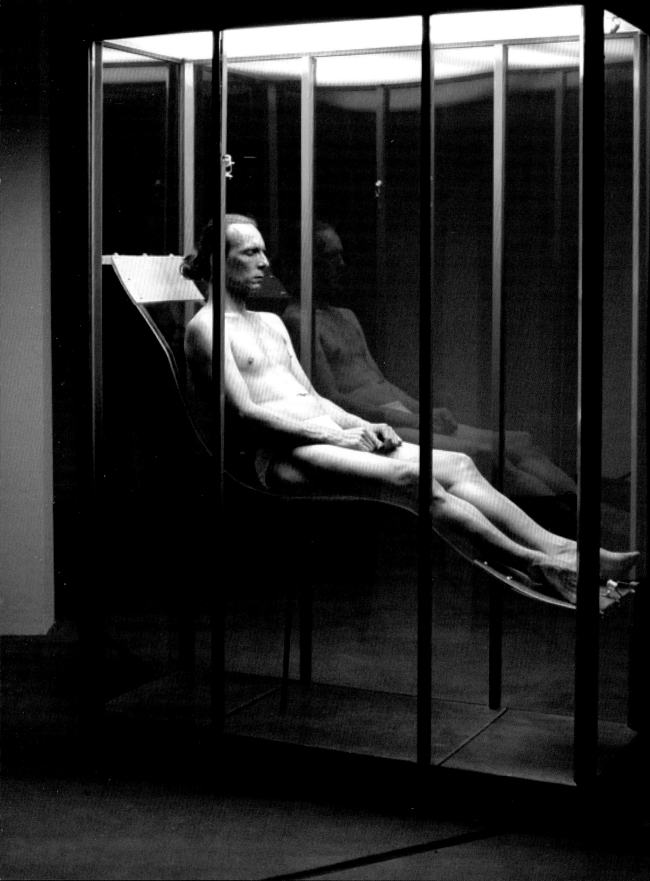

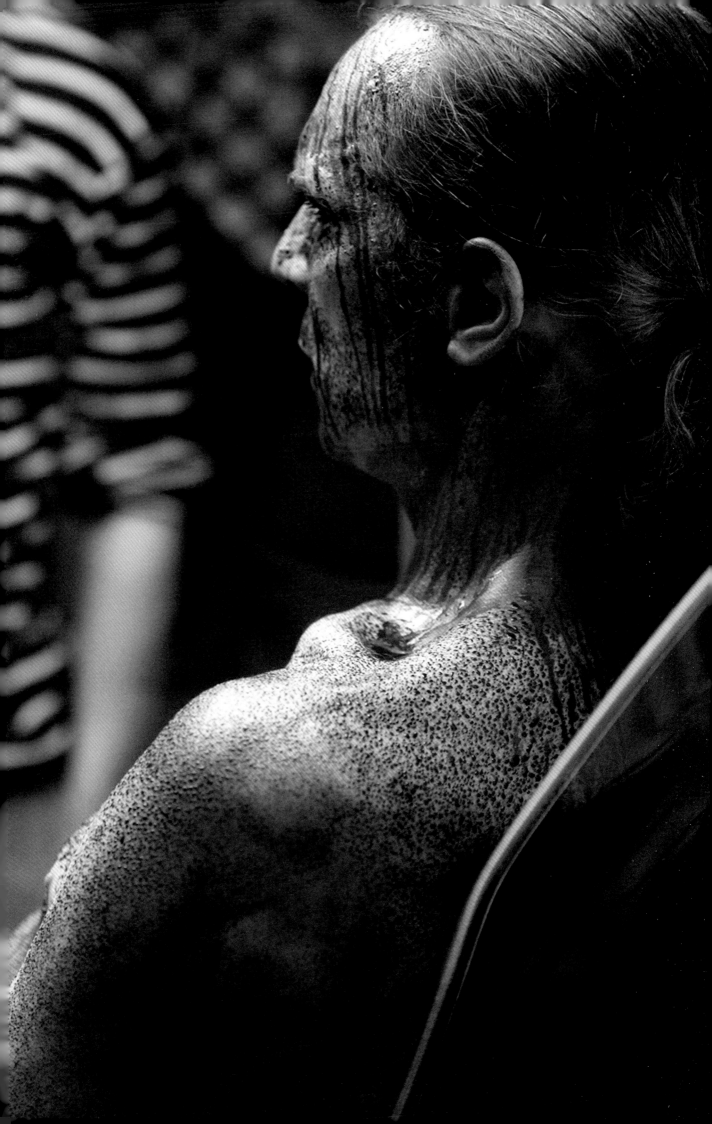

me down like an infected ass I'm emptying myself of my own body I'm emptying myself expelled colour I'm expelling myself I'm painting myself ridiculous blue magic of the loops of the body colour

20.47 the saliva comes after a sudden tired feeling I am so passive I can't keep in this mouthful all the unsaid words are turning into saliva I no longer have the strength to spit I'm slobbering like a senile traveller watching the journeys go by and bubbles that don't float away lean on the balcony of my mouth to see nothing and end up disappearing drop by drop

20.55 time for the dance of the urine it's time to concentrate and piss on myself like an inattentive child also to piss this blue that has fillled me I don't particularly like blue but at least it's universal I want to be beyond recovery and inject myself with poisons that will make me inoperative in any society based on profit I'm useless and proud of it I am a child liquid glass of blue that you knock back in one swig right under the nose of the laws I resist any idea of evolution of human behaviour quite simply because I don't believe in it I drift in a certain quality of misfortune and I count the dead like in a game I'm not complaining I will never stoop to complaining but neither will I rise to boasting I am nothing and the useless sun burns me just as much as the believer as a gift you will be allowed to cut off one of my arms or see me crying blue tears which will remind you of your childhood as a fish and you will feel like gods stop stop it's soon

20.55 joy of drinking your urine golden rain that finds its way through my entrails proof of love and not vice some people understand others don't I am shameless I piss and there's people looking at me that's the way it is it's exactly the same if no one's looking

21.03 an inner rain comes down like chilli on a plate of rice I'm sweating a blue journey journey I've already written that word several times so that's what poor style is but I don't have the time to watch out for repetitions my time is limited journey journey what the hell who's going to lick my journey and my sweat?

21.04 I'm sweating sky my skin is opening in spaces my skin is opening in colour my skin is opening in silence in the vapour of an imaginary earth that has started to boil belly of fire that draws premonitory and incomprehensible clouds eighty degrees celsius at my stoical feet I swallow the burns that pass through me without leaving me any more marks I am beyond pain I look at myself opening I offer my sky through my sweat

21.17 my body like a shapeless mass like a white chasm like a smile of the skin like a shapeless swarming blue anthill like a cobweb of free nerves like a stone like dripping blood like a caress to your body like a love poem like a straw like a self-service for silences like

21.18 the heart is dancing actually it's hopeless a heart that dances is a totally romantic image I leave it to you to imagine but to see it is something else two membranes clapping hands in silent applause for the animal victory of the impulses invisible heart in its bottom of love the body chameleon of the heart

21.25 skin wagon of lips hot metal of bonds orifices offered up to my tongue thirst heat stirring the sky throat coal black saliva seeking the orifice rainbow fingers stones of pins and needles blood hammer itchy scratchings woman's name engraved in vitriol in the rib cage the panther is hungry for promised folds my hands are thirsty for the fountain single train stirring up the burning lake your bird with famished beaks hurtles along my paths of nerves algae all is shouting ball you're bouncing with open mouth

21.37 the end of the arbitrary hours the dance of the intestines the one that goes on for kilometers and fits into a supermarket bag I will leave you the image of my intestine smooth and blue like frozen smoke and will spare you opening them up with their stink so much shit and turds have travelled have passed willy-nilly down this tunnel this flexible walking sewer this maze where blood plays the part of dracula you're always someone else's tiny dracula because it is commonplace nowadays to be a dracula everyone is dracula everyone is eating feeding on the other who will want some of my blue blood and of all my blue secretions who will want my chemical aftertaste who will want my motionless passive body which forces clearcut decisions which forces you to take up a stance to say I'm not like that but rather like this and see how the ridiculous is everywhere I too cannot avoid being ridiculous I am ridiculous if I think of other fates but I live here in my body in this country I had no choice although some would like to insinuate that but I'm not complaining we have a useless battle inside us even though it can make humanity evolve but I don't believe in evolution I'm repeating myself you have to repeat the essential things educate yourself in renouncing everything the obvious thing is that we're going to die and that we are clowns before the mirror of our own death which is also the death of other people without the ego no other without the other no me me the other of another et caetera since the dawn of time I have been having fun so I put on a disguise and transform myself

21.25 it is over but not really over the public is just going out without applauding it is respect for the silence that makes me say that I have been eaten up like a mirror and that nobody dares to applaud himself

21.30 I'm coming out of my paralysis pain of separation between the motionless one and the walker pain of separation from the public some want to stay back to see my first movement it is not good to look at I'm telling you a choked bedridden body cry stuffed with sharp pins and needles long shaky walk towards the shower I wash myself unthinkingly I wash myself the water is blue I rub myself down until I turn red it takes a long time to get rid of the blue I can't get completely rid of it I come out of the shower and put on my everyday clothes I am alone before realizing that no one is going to come and that's very good seeing is enough there's nothing to speak I leave them with their disappointment at not seeing me move, at not seeing me naked, at not seeing a proper show, I leave them with their doubt and the unsuspected that gradually dawns on them with the violence of immobility more fearsome than the panther that would leap out of my shadow with the firm intention of protecting me and feeding itself.

This working document is as yet still unfinished. I began writing it during rehearsals and have kept working on it for several years now. It is divided into sections like a diary, but instead of from day to day, from minute to minute. In this way I can also demonstrate a principle of the physical time-related experience whereby one minute is a relative duration, where an infinite number of things might happen in the space of a minute, or nothing at all.

Thanks to Yann Gioria (original soundtrack) and Jens Hauser (curator).

Biological Habitat: Developing Living Spaces ZBIGNIEW OKSIUTA

A fig is not a fruit but a flower garden turned inside out. It looks like a fruit. It tastes like a fruit. It occupies a fruit-shaped niche in our mental menus and in the deep structures recognized by anthropologists. Yet it is not a fruit; it is an enclosed garden, a hanging garden and one of the wonders of the world [...] A garden, on the human scale, is a population of flowers covering many square yards. The pollinators of figs are so tiny that, to them, the whole interior of the single fig might seem like a garden, though admittedly a small, cottage garden. It is planted with hundreds of miniature flowers, both male and female, each with its own diminutive parts. Moreover the fig really is an enclosed and largely self-sufficient world for the minuscule pollinators.

Richard Dawkins, *Climbing Mount Improbable*[1]

1 Richard Dawkins, *Climbing Mount Improbable* (New York/London: W.W. Norton, 1996), 299–300.

A system can only emerge once its borders have been defined. Evolution has developed a universal solution for a biological, liquid membrane – a film of 'skin' that separates and protects the content from the surrounding environment. In *Der Ursprung des Lebens* (*The Origin of Life*) Reinhard W. Kaplan writes, 'every organism is a unit which is demarcated from its surroundings, an individual with internal subunits going down to the molecular level. Even one-cell microbes are delimited *drops or clumps* of protoplasm which include further substructures, the so-called organelles: ribosomes, membranes and the genome, for example.'[2] In this act of demarcation, wherein a system can develop and then become an individual, lies the deciding evolutionary step. A membrane can characteristically be understood as a separation of various environments and consequently the possibility arises that, in newly created worlds, completely opposed processes such as division and synthesis could take place. Self-organization is an immanent characteristic of material, and it is thanks to the laws of the universe that such creations can come into existence of their own accord. Each process takes place in fluid media. Water is a synonym for dynamics. This malleable state of matter is the only one that allows for self-organization processes and for life as we know it. Liquid states enable processes to occur not only at the molecular level, but also at a macro scale – at the embryonic stage of the development of living organisms it liberates the foetus from the impact of gravity and allows it to develop freely. All living cells are surrounded by membranes, and, as James Lovelock writes,

2 Reinhard W. Kaplan, *Der Ursprung des Lebens. Biogenetik, ein Forschungsgebiet heutiger Naturwissenschaft* (Stuttgart: Thieme Verlag, 2nd edn 1978 [1972]), 118.

hardly more substantial than a soap film, [a membrane] is as effective a barrier to leakage of the cell's constituents as the hull of a ship to water or the fuselage of an aircraft to the outside atmosphere. However, the watertightness of a living cell is achieved by quite different means from that of a ship's hull. The latter works mechanically and statically; the cell wall does its job by active and dynamic use of biochemical processes.[3]

3 James Lovelock, *Gaia: A New Look at Life on Earth* (Oxford: Oxford University Press, 1979), 84.

Naturally, separating oneself from the environment, creating barriers and walls, is also a central human activity. We must protect ourselves in order to survive. Clothing provides our second skin and architecture the third. From the earliest stages of human evolution, people have used – initially – biological matter to separate themselves from their surroundings and to protect themselves against a hostile environment. Like the creation of cellular membranes in biological systems, in the history of human culture the

making of clothing or the construction of a roof over one's head has been a universal and primeval activity, a necessary step towards survival, existence and development. The construction of a spatial boundary between an interior and the surroundings is the basic task of architecture.[4]

4 Cf. also Zbigniew Oksiuta, *Forms, Processes, Consequences* (Białystok/Warsaw: Galeria Arsenał/Centrum Sztuki Współczesnej Zamek Ujazdowski, 2007).

Biological polymers as construction material – form as process

Each of the projects *Spatium Gelatum, Isopycnic Systems* and *Breeding Spaces* explores the possibilities of specific biological habitats. These habitats can be understood as spaces with dynamic membranes, by means of which humans, animals and plants integrate symbiotically, where the intermediary covers act as components of the living community. They protect but should be equally indivisible elements of the system's energy, material and information circulation. For my prototypes I employ biopolymers of animal and plant origin. Biological polymers are made up of chain macromolecules of natural origin: polynucleotides (DNA and RNA), polysaccharides (cellulose, starch, pectin, chitin, glycogen and agarose), polypeptides and proteins such as collagen, elastin and polyisoprene. Biopolymeric gels belong to the soft matter group, comprising so-called 'compound' or 'three-dimensional liquids' which cannot be classified as either liquids or solids. They can be soft and easy to deform (gelatine gels) or hard and fragile (agar gels). The processes that take place in biological polymers during their transition from liquid to gel to solid state are described by the theory of elasticity, formulated within the framework of physical chemistry. During the setting of a form, planes and membranes change shape and deform in a specific drama dictated by 'bending energy'. As it dries, a slice of bread always bends in the same way. The flat object arches into a double-curved, self-supporting crust (a hyperbolic paraboloid) displaying a mathematically determined geometry and considerable durability.

The aim of my research is to observe deformation processes without any prior aesthetic or formal interference. Chaotic curves and fractal deformations are the effect of precise biological self-organization processes combining the physical and chemical principles of order and beauty in the animated world. Natural constructions tend to be small scale while human structures are large scale. At the fluid molecular level, viscosity and surface tension play a primary role, while the rigid constructions of humans are primarily influenced by gravity. Humans work with the principle of adding on. Small parts are manufactured and put together to form large constructions. In a watery medium, this principle of adding on is not possible. The fluid creation of forms happens through morphogenesis *from inside* due to expansion, growth and reproduction. Right from the start, these processes depend on information which is stored in the nucleus of each cell and which determines the direction of development. At every stage of life an organism is a fully functioning perfect entity. Therefore my *Spatium Gelatum* projects study the rules for forming liquid and gelling objects from biological polymers in liquid state in order to envision architectures at any scale and to shape biological forms and objects into new habitats. *Spatium Gelatum* objects and architectures are biologically renewable. They can exist in a solid or liquid state, be soft or hard, transparent or coloured and they have different smells and flavours.

Work with biopolymers is thus also of special interest because their density is comparable to that of water: when two liquids, which do not mix with each other, have the same or a nearly equal density and a drop of one floats inside a drop of the other, we can observe a state of relative weightlessness, of neutral buoyancy. What I call *Isopycnic Systems* (meaning 'having equal density', from the Greek *isos*, 'equal', and *pyknos*, 'density') in my work describes the aim of creating forms under water, in this neutral buoyancy

The polymer form, X-ray photo.
Radiology EVK Evangelical
Hospital, Cologne-Weyertal,
2007.

Photo: Birgit Vogt © Zbigniew
Oksiuta & VG Bild-Kunst Bonn

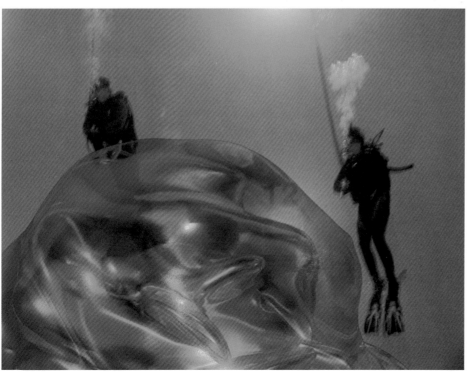

Isopycnic systems (neutral
buoyancy: liquid systems of
equal density), 'Lane Kluski
Technology' ('Poached Dumpling
Technology'). Inflation of the
hollows in a polymer lump
floating under water, videostill,
Mesogloea, 2003. The film
was partly shot in a Neutral
Buoyancy Facility, ESA European
Space Agency, Cologne.

Photo: Uwe Lierman, animation:
Industriesauger-TV, Cologne ©
Zbigniew Oksiuta & VG Bild-
Kunst Bonn

phase, using liquids within liquids, with water comprising a fluid form for the floating gelling polymer mass (in a translation from the Polish, I refer to it as the 'Lane Kluski Technology' or the 'Poached Dumpling Technology'). Other liquids are injected into it to alter its shape and size and to create isomorphous spaces and interiors. By adding liquids of lower density than that of gelatine and water to the mass, it is possible to control the form's density and to maintain it in this floating state. At a practical level the isopycnic state allows the creation of a great variety of amorphous shapes which can potentially be applied to architectural scales, thus offering new possibilities for transforming amorphous forms like those generated by computer simulations.

Breeding Spaces as bioreactors

The principle of molecular, dynamic membranes can also be transferred into the macrocosmic area. The basic units of living are the bubbles which surround the inner organs of higher organisms and comprise the lipid film that protect the cells. It is the skin of our bodies and the biosphere that is draped around our planet: living systems are, independent of size, surrounded by a dynamic membrane. But how are dynamic space systems, based on the universal idea of fluid membranes, created on large scales which allow the conservation and even the cultivation of organisms internally? In biological laboratory experiments flat Petri dishes made of rigid plastic are used, filled with a layer of agar upon which the perfectly enclosed microbes may be bred and observed. More sophisticated bioreactors are also made of containment material which is usually rigid – at least its containment borders are totally impermeable. Such is the principle of our technology. But why are we not considering the use of dynamic membranes here? The idea behind *Breeding Spaces* is to create a three-dimensional organic membrane, the entire interior of which constitutes a bioreactor that would still permit controlled experiments in laboratory conditions. In order to achieve this, the whole transparent research container is constructed of biopolymers, such as agar, agarose or phytogel, as a 'three-dimensional biological Petri dish'. Such sphere-shaped membranes consist of 70–98 per cent water and are filled with air. In the gelation process of this 'bubble', the agar forms stable, albeit soft and flexible, walls which rigidly isolate the interior from the outside environment. The polymer layer provides both a spatial perimeter and a nutrient medium for the micro-organisms inside and stimulates the processes taking place within the membrane.

Breeding Spaces is an attempt to generate a system in which the borderline separating the interior from the outer environment is not a foreign body, made of neutral material (such as Petri dishes or glass containers), but an immanent element of the whole structure. It is simultaneously a boundary *and* a spatial scaffold. It plays an active role in the processes inside the system, thus drawing on properties that are specific to biological membranes in living organisms. The breeding process involves injecting plant cells into the interior of a form, in this way creating a kind of *introverted biosphere*. As the cells multiply on the walls and create stable tissue, the 'bubble' itself begins to self-degrade, thus facilitating the growth of autonomous plant objects. Extending this idea further, *Breeding Spaces* could become not only spaces for breeding but breeding farms in space. Seen from a long-term perspective, the project explores the idea of such thick-fluid, three-dimensional membranes as bioreactors in the most varied surroundings: not only on the earth's surface but also under water and in outer space. The limitation which equally unites and divides each condition is the effect of gravity: normal 1 G gravity on the surface of the earth, relative weightlessness under water and 0 G in space.

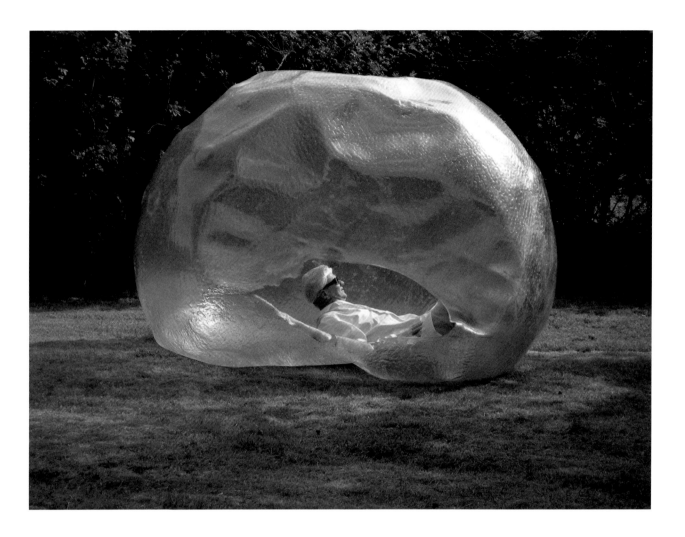

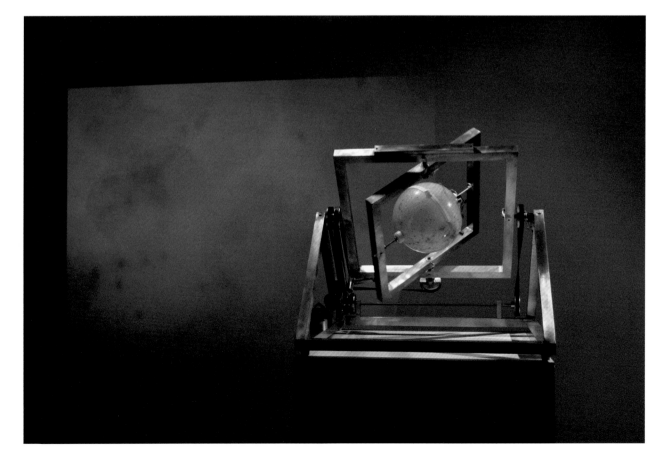

Beyond Gravity

Gravity decisively influences the manifestations of earthly technology. Humans create their static and mechanical objects according to the principles of Euclidean geometry from stiff, dead material: hardened concrete, glass, steel, ceramic. On earth we build houses and construct devices, according to the linear geometry of gravity, directed towards the inside of the globe. Construction generally requires two tools: a level line and a plumb line. The construction of fluid but stable forms with a larger, architectural scale is not possible in the earthly gravitational field. However, such objects – often designed in the virtual space of computer simulations – can exist under water or in outer space. The organisms that live in a gravitational field are themselves in a hermaphroditic condition, divided between solid and fluid material; they consist primarily *of* water and even develop, as well, particularly in the embryonic stage, *in* water. On earth, these fluid bodies are kept in form by their soft membrane, the skin, and stabilised with a skeleton. In a certain sense we can say that the phenomenon of neutral buoyancy is indeed crucial in the development of life, as the basis for its three-dimensionality. In addition, the watery medium permits the movement of molecules and the transmission of genetic, hormonal or synaptic information. Despite the fact that neutral buoyancy plays so central a role, and that it is largely used in space technology to simulate a state of weightlessness in so-called neutral buoyancy facilities, it is hardly used in the architectural creation of forms. In *Beyond Gravity* I research the possibilities of softer technologies which approximate conditions of weightlessness. Under water, employing biological polymers as construction materials makes the creation of forms by using the phenomenon of relative weightlessness possible. With the 'dead' materials available today this is unthinkable: steel is seven times heavier than water, concrete three times and glass two-and-a-half times. Only artificial materials have a density comparable to that of water. Artificial material, however, is also dead material.

At the moment, we are still sending heavy, static equipment, produced on earth under gravitational conditions, into space – an environment which is not static at all. Like the conquistadors of the past, we are attempting to erect earthly outposts. The dangers that await us there are not wild humans, exotic animals or viral illnesses but rather the deadly emptiness of a vacuum. As a result, we have set out to build solid, fortified walls there, too. However, does not living (or surviving) in the cosmos demand an entirely new habitat? In order to make survival of a biological system possible in outer space, the universal principle of a dynamic covering might present the cosmic solution, as a new biosphere, a reactor more focused on pressing ahead with the further development of existing beings than merely protecting them. The tactic of life has always been not to colonize new areas, for example, but to adjust to them and in so doing to change itself. How can such a new form of conquering be imagined? Perhaps as universal replicator DNA embedded in biological mega-incubators. Swarms of small cell-like biospheres could drift through the emptiness of the cosmos. They could be microscopic and be catapulted with natural forces into the earth's orbit. By means of the magnetic fields around our planet, electrically charged micro-organisms could overcome the earth's gravity and then die, putting the vacuum and cosmic radiation to severe tests, or else mutate to suggest new organisms in the cosmos.

Cosmic Garden

As a logical consequence, the project of a *Cosmic Garden* is thus a possibility here, a transparent polymer bubble, with a diameter of several metres and filled with air, 'poured' into outer space and, thanks to planetary rotation, having artificially created gravity. In such an isolated biosphere, plants grow and organisms, flooded by the sun, create a

The *Cosmic Garden*, 2003–2007.
A liquid polymer pneu (a
bubble cast) made in space as
a container for breeding live
organisms, videostill, *Made in
Space*, 2007

Animation: André Hindenburg,
Industriesauger-TV, Cologne ©
Zbigniew Oksiuta & VG Bild-
Kunst Bonn

garden. I am already simulating each physical parameter of the project – on earth – in a
3-D *Klinostat*. This *random positioning machine* constitutes a scientific tool which
researches the effect of gravitation on plant growth. Owing to rotation the tool creates
a condition of weightlessness at its centre in the three-dimensional sphere, fixed in the
metal frames of the *Klinostat*, as a *Breeding Space*. Depending on the speed of rotation,
the tool can function either as a centrifuge or a bioreactor. It will become a model of a
Cosmic Garden.

Since the biological membrane is a universal principle and forms the basis of each
living system in the cosmos, it is conceivable in a great variety of consistencies and sizes,
as a soft, gel-like or fluid object, the size of a pill, a fruit, a house or a biosphere. As a
bioreactor, incubator or artificial placenta, it would become the new cradle of life and
could in the future allow us to cultivate food, tools and shelters. It could even support us
in settling the cosmos – it is a *life form*, thus, with a biological future.

Zbigniew Oksiuta *Biological Habitat*
Technical cooperation: Wolf-Peter Walter, Econtis GmbH, Emmen, Holland.
Scientific cooperation: Prof. Dr Michael Melkonian, Thomas Naumann, Dr Björn Podola, Botanical
Institute, University of Cologne. Leo Leson, Ronald Zürner, Precision Mechanics Studio, Botanical
Institute, University of Cologne. Jens Hauslage, Institut of Aerospace Medicine, German Aerospace
Center, Cologne.
Medial cooperation: Sebastian Kaltmeyer, Martin Ziebell, André Hindenburg, Hauke
Sachsenhausen, Jens Höbelheinrich Industriesauger-TV, Cologne

Light, only light JUN TAKITA

Nature inspires humans – and art is the artifice that they create. In this correlation, the natural and the artificial are not a contradiction but an inseparable tandem. They are in fact inseparable like art and science, the poetic and the rational, necessary complements to harmony. Of course, when I was a child, I marvelled mostly at natural landscapes. Having had the good fortune to live on nature's edge, I was close to rich and infinitely varied countryside: plants, tiny animals, insects. Then came the awakening to the fact that economic and urban development were fighting to take over this nature. Grey, dry concrete were to kill off all the greenery and the fauna. And most of all, the little fireflies that I loved were disappearing. But economic development and activity cannot be pronounced 'guilty', in the sense that the desire to proliferate, to reproduce, to invent and construct, it is this 'human nature' without which art would not exist. What makes these new landscapes ugly are the excesses – and the lack of creativity. How then to create a different type of landscape going beyond the nostalgia for paradise, faced with the impact of a technocratic future? Artistic action takes place where these two sides, far from requiring negotiation or confrontation, are no longer distinct, where art leads to a landscape that becomes a direct extension of the body, of my body. The landscape of a dreamt reality.

Light, only light[1] is a sculpture in the shape of my brain, made using a magnetic resonance scanner. The pictures obtained with the scanner were first restored as 3D images by computer, then turned through a fritting process into a resin form, which is then covered with a bioluminescent transgenic moss, capable of emitting light in the same way as fireflies, glow-worms and certain deepwater fish do. For this, existing laboratory techniques have to be adapted, as research scientists only handle moss the size of a Petri dish, never cultures the size of our head. Work on this unusual scale in fact considerably increases the risk of contamination from moulds that are naturally present in the air, which can eat up the moss literally overnight in the event of contamination. In the first version of *Light, only light*, the brain thus totally covered with moss would be placed in a darkroom, and its luminosity captured on camera for about ten minutes until the image gradually begins to appear on the screen. In the latest version, with the use of a transgenic moss of higher bioluminescence, it ought to be visible to the naked eye.

To be faced in this way with one's own internal cerebral organ, a replica of it really alive and perceptible thanks to the new (bio)technologies, is a singular experience that goes against conventions which hold that there is a boundary separating the inside and the outside of a body. Here the boundary is no longer a barrier. It is a set of networks, just as the mass of the brain is made up of infinitely long neural networks and millions of connections, through which stimulating environmental information is gently turned into images of the world. What I am interested in is the brain skin, with its crumpled surface and its multiple folds in which light creates a strange relief. I feel there is an analogy between the formation of this skin and the process of visual perception: the transformation of light into an image projected onto the back of our head, like the creation of a light skin. Thus the light, caught in an infinite space located between the observer and the observed object, will indeed have its shape. In *Light, only light*, rather than creating its own volume, the moss covers the surface of the support. The desire to look, and the natural desire of the growing moss to cover its brain-support, together form this skin of light. *Light, only light* is a landscape-image where the beholder is faced with his or her own image. Just as any landscape only exists when a gaze captures light, without light the beholder can see

1 An earlier version of *Light, only light* was produced in 2004 jointly with the biologist Fabien Nogué of the INRA in Versailles, at the Station de Génétique et Amélioration des Plantes, and with the help of Professor Setsuyuki Aoki of Nagoya University, the maker of the genetically modified moss used in this work. For the *sk-interfaces* exhibition, a new moss with superior visibility qualities of luminescence is being specially developed at Leeds University's Centre for Plant Sciences, with the help of Dr Andrew C. Cuming and Yasuko Kamisugi.

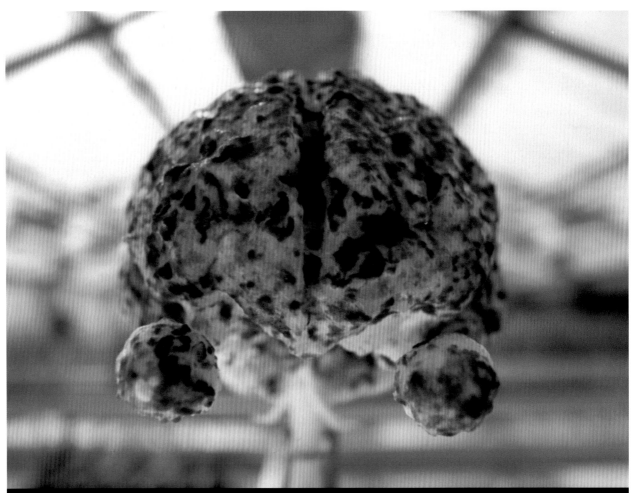

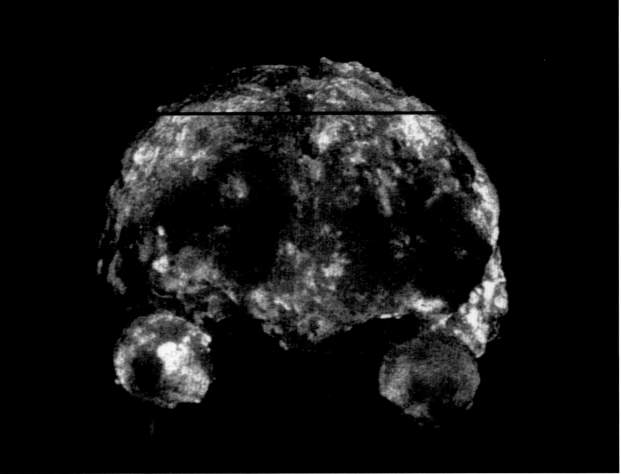

nothing. The relationship between humans and light sums up the question of physical and mental existences. The one brings the other into being. Through light, perception builds up a world view in human beings.

About 3.5 billion years ago, photosynthesis opened the path to the evolution of living beings who since then have found fertile conditions to diversify on earth – thanks to light. According to traditional classification, beings that use photosynthesis belong to the plant kingdom. But none of these has bioluminescence, or the ability to emit light. This phenomenon is only found in a very few animal species, with the exception of a few cases such as *Dinoflagellata*, which belong to both the plant and animal kingdoms. Photosynthesis is the process whereby light is turned into energy, whereas bioluminescence is the process of consuming light. Accordingly, with respect to biological evolution, photosynthesis and bioluminescence should not exist together in a single body. However, in the last few decades it has become possible to create luminescent plants through genetic manipulation, creating things that are and at the same time are not plants.

In traditional gardens, the landscape is organized around the viewer's perception: his reality and the world around him are brought together as one. By placing these technological plants in a brain garden, the viewer sees the light he has himself created. This is a display of the utopia of our era: a technique of man's own invention allows him to create a luminous other. This is indeed the expression of man's unfulfillable desire to possess light. Here, the sculpture in the shape of a luminous brain stands for light-emitting man superposed on light-receiving man. Emitting and perceiving as reflexive gestures call for a term capable of embodying these two aspects of light. In this bioluminescent brain garden the phenomenon of light unfolds as a unified perceptual experience.

The Midas Project PAUL THOMAS

The *Midas* project is a visual and sonic installation that amplifies certain aspects of experience at a nano level. The *Midas* project is analogous to the curse of the fabled Midas, King of Phrygia, to whom Dionysus gave the power of turning all that he touched into gold. This gift of touch soon changed for the king from a source of pride in his ability to a curse, as even his food and drink transformed into gold. The metonymic work is based on this Midas story, which parallels the transmutability of matter predicted by some nano scientists. As early as 1959 in his paper 'There's Plenty of Room at the Bottom',[1] Richard Feynman made social predictions concerning the potential of nanotechnology to transmute knowledge, stating that there 'is enough room on the head of a pin to put all of the Encyclopedia Britannica'. Eric Drexler further explored these ideas in his 1986 book *Engines of Creation: The Coming Era of Nanotechnology*,[2] in which he hypothesized on a 'grey goo' theory, suggesting that manipulating atoms could lead to a chain reaction where self-replicating nanobots became destructive. The action of the nanobots would call to mind the touch of the mythical King Midas. Bill Joy discussed these concepts of transference and transformation in an article in *Wired* magazine: 'It is most of all the power of destructive self-replication in genetics, nanotechnology and robotics (GNR) that should give us pause'.[3]

The *Midas* project uses the atomic force microscope (AFM), invented in 1986, and developed at the end of long line of optical microscopes introduced since the early 1600s. Robert Hooke (1635–1703) used the optical microscope to study living systems.[4] Optical microscopes were used exclusively until 1931 when the first electron microscope was introduced. The scanning probe microscope (SPM) was introduced in 1981, leading the way for the scanning tunnelling microscope (STM) and the AFM. Optical microscopes have a number of limitations in that they can only image dark or strongly refracting objects effectively. The diffraction limits resolution to approximately 0.2 micrometres, and ambient light can diffuse the focus. Unlike previous microscopes, the AFM is not optical and therefore the name is a misnomer.

1 R. P. Feynman, 'There's Plenty of Room at the Bottom', *Engineering and Science* 24.1 (February 1960), http://www.zyvex.com/nanotech/feynman.html (accessed 1 November 2007).

2 K. E. Drexler, *Engines of Creation: The Coming Era of Nanotechnology* (New York: Anchor Books, 1986), http://www.e-drexler.com/d/06/00/EOC/EOC_Table_of_Contents.html (accessed 1 November 2007).

3 B. Joy, 'Why The Future Doesn't Need Us', *Wired* 8.4 (April 2000), http://www.wired.com/wired/archive/8.04/joy.html (accessed 1 November 2007)

4 It was Robert Hooke who published *Micrographia* (1665), in which he coined the term 'cell'. When looking through the microscope at box-like cells of cork he was reminded of a monk's cell in a monastery.

The *Midas* project, installation at the Enter 3 Prague, 2007.

Photo © Paul Thomas

For the realization of this installation, Oron Catts and Ionat Zurr cultured skin cells on the substrates at the SymbioticA Research Lab in preparation for them to be scanned. The process of culturing skin cells was to create a unique set of samples from which to work, allowing me to explore various experiments with specific cells. The AFM uses a cantilever probe to touch the surface, reverting to a scanning process where an image of the surface is obtained by mechanically moving the probe in a raster scan of the specimen, line by line, and recording the probe-surface interaction via a laser being reflected on a photodiode. The AFM produces images of atoms, constructing a machinic visualization of the invisible. By scanning a skin cell with both a gold-coated and uncoated cantilever tip, specific recorded data for each event can be comparatively examined. Using the AFM in force spectroscopy mode, which only records the up and down motion of the cantilever, the transition of atomic vibrations between a skin cell and gold is demonstrated. The recorded data of vibrating atoms is translated into sound files to be presented in conjunction with a genetic algorithmic visualization of the skin cell. The algorithm is written to contaminate the skin cell's image, replicating a Drexlerian deterritorializing landscape for semi-autonomous nano assemblers. In the nano world bodies that can be deterritorialized can be reterritorialized. The reterritorialization of atoms can be constructed from a bottom-up approach. In the same way, the binary code of digital culture is based on machinic deterritorialization and reterritorialization of data by digital devices. The machinic controls interpret and process the decoding of data into the manifestation of a thing as a co-conspirator, re-coding and re-translating. The encoded and decoded machinic interpretation implies a territory of continual re-translation as a reaction to chaos.

The *Midas* project uses the skin cell as a visual metaphor for exploring the deterritorialized and reterritorialized nanobiological body. In the installation, semi-autonomous self-organizing nanobots affect the AFM's imaging of the skin cell, transmuting it into gold. The experience of touch is represented in this process via the viewer making contact with a gold-coated metal skin cell constructed from a 3D plotted image. This action plays the sound of the atoms and releases nanobots, seeded from the recorded data. The digital sound for the installation presents the viewer with the AFM's

The *Midas* project, installation at the Enter 3 Prague, 2007, which presented a projection of a single cell where a genetic algorithm was written for semi-autonomous self-organizing nanobots to affect the digital image.

Photo © Paul Thomas

The *Midas* project, installation
at the Enter 3 Prague, 2007.

Photo © Mike Phillips

tactile analysis as an audible topographic map where speakers amplify the data of the atoms' vibrations, making that which is infinitely small both audible and palpable.

To define a contemporary understanding of matter, Colin Milburn states at the inception of nanotechnologies as a scientific discipline that it 'provokes the hyperreal collapse of humanistic discourse, puncturing the fragile membrane between real and simulation, science and science fiction, organism and machine, and heralding metamorphic futures and cyborganic discontinuities'.[5] Thus the possibilities of metamorphic and cyborganic discourses being part human, part the surrounding space and part technology extends our spatial concerns in which the boundaries of the body become a signifier of an imagined particle relationship with the space between and enveloping us. The *Midas* project reconfigures perceptions of space and scale by constructing an experiential space. This space allows for exploration and questions, and further highlights the infinite smallness and the extent to which our perception of scale is of major importance in defining humanity. The sensorial analogy of touch to nanotechnology is confronted in a humanizing way through an immersive desire to be spatially connected to the world around us. 'Nano art' allows for a reconfiguring of our conscious understanding of space, which is our lived experience, generating the potential for new spatial understanding.

5 C. Milburn, 'Nanotechnology in the Age of Posthuman Engineering: Science Fiction as Science', in N. K. Hayles (ed.), *Nanoculture: Implications of the New Technoscience* (Bristol: Intellect Books, 2004), 123.

This project was in collaboration with Kevin Raxworthy and was assisted by Oron Catts and Ionat Zurr (SymbioticA), Dr Thomas Becker (Nano Research Institute at Curtin University of Technology, Perth) and Adrian Reeves (Department of Art, Curtin University of Technology, Perth).

Re-thinking Touch ZANE BERZINA

My research and practice evolves around explorations of the biomedical, interactive, tactile and aesthetic characteristics of human skin tissue. From both an artist's and designer's perspective I am fascinated by the dermis as a material, sensor, contact organ and medium for non-verbal communications. While our lives are increasingly surrounded with artificial intelligence and digital networks, I am interested in the directness of the skin – skin as an analogue system. Both the design of the *sk-interfaces* book concept and the *Touch Me* installation are organic continuations of this lengthy research process.

I have focused my practice-led study on the skin tissue as an intelligent natural material on the premise that it can serve as a model and metaphor for the development of responsive, active or interactive membrane systems which behave, look or feel like skin. I explore the epidermis in terms of biological chain reactions and mechanisms, aiming to translate 'skin technology', how it is engineered by nature and responds to external and internal stimuli, into my work. In the past decades skin as a highly complex 'intelligent interface' has increasingly served as an inspiration and model for concepts in design, art, architecture, technology and materials science to conceive surfaces and membranes that are flexible, translucent, functional, adaptive and responsive. Due to specialized material properties these systems may respond to pressure, sound, light, fluids, heat, electricity, chemical or mechanical stimuli. They are designed to interact with people and environments. Examples include responsive architectural membranes that can register noise levels in a building and translate them into visual colour-change displays on the outer skin of the building; sportswear with integrated thermo-regulating systems; self-cleaning and antibacterial surfaces; flexible textile membranes with interwoven mechanical and digital networks such as computer keyboards that can be rolled up; or textile systems with embedded sensors and actuators which can be used for medical body monitoring purposes for patients, reducing the need for hospitalization.

Despite my preoccupation with the technological and biomedical concepts of dermis, I constantly refer back to its poetic and social contexts as well as to the emotional aspects of the skin as a mirror of our mental states reflecting our emotions. There is a clear link between our skin and our nervous system, as 'in the embryo, the skin and the brain are formed from the same membrane, the ectoderm'.[1] I address this embryonic link between

1 Claudia Benthien, *Skin: On the Cultural Border Between Self and the World* (New York: Columbia University Press, 2002).

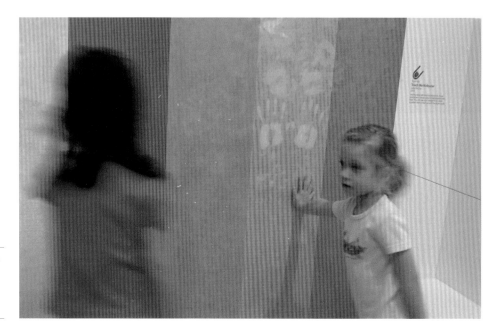

Touch Me, solo exhibition at the Latvian Foreign Arts Museum, Riga, 2006.

Photo © Zane Berzina

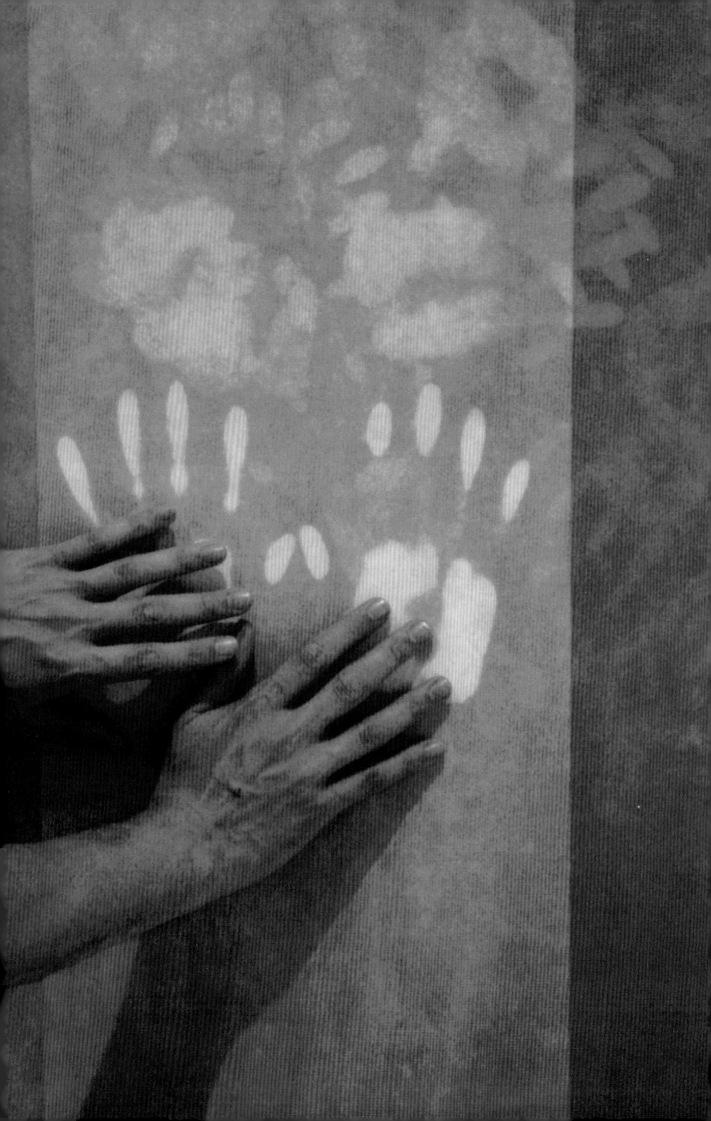

← *Touch Me*, solo exhibition at the Latvian Foreign Arts Museum, Riga, 2006.

Photo © Zane Berzina

the skin and the brain in my interactive installations. By choosing ordinary objects as my starting point (wall, book, etc.) and employing thermochromic pigments which react to changes in temperature in combination with human body heat as a trigger for the colour-change processes, I explore the possibilities for referring to the various psychological states of our skin. The sensory installation *Touch Me* is one version of my attempts to equip our environments with skin-like responsiveness. People are invited to interact with the wall by touching it and rendering their own bodily heat patterns of various intensities. These are temporarily recorded on the sensory colour-changing wall until they fade away completely. The walls act like analogue and visual thermometers responding to changes in heat levels initiated by human skin warmth, and respond directly to the intensity and duration of the touch, reflecting on the somatic aspects of dermis.

The German sociologist Georg Simmel once called touch 'the confirmatory sense' which collects information and confirms data received by the other senses and therefore is our actual sense of reality.[2] Only something we can physically grasp embodies true reality for us. My intention is to work in particular with touch and vision in order to encourage people to experience these senses in unusual ways. Both the book you are holding in your hands right now and the *Touch Me* walls carry elements of physical transformation. The *Touch Me* installation invites visitors to create visual responses through touch and metamorphoses from one state into another. The access to the written content in the book is conditioned by the combination of intellectual and sensory activities, and meaning unfolds through physical and mental interaction between the reader and the book.

2 Georg Simmel, 'Sociology of Senses: Visual Interaction' (1908), in R. Park and E. W. Burgess (eds), *Introduction to the Science of Sociology* (Chicago: University of Chicago Press, 1921).

Special thanks to: Cornelius, UK

Olivier Goulet's SkinBag Corps.EXT FABIENNE STAHL

Olivier Goulet's *SkinBag* family is made up of synthetic skin, bags, accessories and overgarments with their distinctive folded texture, flexible material and seamless, organic appearance linked to the way they are cast. You can view the *SkinBags* as bodily extensions, external organs that serve as holdalls for the items we have around us. Covers for computers, cameras, pods and other digital components are multimedia second skins that convey the miniaturization and fragmentation of computers distributed on the surface of and inside our bodies, and which will end up being connected up to our brains. As it becomes neural, our skin becomes porous. Meanwhile the overgarments can be seen as skins turned over to reveal our muscles, scalps of a sort that are at once attractive and repulsive, but which conceptually refer back to the idea of moulting. The notion of human mutation is here brought about by the wish to take on a new appearance. Our ontological dissatisfaction engenders a desire for a metamorphosis and a perfecting of our current body as exhibited by the skin.

While the traditional garment gives our skin the appearance of fabric, the *SkinBags* seek to look more lifelike. Olivier Goulet is primarily interested, not in the naked being, but in the social being as it appears to others, including our dress and our communication extensions (money, keys, telephone, organizer). The *SkinBags* thus offer our social bodies a novel, paradoxical form of nakedness. The idea is to produce a fresh skin that defines the broader outline of our character and our image. Designed to enter into people's everyday lives, the *SkinBags* are marketed notably by design and fashion boutiques. In Liverpool, Olivier Goulet is designing for FACT his first commercial space *extra muros*, an experimental venue between artistic design and business entirely given over to the *SkinBag*, with a display of numerous prototypes. His first *SkinBag* models looked like supermarket bags, some of them tattooed with brand logos. These *corporations* contrive to *incorporate* their logos into us as they become identifying social signs, turning us into shop signs.

To begin with you always have the difficult definition of a being in permanent flux. The skin, the visible part of the body where the inside interacts with the outside, naturally became a favoured object for the designer artist. Back in 1997, he scanned a man's body which he fragmented into 10 sq. cm pieces and put up for sale on the Internet. This *Vente de Territoire par Correspondance (Territory Mail-Order Selling)* gave an interactive presentation of a metaphorical geography of the body becoming a jigsaw puzzle of more or less abstract territorial organisms bearing witness to the individual experience.

The *SkinFlags* (2003) are the logical next step. As political continuity, these flags made from synthetic skin signify the obsolescence of the territorial dimension of the nation itself. The *SkinFlags* pastiche national flags, which are sullied by the colonial conduct of the human race. They denounce the importance attached to national borders, those territorial boundaries inherited from endless wars, symptomatic of man's archaic behaviour patterns. Flags are the emblems of local powers which hamper the emergence of a federal world culture. Interest and affinity groups of all kinds interpenetrate each other beyond our borders, making nation territories anachronistic. Hence the folds of the *SkinFlags* carry on from one skin colour to another; beyond any 'racial', ideological distinctions the group gels together in the links between its members. The *SkinFlags* give concrete form, through the actual material quality of the medium, to this social body that can only exist in relation *to the other: ma peau est mon drapeau* ('my skin is my flag').

These questions within the realm of the visual arts are extended into the fields of performance and dance (Cathy Sharp's *Skin* choreography of 2006; *Orbitallink*

TOP LEFT *SB-élégance* and *SB-vest*, 2001.

TOP RIGHT *SB-suit*, 2004.

BOTTOM LEFT *SkinFlag Great-Britain*, synthetic skin, 80 x 120 cm, 2003.

Photo © Olivier Goulet

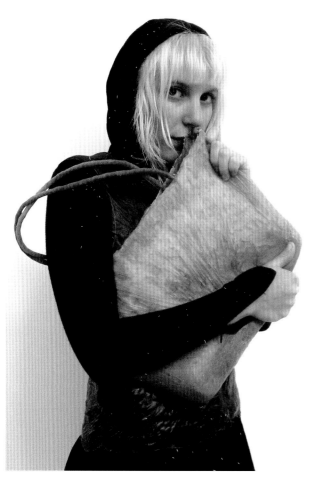

Protected Kiss (Chris + Phil), 2004,
photograph 40 x 60 cm, 2004.

Courtesy of the artist

improvisations coordinated by Ray Nakazawa in 2005/06). In *Baisers Protégés* (protected
kisses), two people are encouraged to kiss each other while wearing 'face condoms',
hermetic-like masks made by taking face casts, which leave you free to kiss whomever you
like with nothing to worry about, but which stop you seeing, feeling or breathing even.
The kiss as an aspiration to a fusional relationship and a sensuous act of love-making – to
kiss is to apply one's mouth onto one's chosen mouth – is turned in *Baisers Protégés* into
a disembodied, sham relationship, creating 'couples' who are strained, not matched, like
two total strangers. The intimacy is sham, there is no feeling, the impulse is frustrated...
But, while the approach is blind, as in René Magritte's painting *The Lovers*, the bodies'
embrace is real enough. Where does sensation stop and simulation begin? The fictional
appearance becomes more alive than the sensation actually felt. The *other* still remains
inaccessible. It is through the skin and its moultings that these games of fluctuating
identities are played – in the installation *Merci de laisser votre peau au vestiaire*[1] (please
leave your skin in the cloakroom) human moultings are hung up in a closet.

1 Marc-Olivier Gonseth, Yann
Laville and Grégoire Mayor (eds),
Figures de l'Artifice (Neuchâtel:
Musée d'Ethnographie de
Neuchâtel, 2007).

Biographies

Mike Stubbs (UK)

Until being jointly appointed Director of FACT (Foundation for Art and Creative Technology) and Professor of Art, Media and Curating at Liverpool John Moores University, Mike Stubbs was Head of Exhibitions at ACMI (the Australian Centre for Moving Image), driving a hugely successful programme including the award-winning exhibition, *White Noise*. His work as Director of Hull Time Based Arts first won him recognition as a primary promoter of new media and performance art in an international context, where he set up Time Base, a venue, EMARE (European Media Arts Residency Exchange) and the international ROOT Festival.

Stubbs's own internationally commissioned art-work encompasses films for broadcast, media installations for galleries and large-scale projections for public environs. Much of this has been made through a process of interdisciplinary research and residency.

In 2004 he received a Fleck Fellowship from the Banff Art Centre, Canada.

http://www.fact.co.uk/
http://www.forma.org.uk/artists/produced/mike_stubbs.html

Marta Rupérez (ESP / UK)

Marta Rupérez was appointed New Media Curator at FACT (Foundation for Art and Creative Technology) in July 2005. Trained as an art historian (UAM, Spain, 1999) and an arts administrator (MA 2003 – Fulbright Scholar; NYU, USA, 2003) her focus is on the study and production of contemporary creative expressions that incorporate technology. During her time in the US, Marta held temporary positions at institutions such as Rhizome.org, Guggenheim and the SFMoMA; she was also the editor of *Artscape* magazine and regularly contributed to this and other periodical publications. Marta has coordinated and produced exhibitions and events at the Kate Ganz Gallery, NY; International House, NY; Havana Biennial 2003, Cuba; basis voor actuele Kunst, Utrecht; ARCO 2004 & 2005 (Contemporary Art Fair, Madrid); the Angel Orensanz Foundation, NY; UNDEAF, Rotterdam (2007). FACT exhibitions include: *Human Computer Interaction* (Spring 2006), *Experimenta Under the Radar* (Summer 2006), *Chelpa Ferro* (Winter 2006/07), *David Rokeby* (Spring 2007), *Re: [Video Positive]* (Autumn 2007).

Jens Hauser (DE / FR)

Jens Hauser is a Paris-based art curator, writer, cultural journalist and video maker focusing on the interactions between art and technology, and on trans-genre and contextual aesthetics. Beside *sk-interfaces* at FACT, Hauser has organized *L'Art Biotech* (2003), a show on biotechnological art at the National Arts and Culture Centre, Le Lieu Unique, Nantes, and *Still, Living* (2007) at the Biennale of Electronic Arts Perth. He is also co-curating the *Article Biennale* in Stavanger (European Capital of Culture 2008 together with Liverpool), and will stage *sk-interfaces* at Casino, the Contemporary Arts Center, Luxembourg, in 2009. In 2005 Hauser received the Fund for Arts Research Grant from the American Center Foundation. He is currently a lecturer at the Institute of Media Studies at Ruhr University Bochum, Germany, and has been a guest lecturer at various international institutions including the School of the Art Institute of Chicago; Hochschule für Gestaltung und Kunst, Zürich; Donau University, Krems; and Tbilisi University, Georgia. Hauser is also a director of creative radio pieces, sound environments and documentary films which have been shown at festivals and as video installations in museums worldwide. In 1992 he was a founding collaborator of the European cultural television channel *Arte* and regularly contributes to its programmes.

← separator
Zane Berzina, *Topology of Skin II*, 2007, drawing.

Courtesy of the artist

Stéphane Dumas (FR)

Stéphane Dumas is a visual artist and an art theoretician. As an artist, he works on the fragmented human figure and the skin. He has exhibited an evolving installation called *The Lost Skins' Room (La salle des peaux perdues)*. His work has been shown in numerous places, including Galerie Isabelle Bongard and Salon de Montrouge in Paris, and the Bronx Museum and Safe-T-Gallery in New York. Dumas's work is in the Documenta Archives, Kassel, Germany, and the Brooklyn Museum, New York, among other museum collections. He teaches at ESAA Duperré, Paris. As a theoretician, he has written papers about the problem of embodiment in art, the status of image as a 'creative skin' and the relationship between contemporary creation and mythology. He defended a PhD thesis at Sorbonne University entitled 'Creative Skin: The Marsyas Myth, a Visual Paradigm'. A book on this theme is in preparation.

Richard Cavell (CA)

Richard Cavell is author of *McLuhan in Space: A Cultural Geography* (2002); co-producer, with Jamie Hilder, of the website spectersofmcluhan. net; editor of *Love, Hate and Fear in Canada's Cold War* (2004); co-editor, with Peter Dickinson, of *Sexing the Maple: A Canadian Sourcebook* (2006); and co-editor, with Imre Szeman, of a special double issue of the *Review of Education, Pedagogy & Cultural Studies* (2007: 29.1–2) on cultural studies in Canada. He is also joint founding editor, with Szeman, of the *Cultural Spaces* series at the University of Toronto Press.

Nicole C. Karafyllis (DE)

Nicole C. Karafyllis is an assistant professor at the Institute of Philosophy at Stuttgart University and a Visiting Professor of Vienna University. She studied philosophy and biology in parallel in Germany, the UK and Egypt, and received a doctorate in Ethics in Science and Humanities (Tübingen University, 1999). Her training in philosophy included a thesis on 'The Phenomenology of Growth'. Since 1998 she has been a lecturer at the Goethe University, Frankfurt am Main. Within philosophy, she deals with phenomenology, anthropology, bioethics, philosophy of technology, history of science, technology assessment, and is developing a theory on biofacticity. She introduced the term biofact into philosophy in 2001 to stress the shifting borders between the concepts of nature, biology and technology. Another main topic of her work is the philosophy of plants, situated in a phenomenology of growth.

John A. Hunt (UK)

John A. Hunt (DSc PhD) is Reader in Tissue Engineering, Clinical Engineering (UK Centre for Tissue Engineering (UKCTE)); he has been in this field of research for the last nineteen years, with over 90 scientific publications and recently obtained his DSc entitled 'Cell Material Homeostasis'. He is Associate Editor for Biomaterials, Subject Editor for Biomaterials in *Current Opinion in Solid State and Materials Science*, and on the Editorial Board of the *International Journal of Adipose Tissue* (IJAT). His research focuses on the assessment of the cellular and molecular mechanisms of biocompatibility and tissue engineering. As an applied science it is very important to learn from and encourage other disciplines into the subject. The research is global and encompasses both industrial and academic partners. In Europe, Clinical Engineering is the scientific co-ordinator of STEPS, an integrated programme of research in Framework VI with 23 European partners to take a systems approach to tissue engineering.

Jill Scott (AU / CH)

Jill Scott was born in 1952 in Melbourne, Australia, and has been working and living in Switzerland since 2003. Currently she is Professor for Research in the Institute of Cultural Studies in Art, Media and Design at the Zürich University of the Arts (ZHDK) and Co-Director of the Artists-in-Labs Program (a collaboration with the Ministry for Culture, Switzerland) which places artists from all disciplines into physics, computer, engineering and life science labs. She is also Vice Director of the Z-Node PhD programme on art and science at the University of Plymouth, UK. Her recent publications include *Artists-in-labs Processes*

of Inquiry (Vienna/New York: Springer, 2006), and *Coded Characters* (ed. Marille Hahne, Hatje Cantz, 2002). Her education includes: PhD, University of Wales (UK), MA USF, San Francisco, as well as a degree in Education (University of Melbourne) and a degree in Art and Design (Victoria College of the Arts). She has been an artist-in-residence at the ZKM, Karlsruhe, Professor of Interactive Environments at Bauhaus University, Weimar and media lecturer and Director of the Australian Video Festival at the University of New South Wales, Sydney. Since 1975, she has exhibited many video artworks, conceptual performances and interactive environments in the USA, Japan, Australia and Europe. Her most recent works involve the construction of interactive media and electronic sculptures based on studies she has conducted in neuroscience, particularly in somatic response and artificial skin (e-skin from 2003) and in retinal neuro-morphology. Currently she is also artist-in-residence with the Stefan Neuhaus Neurobiology group, Institute for Zoology, University of Zurich.

Julia Reodica (USA)

Julia Reodica currently resides in New York, USA. She is an art/science educator, artist and registered nurse. Her on-going work includes traditional art practices combined with the use of biotechnology that encourages public inquiry. Science-related work based on utilizing semi-living systems for exhibition was developed through working within science museums and institutions internationally. In various publications and symposiums, her views on innovative muscle tissue sculpting and the social impact of scientific research have raised new ethical and aesthetic questions about the new 'body' of art. As an artist she is situated in the middle of philosophical and technical influences, placing equal emphasis on both in the creative process. Her art pieces are a conjuration of new symbols that reflect social values cross-culturally.

Tissue Culture & Art Project
Oron Catts (FIN / AU) and Ionat Zurr (UK / AU)

The Tissue Culture & Art Project (initiated in 1996) is an on-going research and development project into the use of tissue technologies as a medium for artistic expression. TC&A was a model for, and is now based in, SymbioticA – the Art and Science Collaborative Research Laboratory, School of Anatomy and Human Biology, University of Western Australia.

Oron Catts, co-founder and Director of SymbioticA, is an artist/researcher and a curator. Originally trained in product design, gaining a BA concentrating on the future interaction of design and biological derived technologies, he went on to gain an MA in Visual Art.

Ionat Zurr, artist/researcher and the Academic Coordinator of SymbioticA, is currently finalizing her doctoral research into the philosophical and ethical issues stemming from the creation of Semi-Living entities.

Both have exhibited, published and run workshops internationally.

Adele Senior (UK)

Adele Senior is currently undertaking an AHRC-funded PhD in Theatre Studies at the Lancaster Institute for the Contemporary Arts, Lancaster University, UK. Her thesis considers the relationship between aesthetics, ethics and politics in the practice and theory of Bio Art, focusing in particular on the work of the Tissue Culture & Art Project (TC&A). She has recently published on this subject in *Technoetic Arts: A Journal of Speculative Research*. As part of her doctoral studies, Adele has completed a research residency at SymbioticA, the Art and Science Collaborative Research Laboratory in the School of Anatomy and Human Biology, University of Western Australia.

ORLAN (FR / USA)

ORLAN works with photography, video, sculpture, installation, performance... between Los Angeles, New York and Paris. In 1977 she presented one of her most famous performances, *The Artist's Kiss*. In 1978 she created the International Symposium of Performance Lyon. In 1982 she founded the first online magazine of contemporary art, *Art-Accès-Revue*, on France's network the Minitel. She wrote the *Carnal Art* manifesto, and from 1990 to 1993 she conducted her series of *surgery-performances*. In 1998 she launched a worldwide tour of standards of beauty in various civilizations (Precolumbian, African, American-Indian, Chinese). She hybridizes her new image (her face modified by surgery) with other culture works in digital photographs. Flammarion published *ORLAN, Carnal Art*, with texts by Bernard Blistène, Christine Buci-Glucksmann, Caroline Cros, Régis Durand, Eleanor Heartney, Laurent Le Bon, Hans Ulrich Obrist, Vivian Rehberg and Julian Zugazagoitia. In 2007 Charta published *ORLAN, The Narrative* with texts by Lorand Hegyi, Donald Kuspit, Marcela Iacub, Phelan Peggy, Joerg Bader, Viola Eugenio. www.orlan.net

Art Orienté objet (FR / FR & CM)

A French duo formed in 1991, Art Orienté objet are concerned with issues of environment and animal experimentations. Art Orienté objet means 'art object oriented', but it can also be read as 'art oriented by objects'. The projects of Marion Laval-Jeantet and Benoît Mangin aim to raise the debate about what is going on behind the closed doors of laboratories and in our society. Their work, deeply grounded in current research, explores the inter-related fields of science and art. On some occasions they use the same tools as scientists. For one of their most iconic works, *Culture de Peaux d'Artistes (Artists' Skin Cultures)*, they asked researchers from a University of Massachusetts skin production laboratory in Boston to take biopsies of their epidermis, which were grown in sterile milieu. Then they got samples deposited on a pig's dermis which they tattooed with animal motifs, mostly of endangered species or those used in biology. The skin became the site of a symbolic alliance and a questioning of the 'species barrier'.

Kira O'Reilly (UK)

Kira O'Reilly is a UK-based artist, employing performance, writing and biotechnical practices with which to consider the body as material and site in which narrative threads of the personal, sexual, social and political knot and unknot in shifting permutations. Her work has been exhibited widely throughout the UK and Europe, Australia and China. She has also presented her work widely speaking at conferences and symposia. In October 2004 she completed a residency at SymbioticA, the art science collaborative research laboratory, University of Western Australia. She was concerned with exploring convergences between tissue culturing and traditional lace-making crafts, using the materiality of skin as material and metaphor. Her research in this area continues, most recently as an artist-in-residence in the School of Biosciences, University of Birmingham 2007. In 2007 she completed a new work, *Untitled (Syncope)*, for SPILL Festival, London.

Stelarc (AU)

Stelarc has used prosthetics, robotics, VR systems, the Internet and biotechnology to explore alternate, intimate and involuntary interfaces with the body. His earlier work includes 25 'stretched skin' body suspensions. His projects include the *Third Hand*, *Virtual Arm*, *Stomach Sculpture*, *Exoskeleton*, *Extra Ear*, *Prosthetic Head*, *Partial Head* and *Walking Head*. He has performed and exhibited in Souterrain Porte IV (Nancy); CAFKA'07; Haptic (Kirchener); Robock (Amsterdam); Teknikunst '05 (Melbourne); Transfigure (ACMI, Melbourne); the Clemenger Contemporary Art Award (NGV, Melbourne); the Yokohama Triennale; the Microwave Media Arts Festival (Hong Kong); and Ars Electronica. In 1997 he was appointed Honorary Professor of Art and Robotics at Carnegie Mellon University. In 2002 he was awarded an Honorary Doctorate by Monash University. He is currently Chair in Performance Art at Brunel University West London and is Senior Research Fellow in the MARCS Labs at the University of Western Sydney. http://www.stelarc.va.com.au

Eduardo Kac (BR)

Eduardo Kac is internationally recognized for his interactive net installations and his Bio Art. A pioneer of telecommunications art in the pre-Web 1980s, Eduardo Kac (pronounced 'Katz') emerged in the early 1990s with his radical telepresence and biotelematic works. His visionary combination of robotics and networking explores the fluidity of subject positions in the post-digital world. His work deals with issues that range from the mythopoetics of online experience (*Uirapuru*) to the cultural impact of biotechnology (*Genesis*); from the changing condition of memory in the digital age (*Time Capsule*) to distributed collective agency (*Teleporting an Unknown State*); from the problematic notion of the 'exotic' (*Rara Avis*) to the creation of life and evolution (*GFP Bunny*). At the dawn of the twenty-first century Kac opened a new direction for contemporary art with his 'transgenic art'– first with a groundbreaking piece entitled *Genesis* (1999), which included an 'artist's gene' he invented, and then with *GFP Bunny*, his fluorescent rabbit called Alba (2000). Kac's work has been exhibited internationally at venues such as Exit Art and Ronald Feldman Fine Arts, New York; Maison Européenne de la Photographie, Paris, and Lieu Unique, Nantes, France; OK Contemporary Art Center, Linz, Austria; InterCommunication Center (ICC), Tokyo; Julia Friedman Gallery, Chicago; Seoul Museum of Art, Korea; and Museum of Modern Art, Rio de Janeiro. Kac's work has been showcased in biennials such as Yokohama Triennial, Japan, Gwangju Biennale, Korea, and Bienal de São Paulo, Brazil. His work is part of the permanent collection of the Museum of Modern Art in New York, the Museum of Modern Art of Valencia, Spain, the ZKM Museum, Karlsruhe, Germany, and the Museum of Modern Art in Rio de Janeiro, among others. Kac's

work has been featured both in contemporary art publications (*Flash Art, Artforum, ARTnews, Kunstforum, Tema Celeste, Artpress, NY Arts Magazine*) and in the mass media (ABC, BBC, PBS, *Le Monde, Boston Globe, Washington Post, Chicago Tribune, New York Times*). The recipient of many awards, Kac lectures and publishes worldwide. His work is documented on the Web: http://www.ekac.org. Eduardo Kac is represented by Fringe Exhibitions, Los Angeles, Black Box Gallery, Copenhagen and Laura Marsiaj Arte Contemporânea, Rio de Janeiro.

Maurice Benayoun (FR)

Maurice Benayoun is a pioneering French new media artist and researcher born in Mascara, Algeria, and living in Paris. His work and research explore the potential of various media from video to virtual reality, web and wireless art, performance, public space large-scale art installations and interactive exhibitions. His work has been widely exhibited over the world and received numerous international awards and prizes. Beside his art works, Benayoun has been involved in significant exhibition design such as the ongoing permanent exhibition for the Arc de Triomphe, Paris. Benayoun teaches new media at Université Paris 1 (Panthéon-Sorbonne) and was invited artist at the Ecole Nationale Supérieure des Beaux Arts of Paris. He is co-founder and artistic director of the CITU research centre where he leads projects about global visualization systems, locative media and mixed reality. Currently he is presenting a first 'retrospective' of his work in Poitiers (France) and a new installation at Palazzo Strozzi, Florence (Italy).

Jean-Baptiste Barrière (FR)

Jean-Baptiste Barrière was born in Paris in 1958. He has made studies of music, art history, philosophy and mathematical logic. He began his career in 1981 at Ircam/Centre Georges Pompidou in Paris, where he was a researcher, before then becoming Director of Musical Research, Education, and finally Production. In 1998 he left Ircam to concentrate on composition. Since then, he has composed the music for all the installations by Maurice Benayoun. He has also composed the music for several multimedia shows, including *100 Objects to Represent the World*, by Peter Greenaway at the Salzburg festival in 1997, and has performed all around the world. Barrière has also realized *Reality Checks*, a cycle of installations and performances, starting with *Autoportrait in motion*, commissioned by the Contemporary Art Museum of Zurich, premiered in January 1998 and presented in various museums around the world.

Critical Art Ensemble (USA)

Critical Art Ensemble (CAE) is a collective of tactical media practitioners of various specializations, including computer graphics and web design, wetware, film/video, photography, text art, book art, and performance. Formed in 1987 in the USA, CAE's focus has been on the exploration of the intersections between art, critical theory, technology, and political activism. The collective has performed and produced a wide variety of projects for an international audience at diverse venues ranging from the street, to the museum, to the Internet. Critical Art Ensemble has also written six books on varying aspects of technology and cultural resistance.

The Office of Experiments (UK)

The Office of Experiments is a temporary institution whose aim is to facilitate and explore event-based work in a context of research and experimentation, as well as archives of visual artists and media. The institution was formed following a series of projects by its initiator Neal White in which self-experimentation and self-instituted methods reflect an impulse to develop conceptual forms of institutional critique. Imagined always as occupying temporary or shifting structures, an acknowledgement of its interest in events over objects, the practice and networks the institution creates represent an interest in counter-cultural forms and their origin and relations with the visual arts. The *Truth Serum* project was realized with the research and help of such a network, and the Office would especially like to thank in particular Nicolas Langlitz of Anthropology Research Collaboratory at Berkeley for his scholarly activities and reflections upon which much of the work was based, and Arts Catalyst and Jens Hauser for their support.

The Office of Experiments has conducted experiments at the National Institute for Medical Research; International3, Manchester; Barbican Gallery, London; Max-Planck-Institute, Berlin; and Sherborne House, Dorset. In 2006 it exhibited with Danish Art group N55, Space On Earth Station at Camden Roundhouse, London. Future projects for 2008–09 include a residency at the Centre for Land Use Interpretation, Utah, USA, supported by the Henry Moore Foundation to be exhibited in the UK as an offsite commission for Camberwell College of Art. A commission for an exhibition at South London Gallery, in summer 2008, will reflect Neal

White's work with the late artist John Latham at his studio in Peckham where the Office of Experiments currently resides. Further research will form a focus for a new project, *Dark Places*, an exhibition at John Hansard Gallery in 2009. Neal White is a member of the board of O+I (formery Artist Placement Group), a Senior Lecturer / Researcher at Bournemouth University and Visiting Fellow with the Critical Practice Research Cluster at Chelsea College of Art.

Nicolas Langlitz (DE)

Nicolas Langlitz is a postdoctoral fellow at Max-Planck-Institute for the History of Science, Berlin. He studied medicine and philosophy in Berlin and Paris and wrote a dissertation in the history of medicine on the psychoanalyst Jacques Lacan's practice of variable-length sessions, which was published as *Die Zeit der Psychoanalyse: Lacan und das Problem der Sitzungsdauer* (Frankfurt/M.: Suhrkamp, 2005). He is currently revising a second dissertation in medical anthropology at the University of California, Berkeley, into a book titled *Neuropsychedelia: The Revival of Hallucinogen Research since the Decade of the Brain*.

Wim Delvoye (BE / CN)

Wim Delvoye, born 1965 in Wervik, Belgium, has been tattooing pigs since the 1990s. In 2004 he set up a tattooed pigs project in the Art Farm in China, which continues today. The artist lives and works in Gent and Beijing and became widely known on the occasion of the Documenta 9 in 1992 with a large 'Mosaic' of white ceramic tiles decorated with beautifully arranged scrolls of excrement. The works encompass a network of definitions and references that are contradictory or cancel each other out, or that mutually propel each other. In all instances his work focuses on commonplace rites and the acquisition of symbols, on reinterpretation, and on the meaningful versus the meaningless. Even though the created objects are often massive, they still create the impression of a playful flow of thoughts with an ironic undertone where many elements come together. His *Cloaca* project, a number of large-scale installations exhibited in several museums around the world, consists of eight machines representing the artificial reproduction of the human digestive tract, implying it is fed twice a day and defecates accordingly.

Ralf Kotschka (DE)

Ralf Kotschka is a media art curator and media producer. Engaged since the early 1980s as experimental film maker, film reviewer and cinema operator, he established as art historian the video art collection of the Art History Department of the University of Trier, Germany. He started as Media Art Curator in 2001 with *STYX-Projektionen*, a video art exhibition at the European Art Academy in Trier. After that he worked as guest curator on different projects and organized several film festivals. He also realizes visual concepts for museums and industry, and publishes his own documentaries and historical film footage on DVD. In several publications he has examined the correlation of the visual language of mainstream cinema with new media art, as well as the changes in perception through media development, especially concerning projected media art. www.visualconcepts01.de, www.profilierungsmaschine.de

Yann Marussich (CH)

Yann Marussich was born in Geneva in 1966. As dancer and performer, he has created about twenty performances and choreographies since 1989. From 1993 to 2000 he was co-director of the Usine theatre in Geneva, where he programmed contemporary dance and more specifically new forms of expression. He is the founder of the ADC Studio, Geneva, created in 1993. His more recent work moves towards solo performance and body-art and includes the performance *Bleu Provisoire* (2001), the body-installation *Self-portrait in an ant-hill* (2004) and *Traversée* (2004). Since *Bleu Provisoire*, his first immobile piece, he has been developing his work with themes of introspection and the control of immobility. In these performances he confronts his body with diverse challenges, or even aggression. He is close to body-art, but in its more poetic aspect. He feels this is where the poetic world of the performer exists in a violent contrast between the subjected body and an absolute impassiveness. His recent work includes *Blessure* (2005), *Soif* (2006), *Verres De Nuit* (2006) and *Nuit De Verre* (2007). He has exhibited these performances all over the world including at Théâtre de l'Usine, Geneva and Galeria Vermelho, São Paulo.

Zbigniew Oksiuta (POL / DE)

Zbigniew Oksiuta is an architect and artist experimenting with the possibility of designing biological spatial structures. His work combines architecture, biology, physics, and genetic engineering, inspired by such unquestionable masters of amorphic structures as Buckminster Fuller and Frei Otto. He consequently revitalizes the legacy of the experimental architecture of the 1960s and 70s. Oksiuta concentrates on reducing his research of space to the very necessary minimum: to the physical existence based primarily upon the verifiable physical and chemical parameters, putting aside historical, social, urbanistic and aesthetic factors. His projects such as *Spatium Gelatum and Breeding Space* examine new soft technologies and biological materials which enable the development of a new kind of living habitat in the biosphere and in space. His work has been shown at venues worldwide, including recent projects at the Venice Biennial, the ArchiLab, d'Orleans, Ars Electronica Linz, Biennale of Electronic Arts Perth and Center for Contemporary Art Warsaw. He lives and works in Cologne, Germany.

Jun Takita (JP / FR)

Jun Takita, born in 1966 in Tokyo, graduated in 1998 from Nihon University, majoring in arts. He received a Masters from Paris Ecole National d'Art in 1992, having received a scholarship from the French government. He explores through his art the phenomenon of the conversion of light by living things. His recent work *Light, only light* expresses humanity's impossible desire to possess light in the unrealized sculpture a *luminous brain* which draws inspiration from the visual concepts of a traditional garden. He works with the National Agriculture Research Institute (France) and the Information Unit for Life Sciences at the University of Nagoya (Japan), and the Centre for Plant Sciences at the University of Leeds (UK).

Paul Thomas (AU)

Paul Thomas is the coordinator of the Studio Electronic Arts (SEA) at Curtin University of Technology and was the founding Director of the Biennale of Electronic Arts Perth. Paul has been working in the area of electronic arts since 1981 when he co-founded the group Media-Space. Media-Space was part of the first global link up with artists connected to ARTEX. In 2000 he founded the Biennale of Electronic Arts Perth. Paul's own current practice-led research, the *Midas* project, focuses on the transition phase between skin and gold at a nano level. The project is in collaboration with the Nano Research Institute, Curtin University of Technology and SymbioticA at the University of Western Australia. Paul is also currently working collaboratively on an intelligent architecture project. The intelligent architecture project will be integrated into the two new buildings that will form a new Mineral and Chemistry Research and Education Precinct. Paul is a practising electronic artist whose research can be seen on his website http://www.visiblespace.com.

Zane Berzina (LV / UK)

Originally from Latvia, the London-based artist, designer and researcher Zane Berzina works on interdisciplinary projects across the fields of science, technology and art. Her practice and research evolves around responsive and interactive textiles, new materials, processes and technologies as well as biomimetic practices. In 2005 Zane completed a practice-based PhD, 'Skin Stories: Charting and Mapping the Skin', at the University of the Arts, London, using analogies of human skin in relation to her textile practice. Since 1991 she has exhibited extensively around Europe. She is a co-founder of the *e-text+ textiles* project in Riga, Latvia, which focuses on investigations of interrelationships between the text and textile practices within technological and electronic environments. Since 2007 Zane Berzina has been a main researcher on the 'E-Static Shadows' project funded by AHRC at the Constance Howard Resource and Research Centre in Textiles and an Associate Member of the Goldsmiths Digital Studios, University of London.

Olivier Goulet (FR / DE)

Olivier Goulet is a French and German transmedia artist, working in France, whose vision is in the crossroads of activism and human design. Through the examination of the emotional body, he decodes the principle of identity. He has explored humanity as a species in the process of disappearance (*Moults*, 1993; *Boxes of Hominoid Insects*, 1998; *Human Hunting Trophies* since 1996), he has imagined the mutation of the human body, that painful journey from egocentric individualism towards an optimal collective identification and networking (*The Relic of Bionic Man*, 2001; *Brain Rezos*, 2006; Conference 'To finish with anthropomorphism', Sorbonne, Paris, 2006). Since 2001 he has been working on the SkinBag project, a synthetic skin, as a metaphorical fusion between organic and digital.

Fabienne Stahl (FR)

Fabienne Stahl is a France-based art historian. She was attached to museums for five years (curator at the Museum of Châteauroux and at the Museum of Modern Art of Saint-Etienne). Since 2003 she has worked with Olivier Goulet. With him, she has co-produced video clips (*Bodies masqued* and *O game*, 2004), worked on several projects (*Face condom*, *Protected kisses* and *FaceCape*) and organized different events for SkinBag (performance, *Night of mutation*, Budapest, 2006). She has written many texts about Olivier Goulet, especially about *Territory Mail-order Selling* (*Museum of cast*, Lyon, 2004; *Edit* [web magazine] 2006). At the same time, she is a specialist on the work of Maurice Denis with a thesis in progress on the religious decorations of Maurice Denis between the two world wars at Blaise Pascal University, Clermont-Ferrand, and she is a research assistant to Claire Denis.

Funders and Supporters

Exhibition

Exhibition made possible in part through the support of the American Center Foundation

with the support of the institut Francais du Royaume-Uni.

SymbioticA; the Art and Science Collaborative Research Laboratory at the School of Anatomy & Human Biology, University of Western Australia.

THE UNIVERSITY OF WESTERN AUSTRALIA

Liberté • Égalité • Fraternité
RÉPUBLIQUE FRANÇAISE

This translation is supported by the French Ministry of Foreign Affairs, as part of the Burgess programme run by the Cultural Department of the French Embassy in London. www.frenchbooknews.com

Artists

Maurice Benayoun

Yann Marussich

Zbigniew Oksiuta

The Office of Experiments

Jun Takita

Conference

sk-index